P9-DBL-669

GOLDEN STATES OF GRACE

Prayers of the Disinherited

RICK NAHMIAS

UNIVERSITY OF NEW MEXICO PRESS ALBUQUERQUE

© 2010 by the University of New Mexico Press

All rights reserved. Published 2010

Printed in Canada by Friesens

15 14 13 12 11 10 1 2 3 4 5 6

LIBRARY OF CONGRESS CATALOGING-IN-PUBLICATION DATA

Nahmias, Rick, 1965–

Golden states of grace : prayers of the disinherited / Rick Nahmias.

 p. cm.

ISBN 978-0-8263-4677-3 (pbk. : alk. paper)

 1. Marginality, Social—Religious aspects—Exhibitions.

 2. California—Religious life and customs—Exhibitions.

 3. Marginality, Social—California—Exhibitions.

 I. Title.

 BL2527.C2N34 2010

 204'.308694074794—dc22

 2010003602

Book design and type composition by Melissa Tandysh

Composed in 10.25/14.25 ScalaOT Regular

Display type is Cronon Pro

For Steve,

who soothes my soul and lifts my spirit in more ways than he knows.

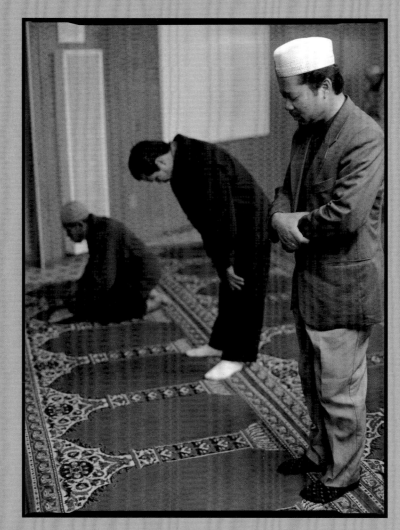

Cham men at prayer, Cham Muslims

GOLDEN STATES OF GRACE

What is prayer? . . .

When words bring you closer to the prisoner in his cell,

to the patient who is dying on his bed alone,

to the starving child,

then it's a prayer.

—ELIE WIESEL

the Mother

May I always
Bring the arms of **the Mother**
To all that I meet.

May I always
Wrap the arms of the Mother
Around myself.

—KALI BABA, KASHI ASHRAM

Gathering, Women of Wisdom

your creation

All people are **your creation**;

Guide us to understand each other without being biased or prejudiced.

Help us to communicate with each other so that we will not be ignorant.

You made us **different tribes and nations**.

Show us how we can take benefit from one another,

Instead of despising one another.

O Lord, help us find the means and methods for building a better society for all.

Amen.

—BROTHER SALIM, CHAM MUSLIM

different tribes and nations

Contents

Remind us

Remind us daily,
and oftener if necessary,
that each of us is Good as Gold.

—HELEN,
IMMACULATE HEART COMMUNITY

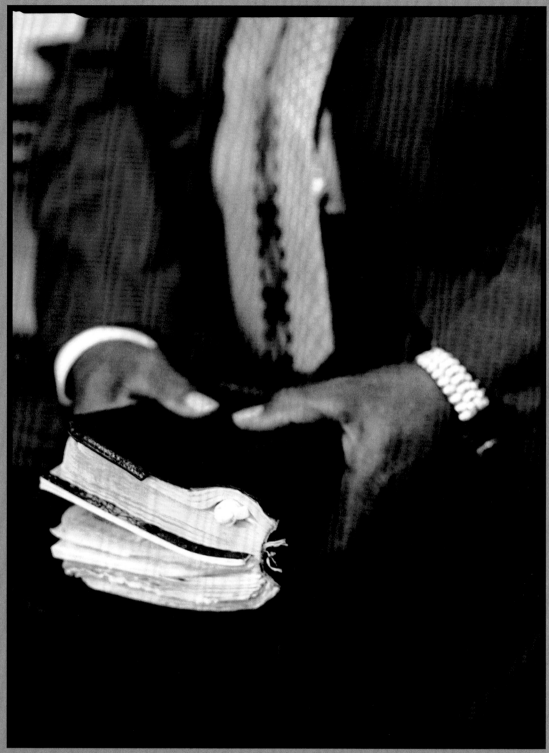

Church elder, Friendship Baptist Church

sharing my blessing

I hope that I will become a more kind and generous person

through loving those around me

and **sharing my blessing** with those in need.

—NATALIE,
DEAF BRANCH OF THE MORMON CHURCH

Foreword

BY JACK MILES, PHD

THE MEANING OF THE PHOTOGRAPHS THAT Rick Nahmias has taken for *Golden States of Grace: Prayers of the Disinherited* will be different for each viewer, beginning with the subjects themselves. But in this connection, it matters crucially for the impact of this book as a whole that, unlike the typical American art photographer, Nahmias does not stand back in contained silence and demand that his work speak for itself. You, the reader of this book, may well find meanings in the photographs other than or even contradictory to those found by the photographer himself, but as well as he can, he will tell you in words as well as photographs what the subjects of the photographs mean to him.

Golden States of Grace introduces the reading public—first and foremost the reading public of California, the proverbial Golden State—to a range of communities that many of us have never seen or thought about before. The phrase *the reading public* defines a group that, large as it is, is limited to those with the ability to read for pleasure and instruction and with money to spend on a rather expensive book or, at least, time to spend reading it through at a library. Millions of poorly educated

and overworked Californians fail to meet one or the other of those two simple criteria. This is not to say, I hasten to add, that the subjects of Nahmias's photographs are themselves necessarily penniless and illiterate. They often are not, and yet it is not saying too much to recognize that they are—to use his own word for them—among California's disinherited. The life that, at a generous estimate, the upper half of California enjoys, the life that is its presumed birthright and inheritance, in which, as in television commercials, there is a cure for every disease and a solution for every problem—this is a life that the subjects of this book do not lead.

That fact taken in isolation might tempt some to characterize this book as an exposé, a work that simply displays or exposes what few have ever seen. Such a work was Jacob Riis's landmark of protest photojournalism, *How the Other Half Lives: Studies among the Tenements of New York*, published in 1890. Riis was a gifted photographer, and he deserves credit for advancing an agenda of conservative social reform. He would not have approved of government-funded urban housing projects, and yet we have good reason to think of him every time we see such a project.

He put an issue on the national agenda that has never quite gone away.

Whatever his gifts, however, Riis clearly saw the subjects of his photography as objects rather than as true subjects. In a good many of his shots, his tenement dwellers are shot bearing a startled expression. They make one think of nocturnal animals caught by a tripwire-activated camera and brought to the pages of *National Geographic*. In fairness, flash photography was such a novelty in 1890 that few of Riis's subjects had ever seen such an explosion of light, especially not in the preelectrification darkness of their own windowless dwellings. And yet the fact remains that for him these people were, first and last, a problem to be solved. Their ways of coping with their lives in the absence of any help from their "betters" were to be deplored, on the whole, rather than celebrated. They were another aspect of the problem rather than any part of its solution. Although the ultimate conceptual frame for the Danish-born Riis's work was his quite consciously espoused Scandinavian Lutheranism, and although we can scarcely then call him indifferent to religion, he was nonetheless little concerned to pursue "the other half" out of their tenements and into the synagogues and Catholic churches that so many of them did attend.

A century later, in a deliberate rejoinder—if something less than a rebuke—to Riis, Camilo José Vergara published a book of photographs and accompanying commentary entitled *How the Other Half Worships*. Like Nahmias in *Golden States of Grace*, Vergara does not by any means see the other half as merely a problem for society to resolve. He views them with compassion, fascination, and respect. Like Nahmias again, Vergara does not objectify the subjects of his photography, and his work includes some informative conversations with clergy in, especially, those vast tracts of our greatest cities that the upper half rarely lays eyes upon. But Vergara is above all a gifted and evocative photographer of the built environment rather than a true portrait photographer. His most haunting and unforgettable photographs are of church buildings as they look when all the worshippers have gone home and their hopes and fears are just an indefinable something lingering in the empty air.

In *Golden States of Grace*, the focus is not on the places but on the people—not on the church as a certain kind of venue but on prayer, especially collective prayer, as a certain kind of group activity. The English noun *church* derives in a complex way from the Greek adjective *kuriakos*, meaning "of or belonging to a lord"—not, in the first instances, the Lord God, but any lord (Greek *kurios*) or official. In the Greek-speaking early church, the first buildings built specifically for worship of *the* Lord, the divine *Kurios*, came to be called *kuriaka*; and from the Greek-speaking Mediterranean that word made its way over the centuries through Germanic northern Europe, changing, as it went, to Scotland, where it became *kirk*, and to England, where it became *church*.

But centuries earlier, before official, dedicated church buildings came into existence, at a time when many of the early Christians themselves belonged to the "other half" of the Roman Empire, they called themselves collectively by another word than *kuriakon*. They employed the somewhat mysterious term *ekklesia*, a word whose literal meaning would be "out calling" or, more accurately, "out summoning." They understood themselves to have been called out or summoned out from wherever and whatever they were by birth into something new. In sociological or socioreligious terms, they had departed from an ethnic identity that included and determined their religious practice, entering into a new kind of social entity in which a fresh religious practice was understood to be compatible with any and every ethnic identity. The Greek-speaking Jews who created the original *ekklesia* were the first to experience this calling. Others, non-Jewish, would follow in huge numbers. Whenever and wherever these people gathered together, they *were* the church in person. When writing letters to them, Saint Paul would write, revealingly, to Aquila and Priscilla and to "the church which is *in* their house." The house was not the church; the people who gathered in it were.

This Christian notion of a voluntary group assembling in the belief that it has been somehow summoned together had from the start more meanings than the transcendence of ethnicity just alluded to. Thus, the new Christian was summoned not just out of a simply given sexual, ethnic, and social identity into a freely chosen assembly in which there was "neither male nor female, neither Jew nor Greek, neither slave nor free." He or she was also summoned out of sin into virtue and out of death into life. Christian conversion was the occurrence of all these changes at once, sometimes in a single blinding moment, as in the conversion of Paul himself.

And yet the process by which people—even at the very bottom of a society—come into company with one another, experiencing what they can only describe as a summons to do so, surely transcends Christianity. A cynic may say of such a coming together that misery loves company, but can the cynic say exactly *why* it does? Can he or she explain the phenomenon—equally common, after all—of misery shunning company? "Since my cancer diagnosis, I find that I just don't want to go out in public anymore." Some afflictions prompt that kind of response. But what Rick Nahmias documents—and here I name that which in my judgment makes his photodocumentary exceptional—is the spontaneous formation of communities of people who find an ennobling meaning as they unearth one another, the two kinds of discovery occurring as a single event. Though he is currently without a structured or formal religious affiliation himself, Nahmias nonetheless confesses that he is both fascinated and moved by this process as he observes it unfolding in the communities he feels so mysteriously and powerfully summoned to encounter.

With Vergara and against Riis, Nahmias does not regard the subjects of his photography as a problem to be solved. He does, emphatically, regard them as the worthy subjects, the genuine protagonists, of their own lives. More than that, even, he regards them as, through their conversations with him, the coauthors of his book. As for their prayers, he does not claim that they constitute the solution to any

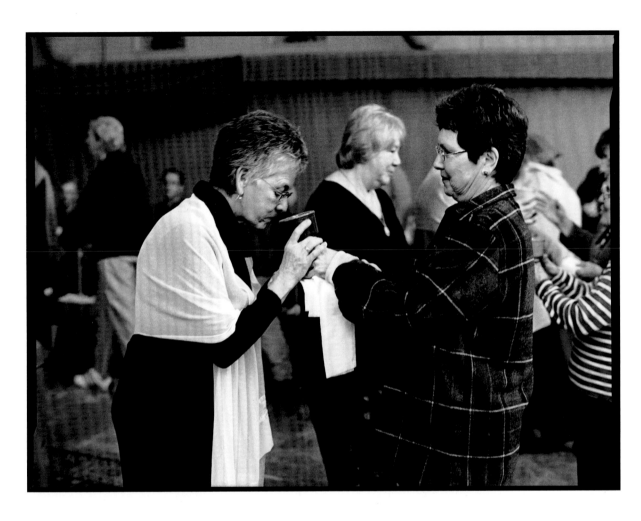

Communion,
Immaculate
Heart
Community

problem. Deaf Mormons, at the conclusion of one of their services, do not expect to recover their hearing. Imprisoned Buddhists do not expect to be paroled. Difficult as it may be to capture in words the final point of such exercises, the point is clearly neither to forget the shared condition nor to eliminate it. The benefit of the exercises is rather to be realized as the summoned together recognize in one another a value and dignity that, note well, they have not collectively conferred upon each other but only collectively discovered. They had it before they found it. They just didn't know they had it. It is this process of discovering that Nahmias finds most ingratiating.

"Ingratiating?" you ask. I use this perhaps surprising term by design.

The word *ingratiating*, like the word *grace* in the title of this book, belongs to a family of cognate words including *gracious, graceful, grateful, disgrace, graceless,* and even *ingrate*. Here in California, where Spanish is the omnipresent second language, we can add a Spanish word to the mix. Even English-speaking Californians usually know enough Spanish to say "thank you" in that language: *gracias* or *muchas gracias.* Spanish *gracias* belongs to the same larger Indo-European family of cognate words whose core notion, to employ an abstract noun belonging to the same family, is that of *gratitude.*

A gracious host is one whose manner says not just, "I am glad to see you," but also, "I am grateful to be seeing you. It is you who are giving something to me." A graceful woman is one who, rather than being proud of, let's say, her beauty, seems rather to

be humbly grateful for it. An ingratiating community is one that makes you grateful for its existence, inducing the attitude that was induced in Nahmias by his experiences with these communities of the disinherited. In Christian theology, the "state of grace" is the antithesis of the state of sin and guilt, and the originating difference between the two is indeed the difference between gratitude and the guilty pride that asserts, against what it knows, that "whoever I am and whatever I have I owe to nobody but me." "I am pride," a character in a Christopher Marlowe play proclaims. "I have no father." Contrast that with the beautiful and rather liberating Muslim notion that since everything comes from God and will eventually return to him, we humans are mere custodians—viziers not just of our possessions or of this planet but even of our very talents and personalities, such as they are, and of our defects, scars, and handicaps. God owns them and will eventually reclaim them. We have just been given temporary custody of them. Simone Weil once wrote that a man who would boast of his intelligence is like an animal boasting of the size of its cage. A step beyond that, perhaps, would be the condition of an animal boasting of a cage it did not even own.

The states of grace that Rick Nahmias documents are states of mutual gratitude, achieved against enormous obstacles. Their result is a set of communities of meaning and love that at their best are astonishingly gracious and graceful, even or perhaps especially as they graciously but irresistibly repudiate others' characterization of their condition as moral or physical disgrace.

According to the usual account, California acquired the nickname the Golden State because gold was discovered here in 1849. For most of us who now live here, I suspect, California remains the Golden State because of the golden glow that touches its tawny hills, still sometimes dotted with dark oak, as the sun sets in the Pacific. But this state offers as well, and in some of its unlikeliest corners, golden moments of another kind. By discovering these, not merely exposing them, Rick Nahmias has done California a handsome and gracious service.

Jack Miles is Senior Fellow for Religious Affairs with the Pacific Council on International Policy and Distinguished Professor of English and Religious Studies, University of California, Irvine. Miles won the Pulitzer Prize in 1996 for God: A Biography, *which has since been translated into sixteen languages. A MacArthur Fellow (2003–7) and former member of the* Los Angeles Times *editorial board, he is general editor of* The Norton Anthology of World Religions.

your practice

May **your practice**
bring you balance
in all things.

—MIKE,
BUDDHADHARMA
SANGHA

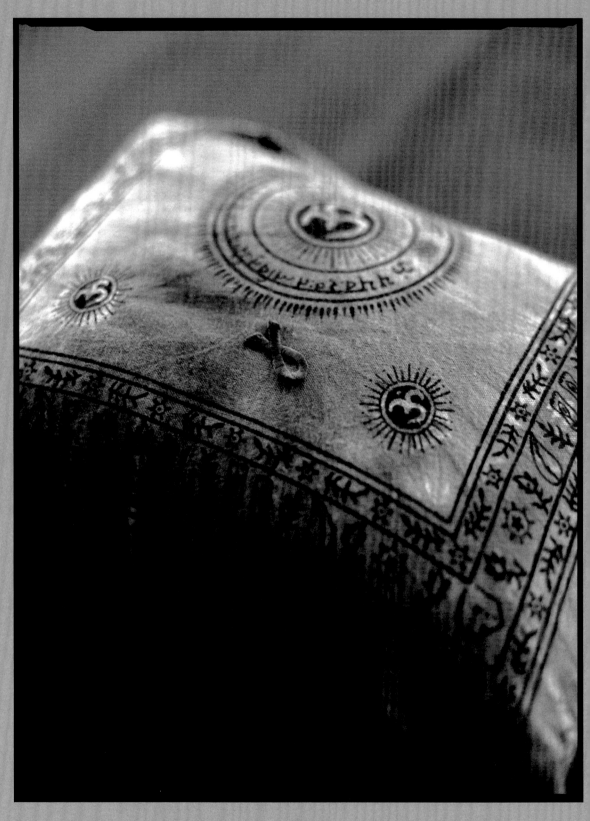

Pillow with AIDS Ribbon,
Kashi Ashram

be always with me

Holy Death, relic of God,

solve my sorrows, with you next to me.

May your infinite desire to do good **be always with me**,

with happiness for all.

Your divine balance with your celestial strength covers us with your sacred cloak,

Holy Death.

— YAJAHIRA, SANTÍSIMA MUERTE (TRANSLATED FROM SPANISH)

Preface

BY RICK NAHMIAS

I AM OF THE FIRM BELIEF THAT EVERY ONE OF us carries something within that is marginalized: some piece of personal history or trait that has been, or that we wish would be, left behind or cast off— the emotional scars left by an abusive alcoholic mother, the malformed foot, the embarrassingly immigrant heritage, and so forth. Compounded by an allegiance to Jung's theory of the collective unconscious, this concept has led me to conclude that those whom society has cast off as "them" are, in reality, "us." It has also inspired the creation of this body of work.

In assembling this book I have hoped to create something of a contemporary visual prayer book— one composed of sacred people, places, and things. I am honored that each of the participating communities contributed original prayers to deep readers' understanding of *how* they believe. I have taken the liberty to thread their words through the entire book, concluding with a single "American Prayer" I composed of emblematic phrases compiled from each of their contributions.

Since I began *Golden States of Grace* in 2003, it has often felt as if our world has drawn increasingly more stark divisions between "us" and "them," be those divides cultural, political, socioeconomic, or religious. Additionally, representations across faith lines have become filled with stereotypes and at times, the outright hatred of "the other." National and international events demonstrate almost daily that we live in an increasingly faith-based society that has shown in many instances its intolerance of those who do not clearly embrace the narrowly defined codes of morality and religious worship. (The day before I began editing this book, a man entered a church in Knoxville, Tennessee, and shot eight people, killing two. His motive: his victims were too liberal in that they supported the inclusion of gays as active members of their congregation, along with racial desegregation and women's rights.)[1] This body of work aims specifically to counteract that intolerance, in the hope that its audience might open itself to discovering (if not experiencing) faith from the bottom up.

Even with the prevalence of mainline religious institutions and middle-class America continuing to exclude and even vilify those they view as beyond the pale, there are still reasons to be hopeful that we, as a society, can see beyond our

religious tunnel vision. A recent study on religious views across America published by the Pew Forum on Religion and Public Life documented that nearly three-quarters of Americans believe that many faiths beyond their own can lead to salvation.[2]

You do not have to want to sit down to breakfast with someone to respect his or her place beside you in sanctuary or in community. Nor is not my intention that this book's readers throw their arms open to embrace the people depicted within it. Rather,

if I have one singular hope, it is that our collective eyes remain open long enough to simply acknowledge *every* human being's need *and* right to come to some profound understanding about his or her own connection to a higher power.

Thus, in the end, *Golden States of Grace* is a study of otherness—the otherness out there, the otherness within each of us, the otherness that begs us to bind together as human beings to celebrate, contemplate, and find meaning in our lives.

Notes

1. Dewan, Shaila. "Hate for Liberals and Gay People Drove Gunman, Police Say." *New York Times*, July 29, 2008.
2. Pew Forum on Religion and Public Life. http://religions.pewforum.org/affiliations.

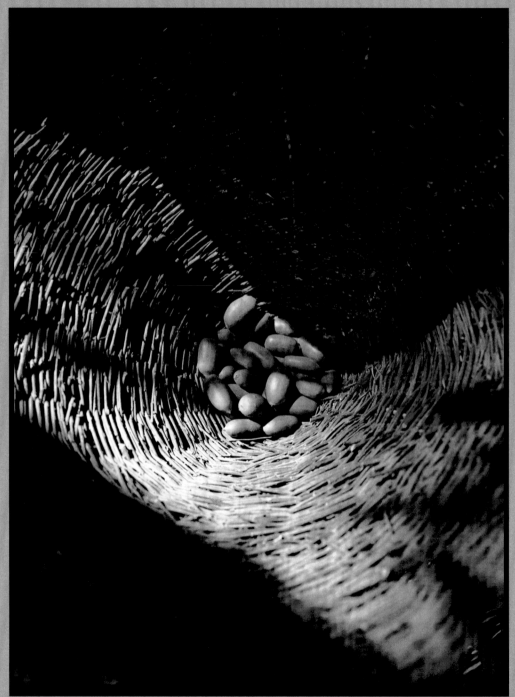

changes in your life

If there are any types of
changes in your life,
you have to believe in yourself.
That's where it starts.
You have to love yourself and
understand yourself
in order **to transition**—in order
to be what you want to be.

—JAIME,
TRANSCENDENCE

Acorns, Federated Indians of Graton Rancheria

In a world of seemingly decreasing hope,

my faith and my association with members of this church strengthens me,

their love and care for one another.

It lets me know that there is still much that is good in the world

and gives me hope for the future

and the strength to meet the challenges before me.

—RANDY,
DEAF BRANCH OF THE MORMON CHURCH

Exhibit Introduction

BY REV. PAUL CHAFFEE

GOLDEN STATES OF GRACE TAKES US ON A religious odyssey through California communities of faith we never imagined were there . . . the nation's only halfway house for addicts self-identified as Jewish, a transsexual gospel choir, a Buddhist community in San Quentin, a Mormon congregation organized by the deaf for the deaf, Latina sex workers worshiping the Mexican folk deity Holy Death, and more. The collection is thoroughly interfaith: American Indian, Buddhist, Catholic, Hindu, intentional interfaith, Jewish, Latter-Day Saint, Muslim, Pentecostal, Protestant, and spiritualist traditions are represented.

In all, eleven communities on the fringes of life today in California opened their doors and trusted Rick Nahmias to enter with his camera, a remarkable tribute from people who have little reason to trust the outside world. They must have sensed the caring, nonjudgmental attitude the artist enjoys. California is a state that prizes an unparalleled ethnic, racial, religious, and sexual diversity. But as you experience *Golden States of Grace*, one photograph after another, your ability to quit fearing the

stranger, to look at and acknowledge "the other," stretches and deepens.

If these exotic contexts tempt the voyeur, seeing the photographs is a gentle rebuke, for they are grounded in respect. The humanness of the portraits is humbling, puncturing our judgments about "those" kinds of people. They have drifted from the mainstream, found themselves outcast, yet their humanity shines through like a light undimmed by life's tough circumstances.

An earlier Rick Nahmias collection focused on migrant workers, another largely invisible community in our midst, men and women who ensure that a cornucopia of fruits and vegetables arrives daily in our kitchens. As in *Golden States of Grace*, Nahmias cut through our expectations and stereotypes to find the beauty and vitality of people living on the edge in this land of abundance.

Religious community is the added element in this new collection—spiritual gatherings, not from one tradition, but from nearly a dozen. At every stop on the journey, without seeming intrusive, the camera provides a window into the spiritual practices

of the marginalized. Nahmias' images convey a palpable sense that we are witnessing the breath of the Spirit in each group, however they define Spirit. It is a moving experience and upsets old assumptions.

When the word congregation suggests something more mainstream than marginalized, Nahmias seems to be saying, we've forgotten our origins. These are the people whose suffering inspired the Buddha's quest for enlightenment. The destitution of the weak and oppressed was mourned by Hebrew prophets. The disenfranchised kept catching Jesus' attention. Helping the disadvantaged is a pillar of Islam. In spite of this common heritage, if we've learned to turn our faces away from the poor and powerless, these photographs make it safe to care about them, to recognize them, perhaps for the first time, as members of the family.

Rev. Paul Chaffee is the executive director of the Interfaith Center at the Presidio, San Francisco.

'Ow

Ma 'ooni kenne-tto We come together

Hunaa ma neenas. So that we celebrate.

Ma molis nis weya. We are grateful for this earth.

Ma molis hii. We are grateful for the sun.

Ma molis 'is liwaako. We are grateful for the waters.

Sutammi maakooni Be with us

Hunaa maako towis **So that we do good in this world**.

Suk weyyatto.

'Ow

So that we do good in this world —EARTH BLESSING,
FEDERATED INDIANS OF GRATON RANCHERIA

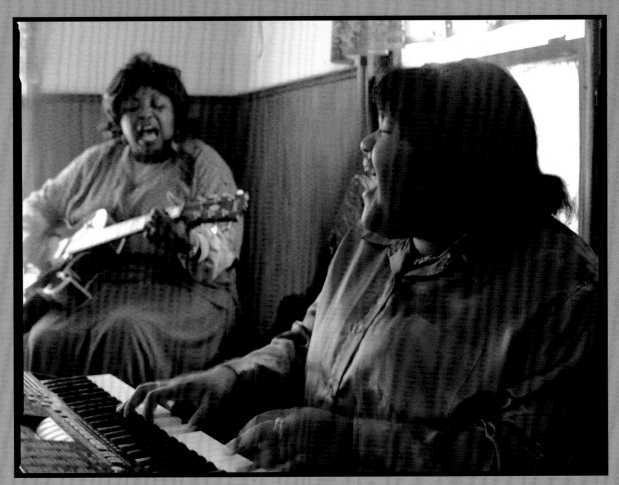

Sunday service, Teviston House of Prayer

GOLDEN STATES OF GRACE
Prayers of the Disinherited

Participating Communities

(listed in order of documentation)

BEIT T'SHUVAH (CULVER CITY):
Having opened its doors in 1987, this is the nation's only halfway house aiding addicts self-identified as Jewish. All residents participate in Twelve Step recovery, which is interwoven with Torah study. Beit T'Shuvah's 115-bed facility works with 170 alcohol, drug, sex, and gambling addicts a year. Its leaders and residents were documented over Passover and Yom Kippur observances.

TRANSCENDENCE (SAN FRANCISCO):
The world's only transgender gospel choir, Transcendence, founded in 2001, provides both a second family for many of its nearly twenty members and a safe environment for them to adjust to their new voices while in transition from hormone treatment. Singing dozens of concerts annually, they were photographed rehearsing and performing for a San Francisco–based arts festival.

BUDDHADHARMA SANGHA AT SAN QUENTIN PRISON (SAN QUENTIN):
This group of Zen Buddhist practitioners is composed of men incarcerated in California's oldest prison. Led by a Zen master from Marin County, they meet every Sunday for several hours, engaging in meditation, chanting, and formal dharma discussions aimed at allowing inmates to reflect on their pasts as well as their futures.

SEX WORKERS DEVOTED TO SANTÍSIMA MUERTE (SAN FRANCISCO):
This community of Latina sex workers, most of whom have immigrated from Guadalajara, Mexico, embraces the female folk deity Santísima Muerte (among other patron saints, such as Saint Jude and the Virgin of Guadalupe). Santísima Muerte—directly translated as "Holy Death" and personified by a cloaked skeleton—is believed to have been sent to rescue the lost or outcast in society and safeguard them from harm. They were documented over several days at their single room occupancy hotels in San Francisco's Tenderloin district.

IMMACULATE HEART COMMUNITY (SANTA BARBARA):

Composed originally of dispensated Catholic nuns with a median age over seventy, this community broke away from the Los Angeles Archdiocese in 1970 after deciding they wanted to pursue a doctrine focusing on social justice, holding strong feminist tenets, and advocating for the marginalized. Exiting their ranks as nuns, they left behind the safety net of jobs, homes, and pensions. IHC membership is open to men and women, single or married, from all Christian denominations, and members come from many fields, including education, social work, and the law. They were documented during their statewide retreat at Casa de Maria in the hills of Santa Barbara.

RURALLY ISOLATED PENTECOSTALS AND BAPTISTS (SAN JOAQUIN VALLEY):

This mostly African American Christian community hails from across the Central Valley, but many of its members travel upwards of sixty miles to worship in one of three small churches in the unincorporated towns of Teviston and Pixley, located in Tulare County, one of California's most impoverished counties. Many congregants were born into families who picked cotton or performed other farm labor. Even after moving on to larger towns like Bakersfield or Fresno, several of them still choose to return weekly to keep these tiny churches alive through prayer and community outreach.

FEDERATED INDIANS OF GRATON RANCHERIA (SANTA ROSA):

This tribe consists of both Coast Miwok and Southern Pomo Native Americans whose ancestors have existed in this region for thousands of years, with territorial lands that included all of Marin and southern Sonoma counties. Having received official recognition by Congress in 2000, in the past few years they have begun reclaiming their ancient rituals, dances, and language. They allowed their annual Acorn Festival to be recorded for the first time for this project.

CHAM MUSLIMS (SANTA ANA):

The Cham, a distinct cultural minority within Cambodia because of their language and Muslim faith, were specifically targeted for annihilation when the Khmer Rouge regime began its genocide in 1975. Of the approximately two hundred fifty thousand Cham, roughly 36 percent, or ninety thousand people, were murdered or starved to death by 1979. Fifteen of the surviving families settled in Orange County in 1980. Eventually, one at a time, they brought other families over to a small apartment complex that housed them, a mosque, and their Sunday school. They were photographed at the close of the Islamic holy month of Ramadan during the feast of Eid ul-Fitr.

WOMEN OF WISDOM AT CALIFORNIA INSTITUTE FOR WOMEN (CHINO-CORONA):

This is an "inside/outside" spirituality group for female prison inmates and the women from outside the penitentiary who join them in forming a faith community. The circle is interfaith and multicultural, as dictated by the women in prison themselves. The group is composed of approximately ten women from the "outside" and thirty women on the "inside" who participate in a monthly evening of dialogue, ritual, and listening to the Spirit within and among them.

DEAF MEMBERS OF THE UNIVERSITY CITY BRANCH OF THE CHURCH OF LATTER-DAY SAINTS (SAN DIEGO):

Started in 1990, this branch of the Mormon Church caters especially to deaf as well as some blind church members. With a number of service projects, in-house visits, sacrament meetings, and even musical stage performances, this branch has dozens of members. It was formed out of a desire for hearing-impaired individuals to take part in spiritual devotion and community events that would not be compromised due to their disability.

PEOPLE WITH HIV/AIDS AT KASHI ASHRAM (WEST HOLLYWOOD):

Though open to people of all faiths, the ashram uses a combination of Hindu sacred practices and traditions, including yoga and meditation, to reach its members, many of whom are HIV positive or battling AIDS. Founded in 1976 by Guru Ma Jaya and her *chelas* (students), the community has largely focused, spiritually and practically, on issues of death and dying as well as on performing service to disenfranchised people, especially the poor and those facing life-challenging illnesses.

dreams beyond today

O God, once again the dawn reminds us of you as we gaze and look upon your glory.

Give us the faith that creates possibilities

The hope that enables the **dreams beyond today**

The love that nurtures relationship.

And in your Triune self, make it possible for us for this day

To truly reflect the glory that we saw at dawn.

—ALEXIS, IMMACULATE HEART COMMUNITY

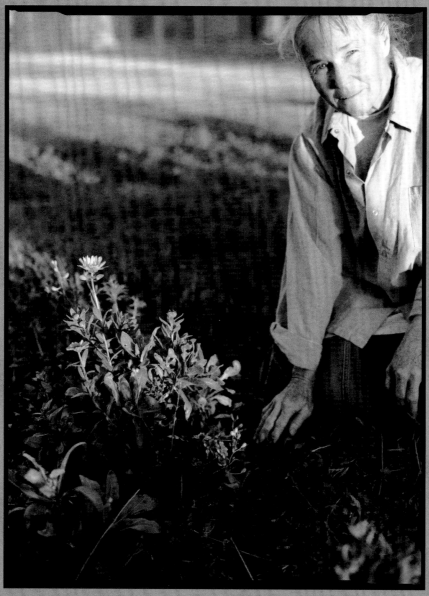

Vonda, a lifer, tends the prison garden, Women of Wisdom

Core Images & Didactics

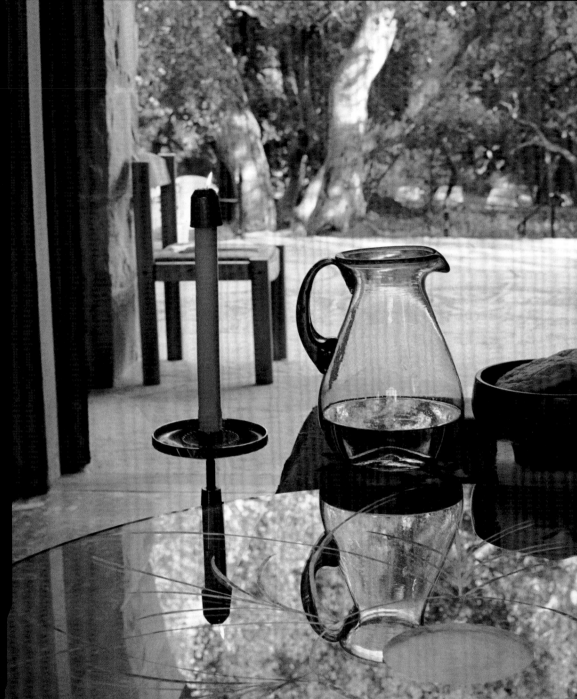

in this
community

Bless every home represented
here
Have your way Lord
Have your way Lord
Put your love in the churches
Let them feel your love for
one another
Look on our community right
now Lord
Move **in this community**
right now Lord.

—ELDER HURD,
FRIENDSHIP BAPTIST CHURCH

The chapel at Casa de Maria before service, Immaculate Heart Community

We give thanks

This day we thank the Creator for all that he
has given to us.
We give thanks for the water, the sun, the
earth, the wind.
We give thanks for the oak tree which feeds us
and other creatures.
We also give thanks for its shade and its wood.
Creator, watch over the oak trees and keep
them alive and strong.

—ACORN FESTIVAL PRAYER,
FEDERATED INDIANS OF GRATON RANCHERIA

Sacred Spaces

Indian Suitcase, Federated Indians of Graton Rancheria

Feathers and headdresses wait to be used by tribal members in the Acorn, as the Acorn Festival has come to be known by the tribe. As an important part of several local tribes' ancestry, acorn festivals were created to celebrate the annual harvest of the prime Indian staple food. Families from scattered villages would gather to share supplies and recent news, as well as perform ceremonial dances of gratitude for the season's bounty. Once numbering twenty thousand strong, all of this tribe's current members are descendants of the lone fourteen survivors from the devastating multicentury genocide and cultural destruction that followed their first contact with Europeans in 1579.

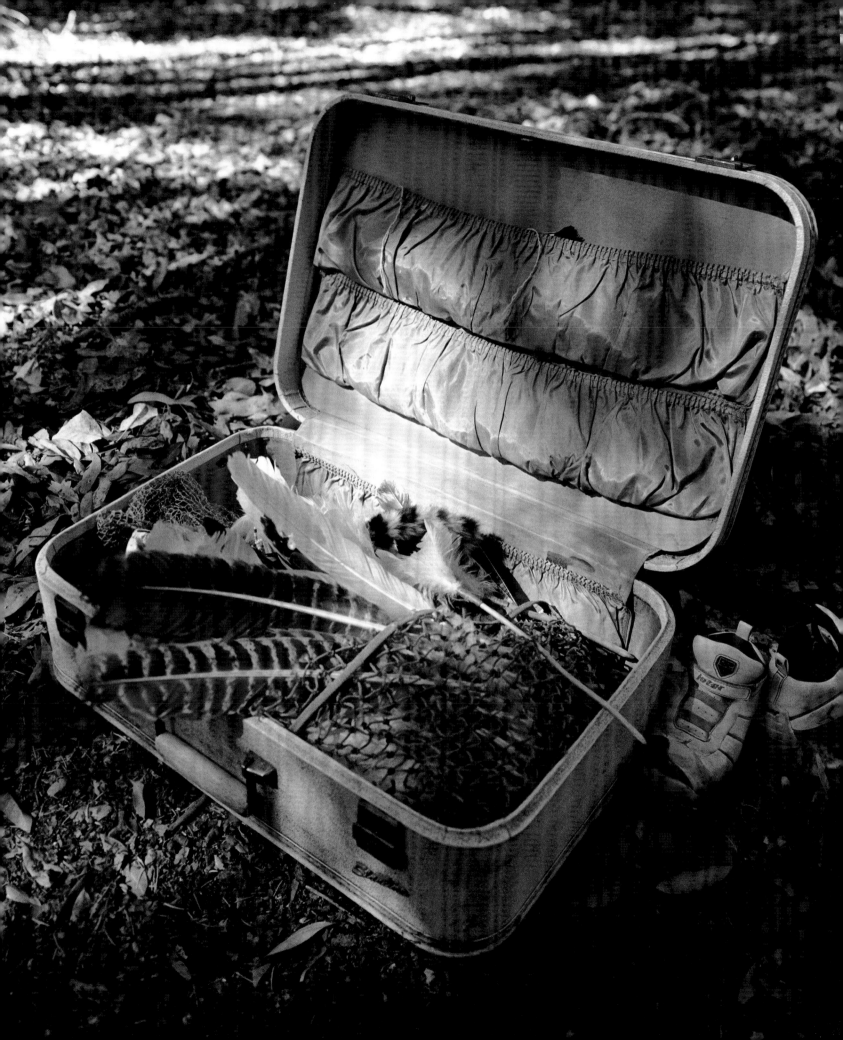

Cham Men at Prayer, Cham Muslims

Shoes are always removed out of respect before one enters
a mosque, and men and women pray in separate rooms
because it is believed that otherwise men will be distracted.
Through tithing, the Cham of Santa Ana have already built
one mosque back in the poor village in Cambodia from
which many of them came, at a cost of $50,000, and they
are currently gathering the funds to complete a second.

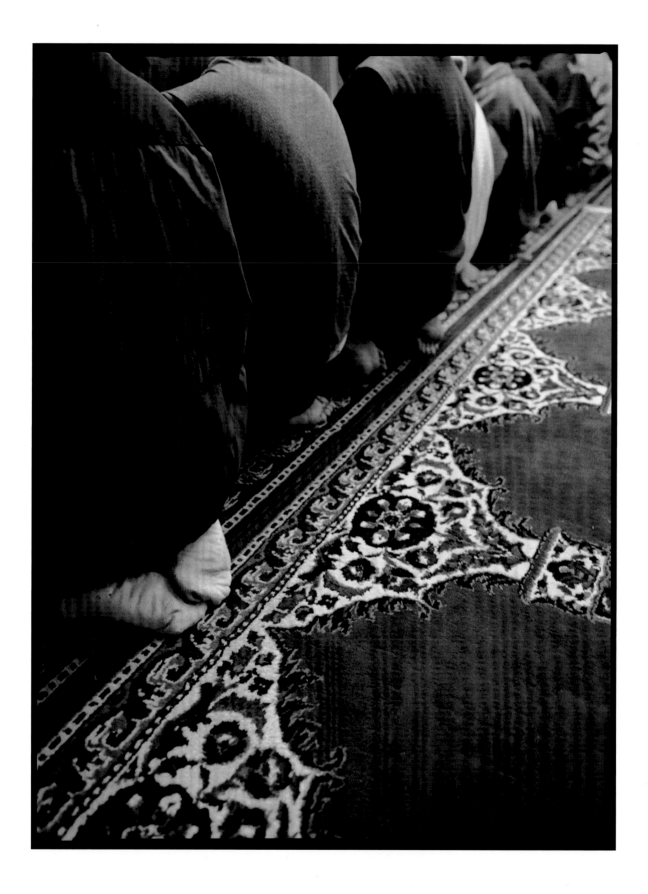

A Sex Worker's Altar, Santísima Muerte

In addition to candles from local *botanicas*, it is common to
see statues, devotional cards, and even fruit left as offerings to
Santísima (also known as Santa) Muerte, who for decades has been
prayed to by people working in dangerous professions: thieves,
drug dealers, taxi drivers, and the like. The candle at the altar por-
trays Anima Sola (Lonely Soul), a Catholic depiction of a suffering
person—almost always shown as a woman—in chains amid the
flames of purgatory. Fresh-cut flowers are left at this altar by its
owner every three days.

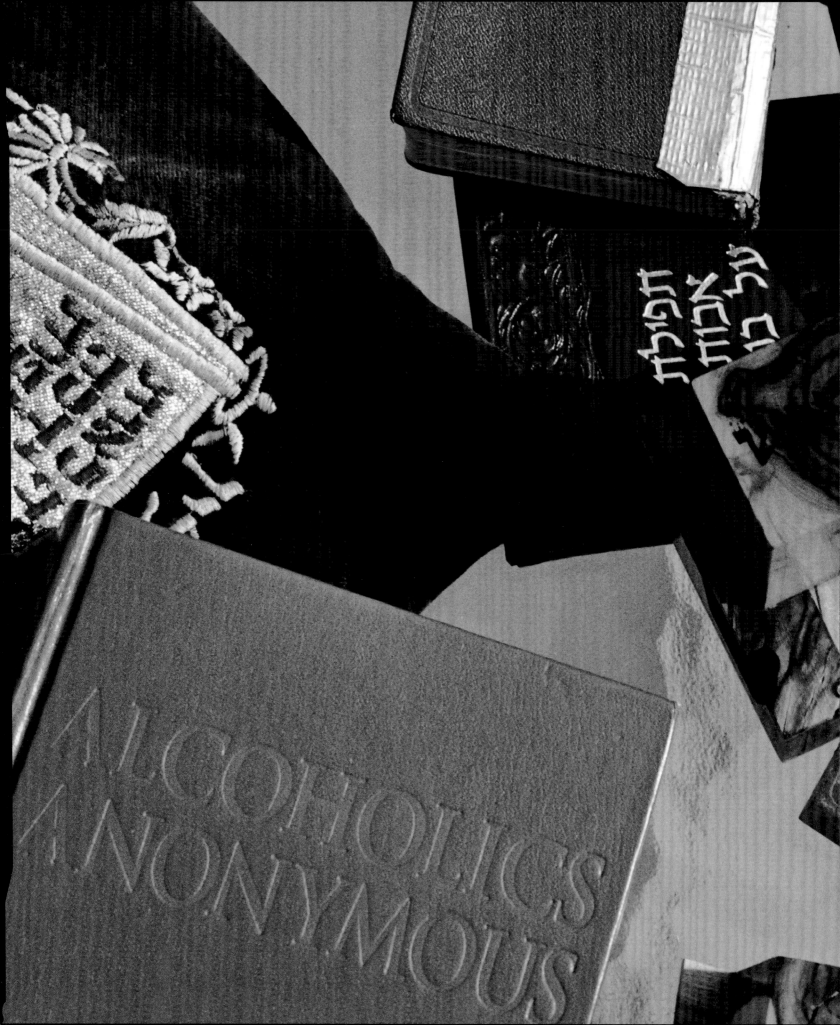

The Twelve Steps, Beit T'Shuvah

For residents of Beit T'Shuvah, prayer books
go hand in hand with the manual to Alcoholics
Anonymous. This is a community where there
are no locks on any doors, and 6:00 a.m. Torah
study and Twelve Step groups are a way of life.
As a result, residents find deep meaning in holi-
days such as Passover, which, according to their
spiritual leader, Rabbi Mark, they look at as an
opportunity to "break our bonds from the slavery
of addiction."

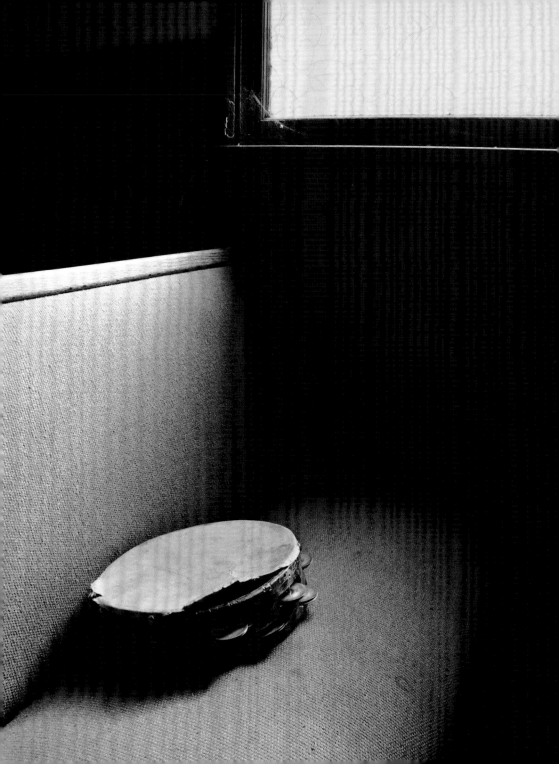

Tambourine, Teviston House of Prayer

Though often the Sunday service here is attended only by
a handful of people, the building, constructed in 1954, is a
touchstone for all in the community. The congregation and its
sister churches are currently on a drive to renovate these clapboard
and stucco structures. All of them are located in Tulare County,
which, even as the world's biggest producer of milk, still ranks as
the fifth poorest region in the nation—below even Appalachia and
the poorest communities of the Deep South. That considered, one
hopeful congregant declares: "I consider this to be home. . . . It's
not the building, not the area. It's the anointing of God. I'm
spiritually fed here, and there's a lot of work God has called on
us to do."

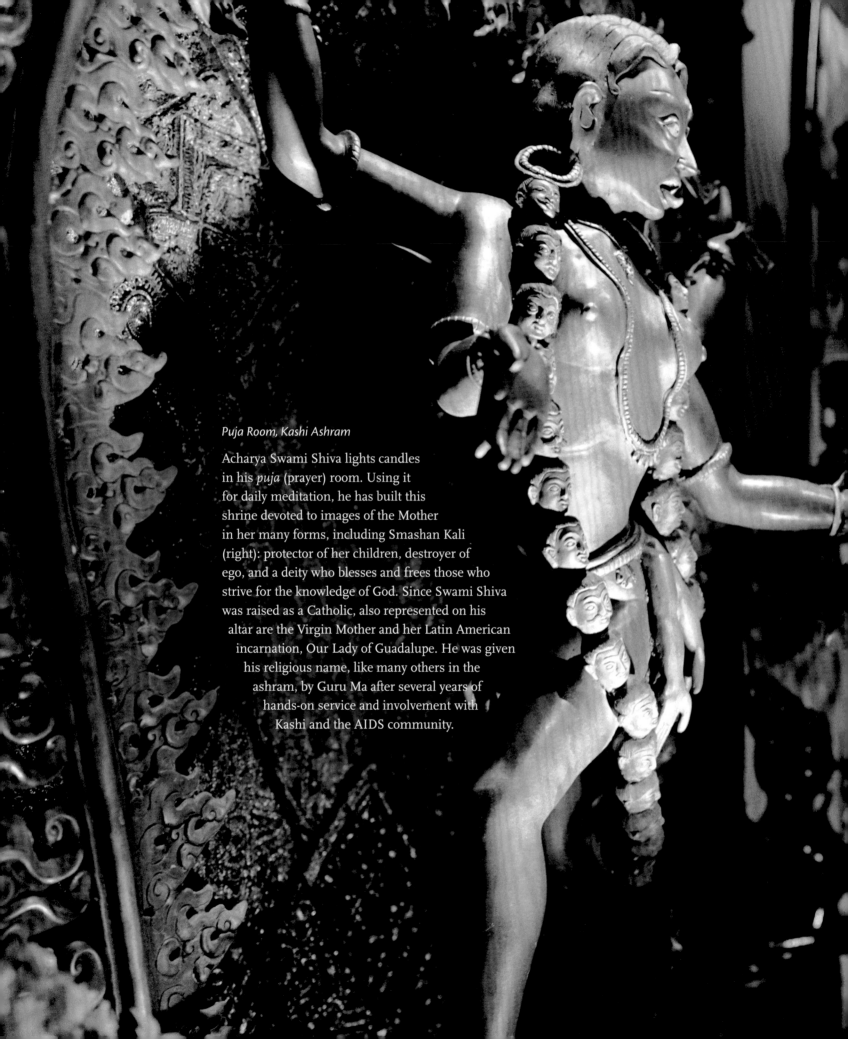

Puja Room, Kashi Ashram

Acharya Swami Shiva lights candles
in his *puja* (prayer) room. Using it
for daily meditation, he has built this
shrine devoted to images of the Mother
in her many forms, including Smashan Kali
(right): protector of her children, destroyer of
ego, and a deity who blesses and frees those who
strive for the knowledge of God. Since Swami Shiva
was raised as a Catholic, also represented on his
altar are the Virgin Mother and her Latin American
incarnation, Our Lady of Guadalupe. He was given
his religious name, like many others in the
ashram, by Guru Ma after several years of
hands-on service and involvement with
Kashi and the AIDS community.

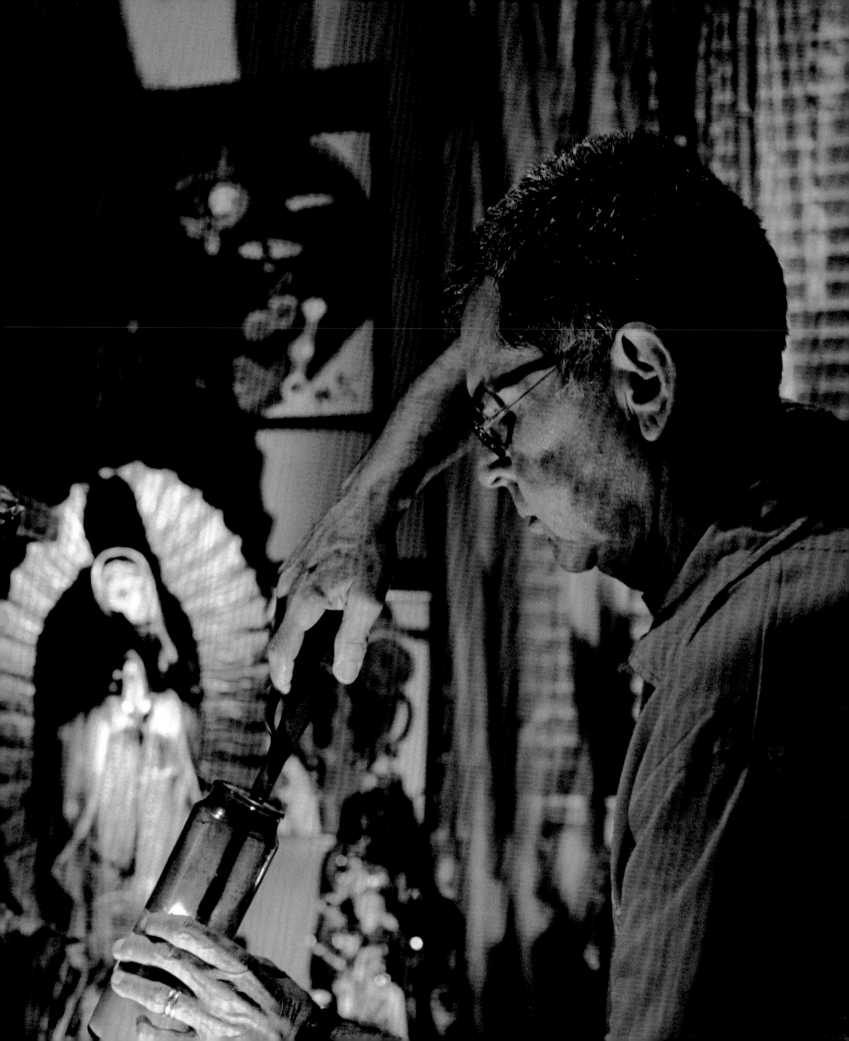

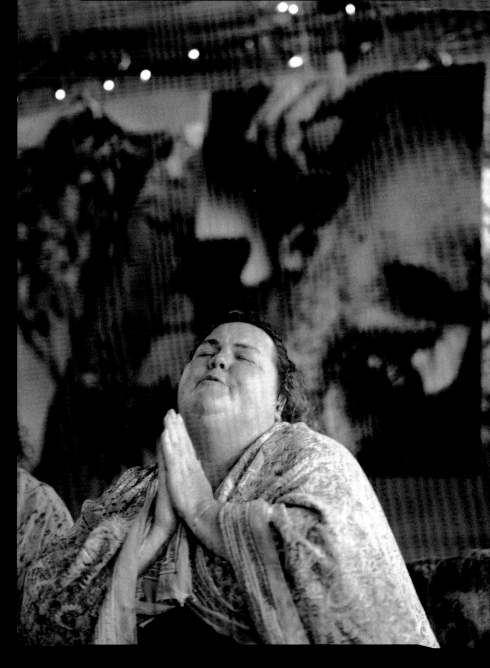

ht and wisdom

The substance of a Buddha is
mindfulness.
Take refuge in mindfulness, and you
will see things more clearly.
Mindfulness brings about
concentration, and concentration
brings about **insight and wisdom**.
Joyful Heart.
Sincere Path.

—KI SHIN JITSU DO (RON),
BUDDHADHARMA SANGHA

Durgaya Jaya welcomes Guru Ma, Kashi Ashram

hear the question

I pray for peace in the struggle

Courage against complacency

Acceptance of self

Acknowledgment of the moment

Love for others

And **reverence for love**

That greed will run its course

Fear will not be the primary motive

Distractions will dissipate

Aware

Awareness above will surge

Then we can **hear the question** . . .

Who do we want to be?

—YESSIAH, BEIT T'SHUVAH

The Individual and God

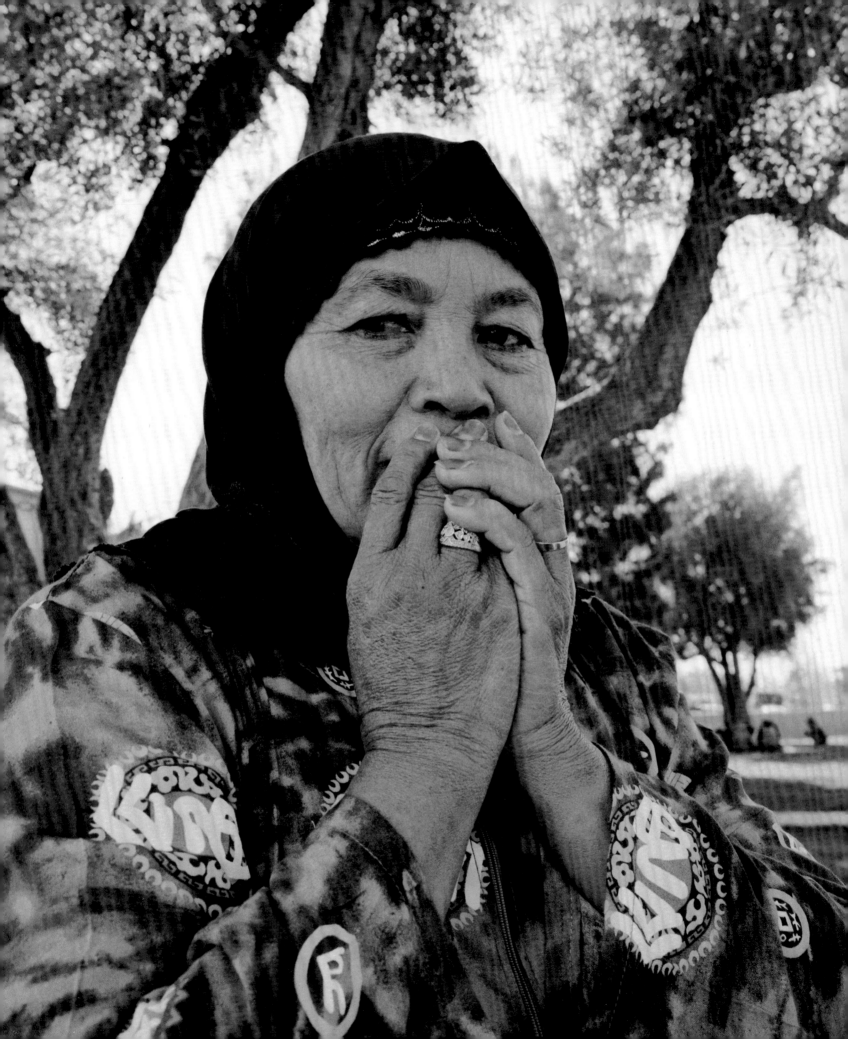

Fatima, Cham Muslims

"When we've encountered something we cannot handle—we just have to trust in God." Soon after the genocide began, Fatima's parents were killed, followed by her husband. Two of her three children were lost to starvation by the Khmer Rouge. Since most Cham were people of the land—fisherman, farmers, and black-smiths—Fatima explains: "When the time of the genocide came, our only concern was survival. There was little TV or radio. All we knew was this horror going on around us."

Mother Williams, Teviston House of Prayer

Born in Arkansas to a family of sixteen, Martha Williams is known as the "Church Mother" because she is the eldest female member of the congregation. Married twice and having survived all her children, Mother Williams loves the rural countryside and working to "save people." Born Baptist, but a long-time Pentecostal, she says: "This is a whole different world we live in now. Altogether different from where I come from. . . . But I've been living here since 1946, getting along with anybody. My job is to look out in the fields and teach the lost souls that don't know Christ. I'm a laborer for the Lord."

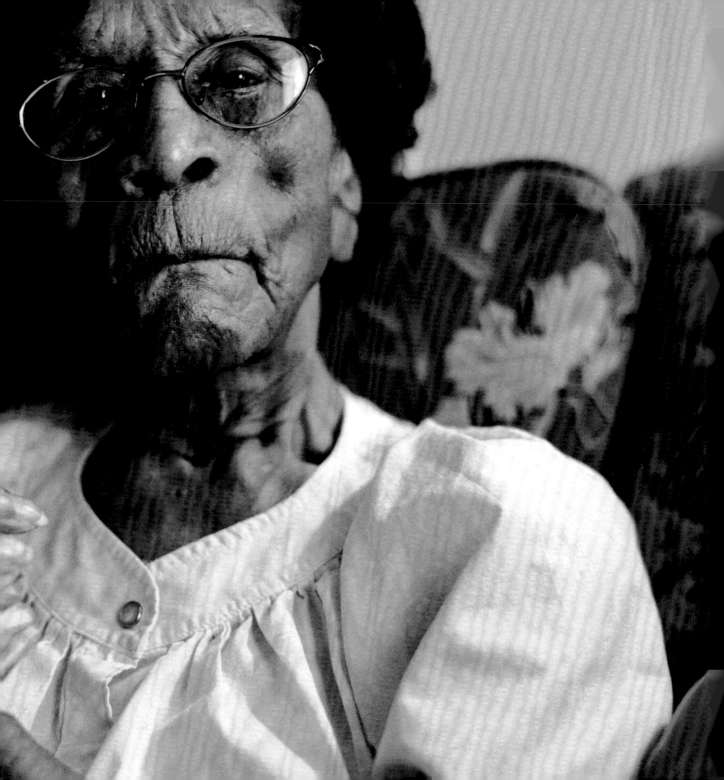

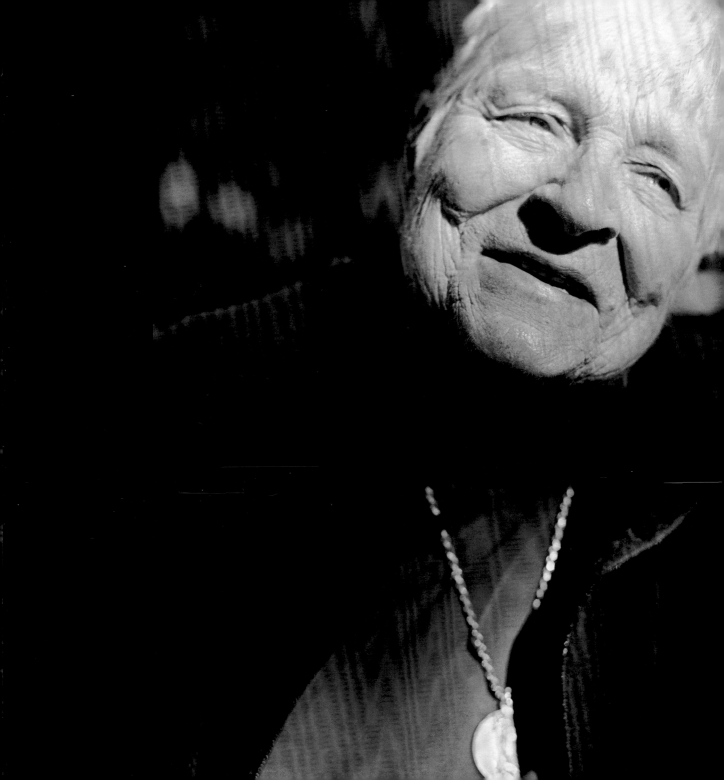

Janet, Immaculate Heart Community

"I have always been a seeker." Originally a Quaker, Janet was disowned by her family when she entered the IHC order back in her twenties, and not until her mother was on her deathbed was she invited back again to see her. Now in her eighties, Janet is regarded as one of America's foremost experts on the Virgin of Guadalupe. Speaking about the uncertainty that engulfed the community when it first broke from the church, she says: "To see us stagger as we tried to hold onto our religious attitudes and spiritual ways and still fit in—you know, [using] lipstick and that sort of thing—that was difficult. But gradually the boat stopped rocking. . . . I am very excited about all of the fresh blood we're getting."

Darrell, Federated Indians of Graton Rancheria

Darrell, half Miwok and half Irish, is one of the eldest tribe members to dance at the Acorn. This ceremony, which coincides with the autumnal equinox, is one of the few surviving ceremonies for the tribe, though they currently are actively reclaiming many lost elements of their culture, from basket weaving to language to tribal song. Darrell and his wife, Teressa, candidly admit they used the support of a Native American sobriety program to bring them through the "wreckage part of our lives" and into a place where they now find great connection through the tribe's dancing. She added: "I come in honor of my mom, who's passed on. We stay connected. She got us here, and we're going to do this till the end."

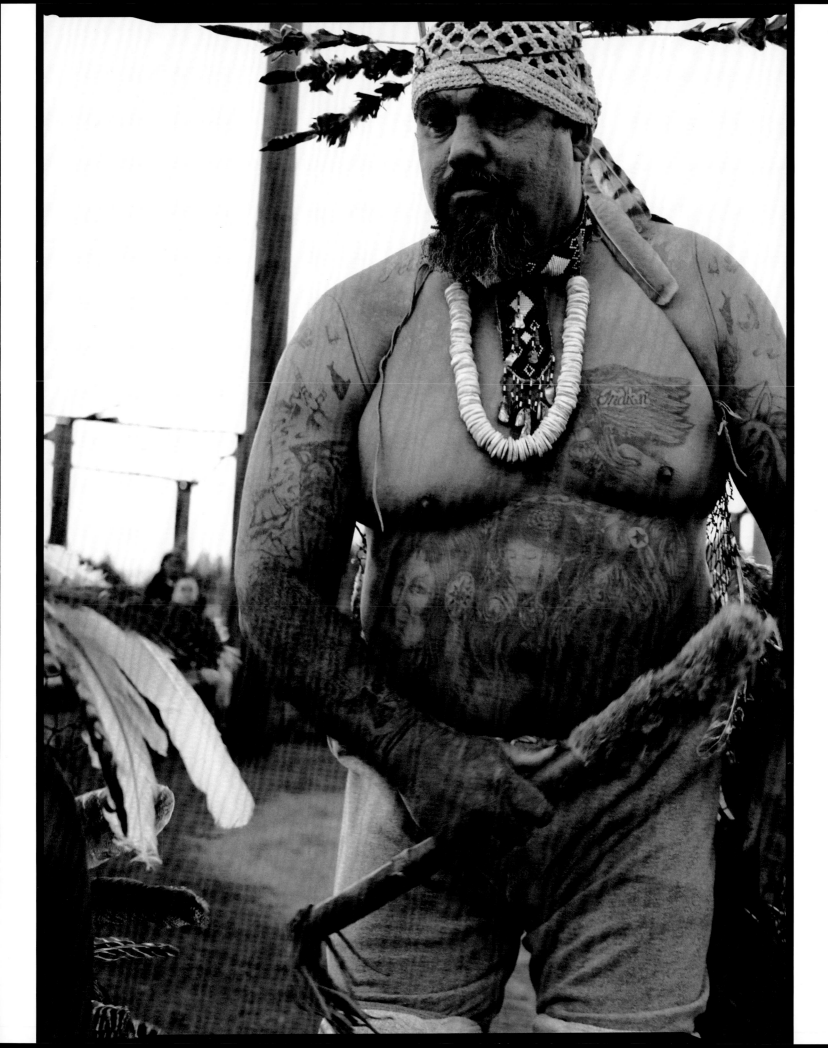

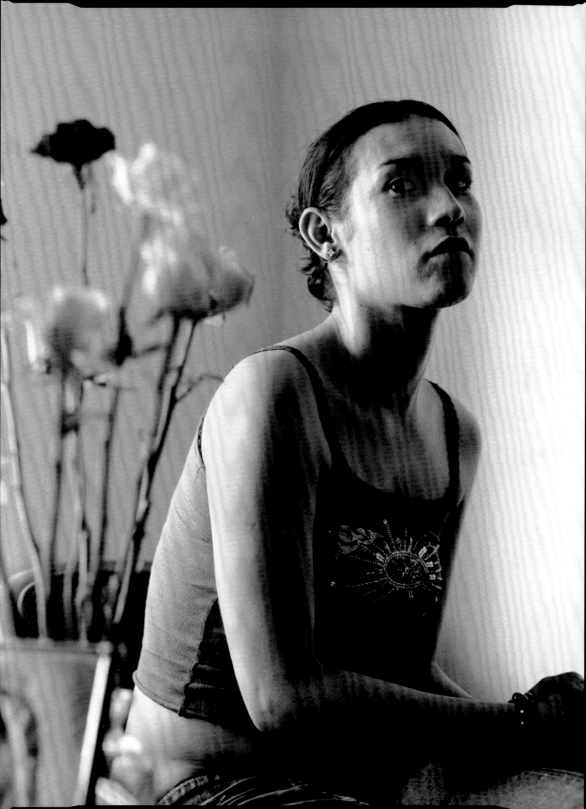

Minni, Santísima Muerte

A sex worker, Minni prays to Santísima Muerte, whom she believes to have been the entity who greeted Jesus when he died. Though she pays close to $600 a month in rent for spartan accommodations at this single room occupancy hotel, Minni constantly keeps a dozen long-stemmed roses at her altar out of respect. The Catholic Church does not recognize the veneration of Santísima Muerte, or "Holy Death," but many within the church admit they have failed to meet the spiritual needs of her followers, one of whom noted: "When you live on the edge, you stop believing in things. . . . With Santísima Muerte I have found peace."

Sister Woodley, Deaf Branch of the Mormon Church

"For every person I have helped, I was given help. For every act of kindness I gave, I was given an act of kindness. For everything I did, I was blessed with something greater." After requesting a mission from church leaders in Salt Lake City, Sister Woodley was sent to San Diego with little knowledge of sign language or of deaf people. She acquired her compassion for the deaf and fluency in American Sign Language during the eighteen months she spent as a missionary, which entailed being restricted to mission rules (no television, no swimming, and only two calls home per year). She declares the experience has "brought me closer to God in a great many ways."

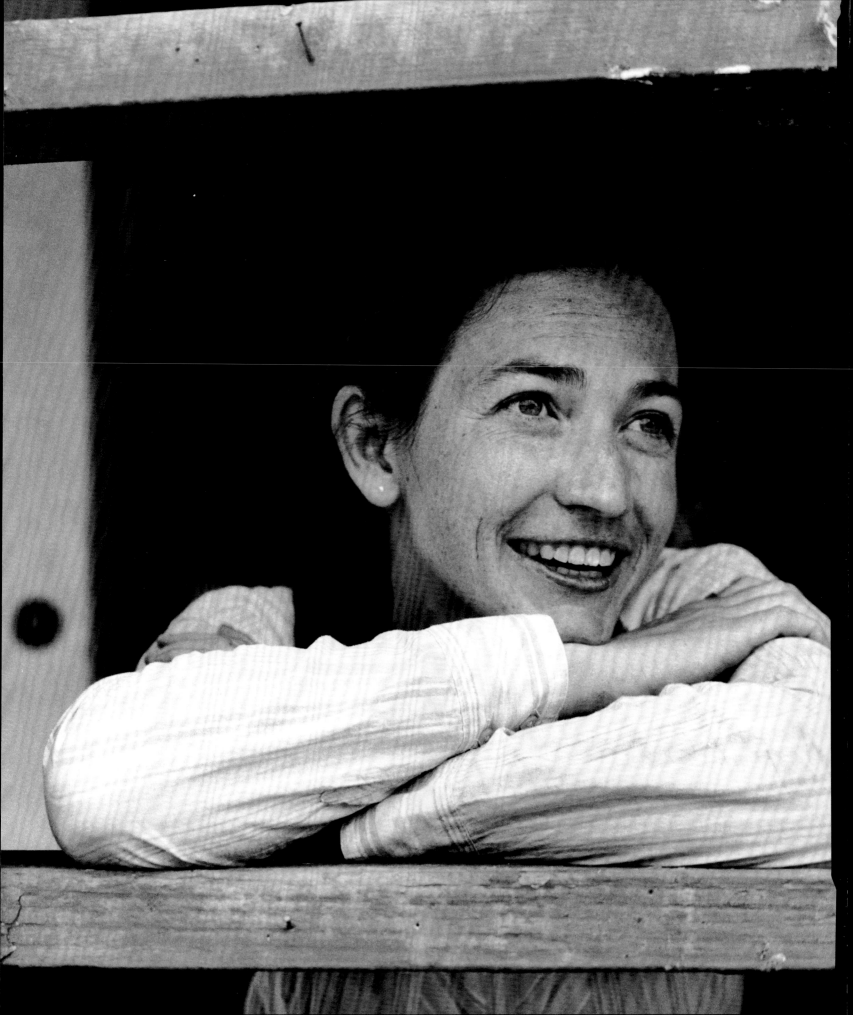

Gloria, Shiloh Church of God in Christ

"In a small church you have more freedom to praise God." Gloria is a powerful voice in the Shiloh Church of God in Christ choir, as well the Sunday school teacher. She has raised her family here, making ends meet through several professions, including nursing, farm work, and teaching. Having been a Shiloh congregant since 1985, she has always found herself drawn to smaller churches. "It hasn't changed much in all this time. It's peaceful and quiet here. Old friends are starting to come back and retire."

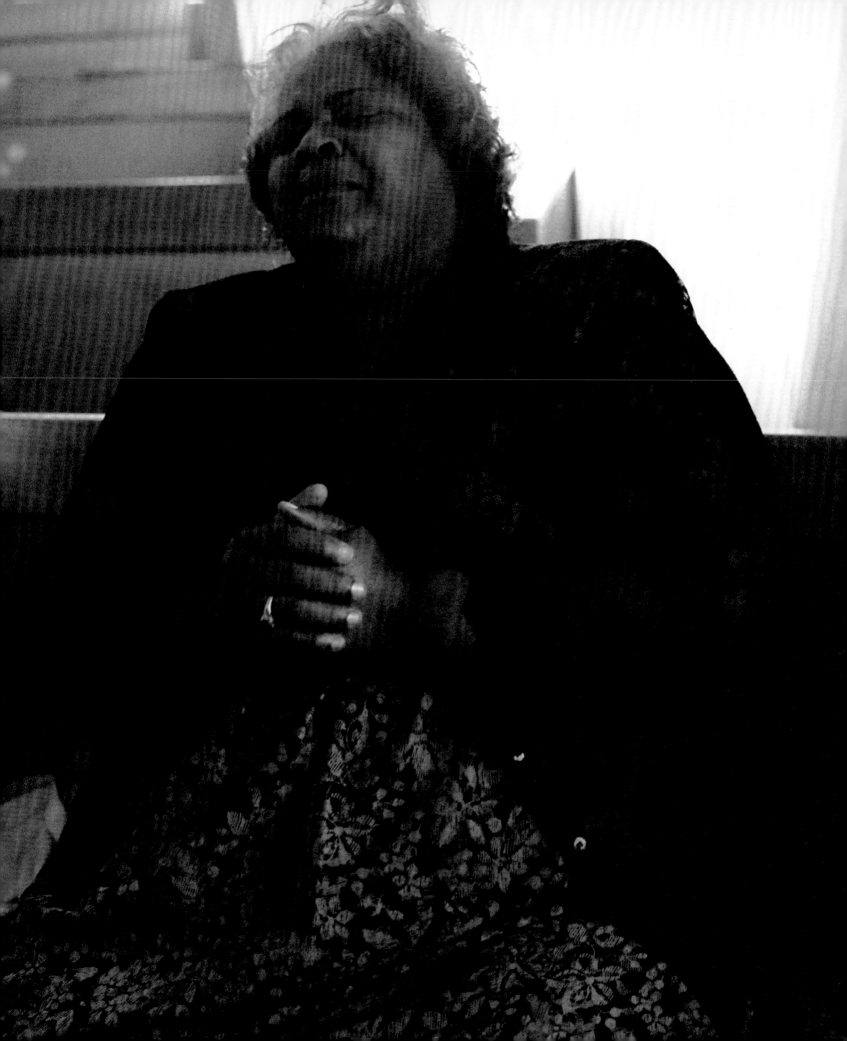

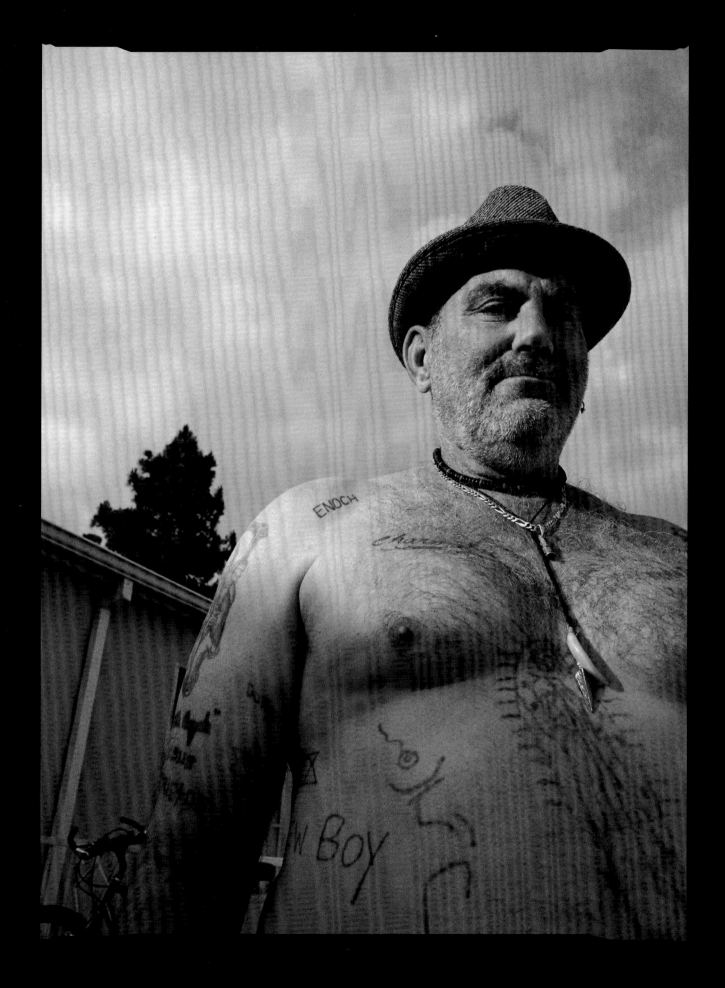

Mark, Beit T'Shuvah

Tattoos covering his body reflect Mark's search for meaning in
Hinduism, Buddhism, Islam, and Judaism. But he says: "I'm a
Jew, like the guys who's born black is black, the guy who's born
Muslim is Muslim. . . . I have a debt to the God of the Jews and
the Jewish people to at least try to live a good life, and do what's
right. . . . God's always been within me, no matter what I've suf-
fered." Back in the 1960s Mark got caught up heavily in drugs.
With his family disowning him, his life became a thirty-five-year
odyssey of homelessness, prison, and mental hospitals. But in
2001, after going through the Beit T'Shuvah program, he began
working in its thrift store and food bank, and he ultimately became
their night watchman.

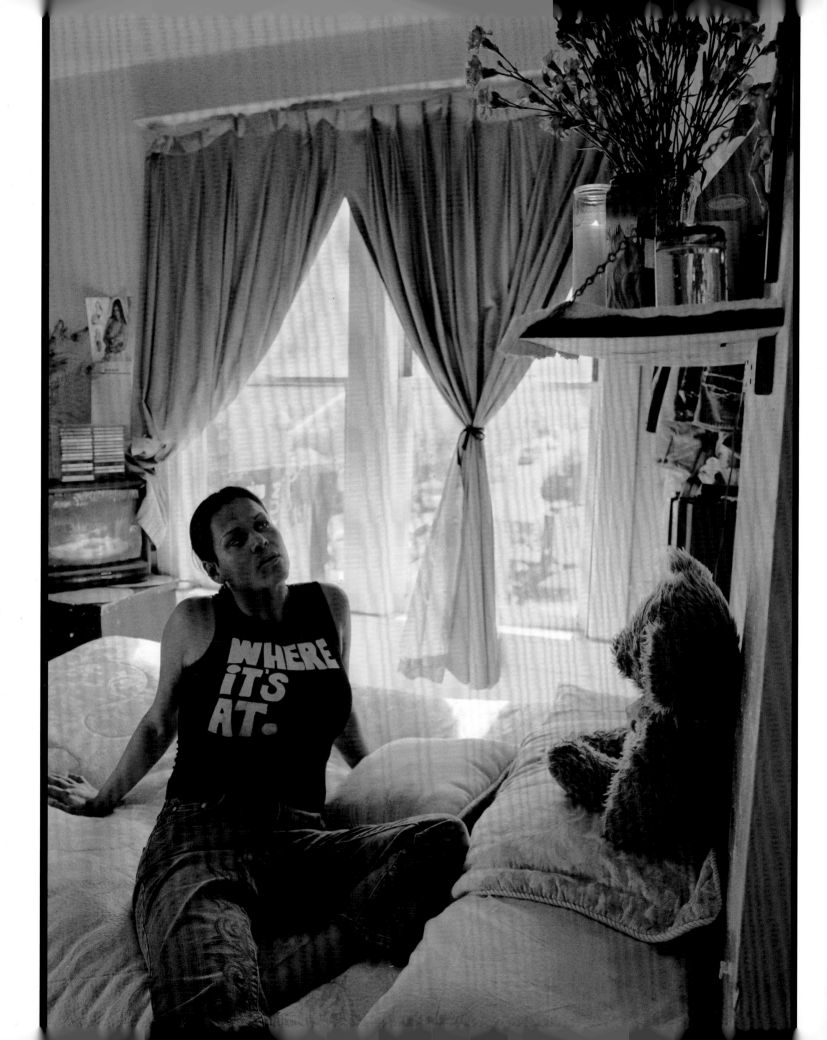

Vanessa, Santísima Muerte

Having come to San Francisco alone, Vanessa, a transsexual sex
worker, prays not just for her safety but for the well-being of her
family, to whom she regularly sends a portion of her earnings.
One of Vanessa's friends, who is also a devotee of Santísima
Muerte, said: "We pray to her because it's about believing in
something and the feeling one gets from believing in something
that exists but that you can't necessarily see."

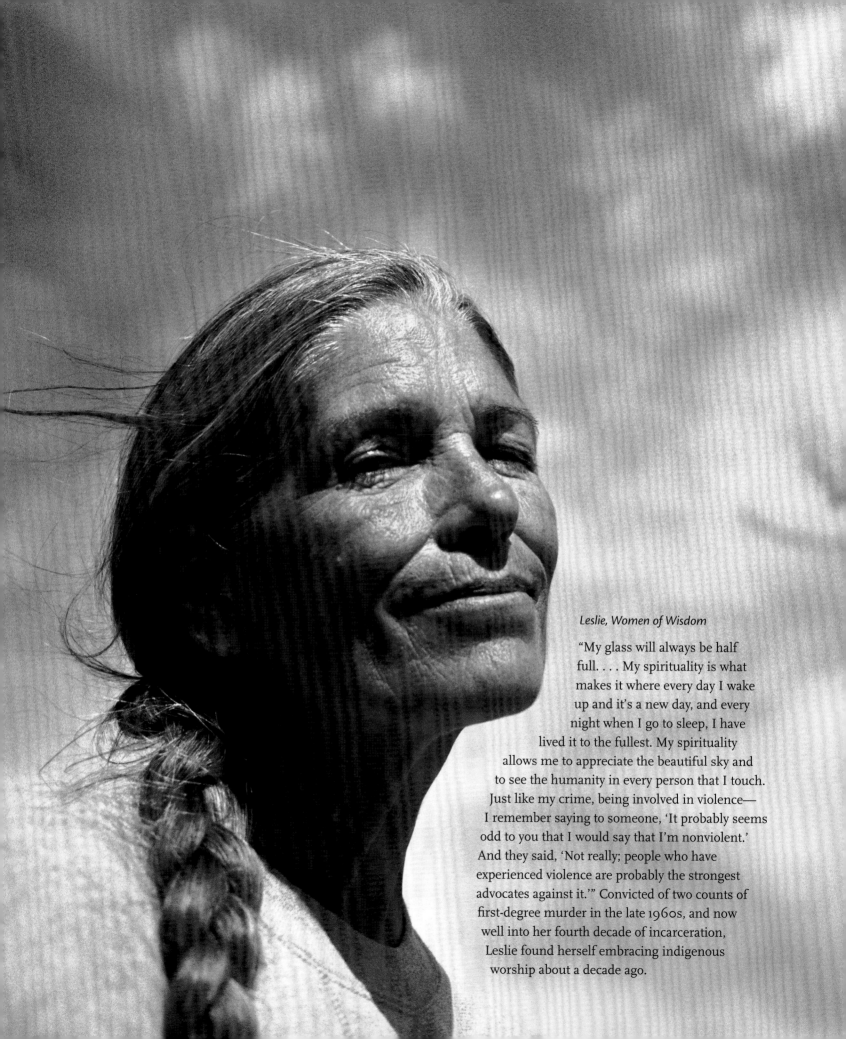

Leslie, Women of Wisdom

"My glass will always be half full. . . . My spirituality is what makes it where every day I wake up and it's a new day, and every night when I go to sleep, I have lived it to the fullest. My spirituality allows me to appreciate the beautiful sky and to see the humanity in every person that I touch. Just like my crime, being involved in violence— I remember saying to someone, 'It probably seems odd to you that I would say that I'm nonviolent.' And they said, 'Not really; people who have experienced violence are probably the strongest advocates against it.'" Convicted of two counts of first-degree murder in the late 1960s, and now well into her fourth decade of incarceration, Leslie found herself embracing indigenous worship about a decade ago.

Suleiman, Cham Muslims

One of the few Cham who returned to live in
Cambodia after the genocide of his people,
Suleiman went so far as to join their Royal Air
Force and left with the rank of colonel. He is
now a businessman based in Orange County.
His military service and immigration from
South Asia have left him speaking five lan-
guages and trying to live by one of the peaceful
mottos that personifies his community: "Make
an enemy a friend, not a friend an enemy."

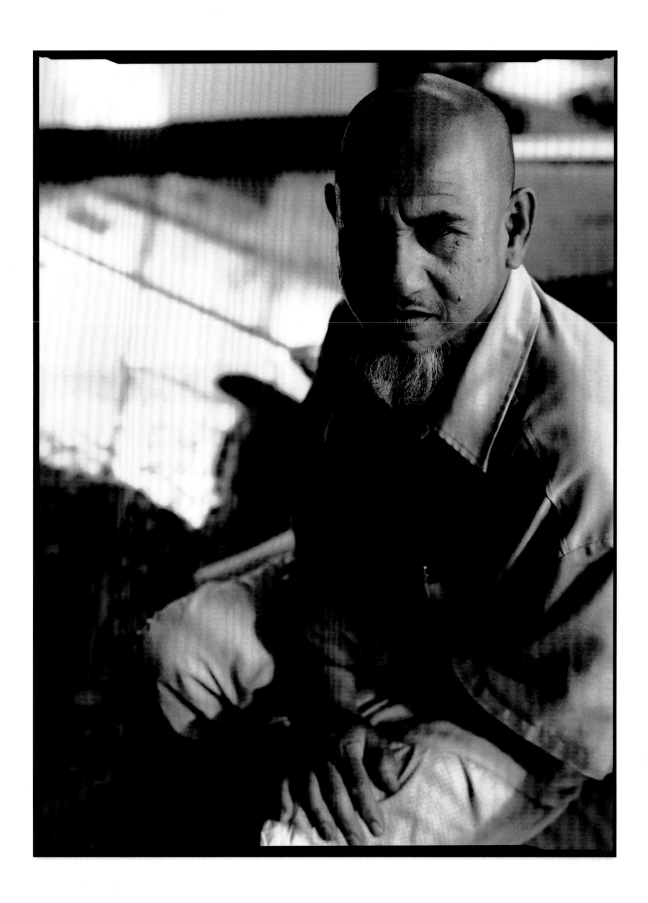

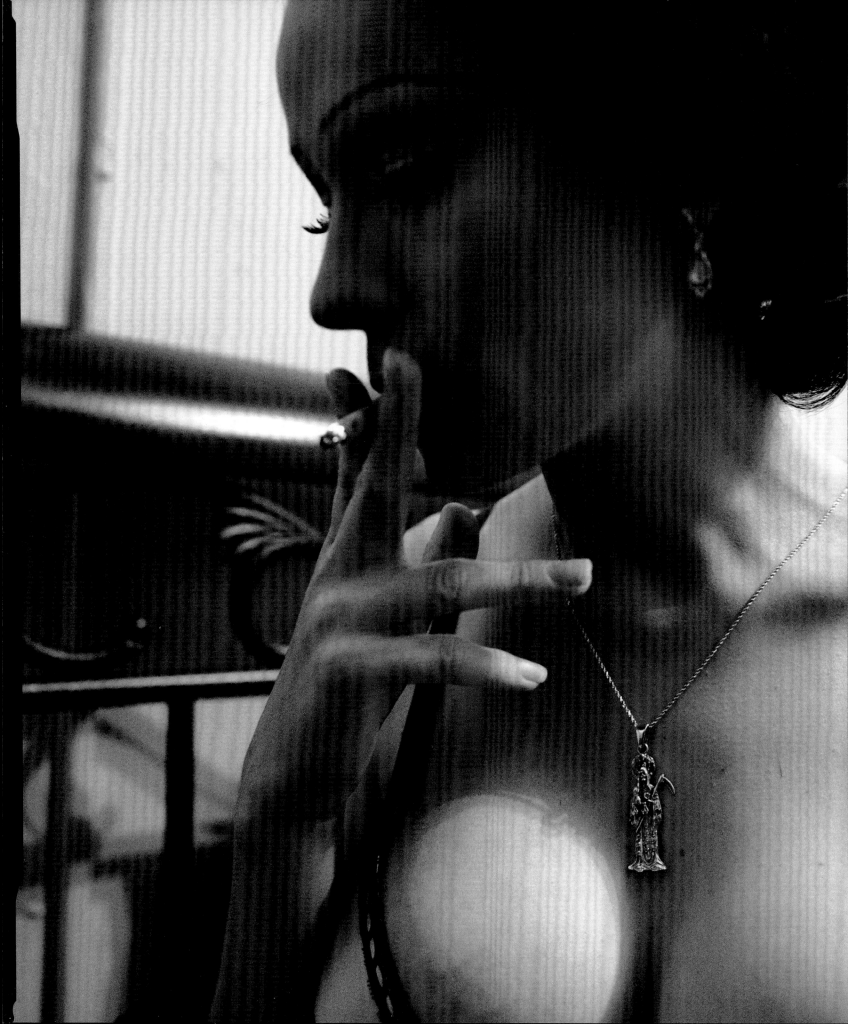

Yajahira, Santísima Muerte

"All of humanity is afraid of death—100 percent of us. This is a preparation for death. More than anything, it's about not being afraid to know there will be something after my spiritual release." Yajahira, a transsexual sex worker, began both praying to Santísima Muerte and prostituting herself at the age of twelve. Due to a strong desire not to be ignorant as she worked the streets, she remained in school until she graduated high school in Guadalajara at age sixteen. As she gets dressed for an evening's work, her rituals include prayers and offerings of apples, garlic, or water at the altar, which was sent to her after she got settled in San Francisco's notorious Tenderloin district. The charm of the Holy Death around Yajahira's neck never leaves her body except when she showers.

the gift bestowed

Another name for God is Kindness,
and the fastest way to God
is through Service.
After thirty-seven years of being graced by a way of life
that embraces all ways and teaches us to
Feed Everyone,
the gift bestowed is that God is truly in the Sharing.

—ACHARYA DURGA DAS,
KASHI ASHRAM

Margo shares, Women of Wisdom

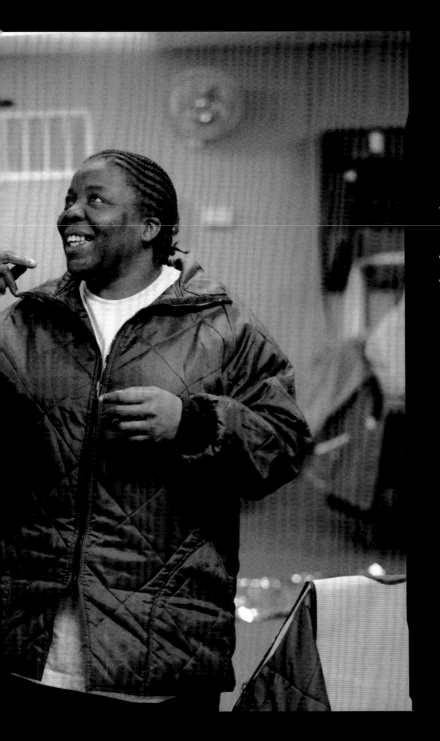

The lie is that we can fit into the world. We're all misfits. We're all misfits who find our place; by **living authentically**, then we fit.

—RABBI MARK,
BEIT T'SHUVAH

*Community
In Spiritus*

living authentically

Rebecca, Deaf Branch of the Mormon Church

"The church helped me understand the purpose of being disabled and made me accept it. . . . We believe that God gives us challenges and trials to help us grow to be better people by learning to overcome the problems." After joining the church in college and spending time in hearing Mormon communities, Rebecca, now part of the deaf branch leadership, believes her disability brings her closer to God.

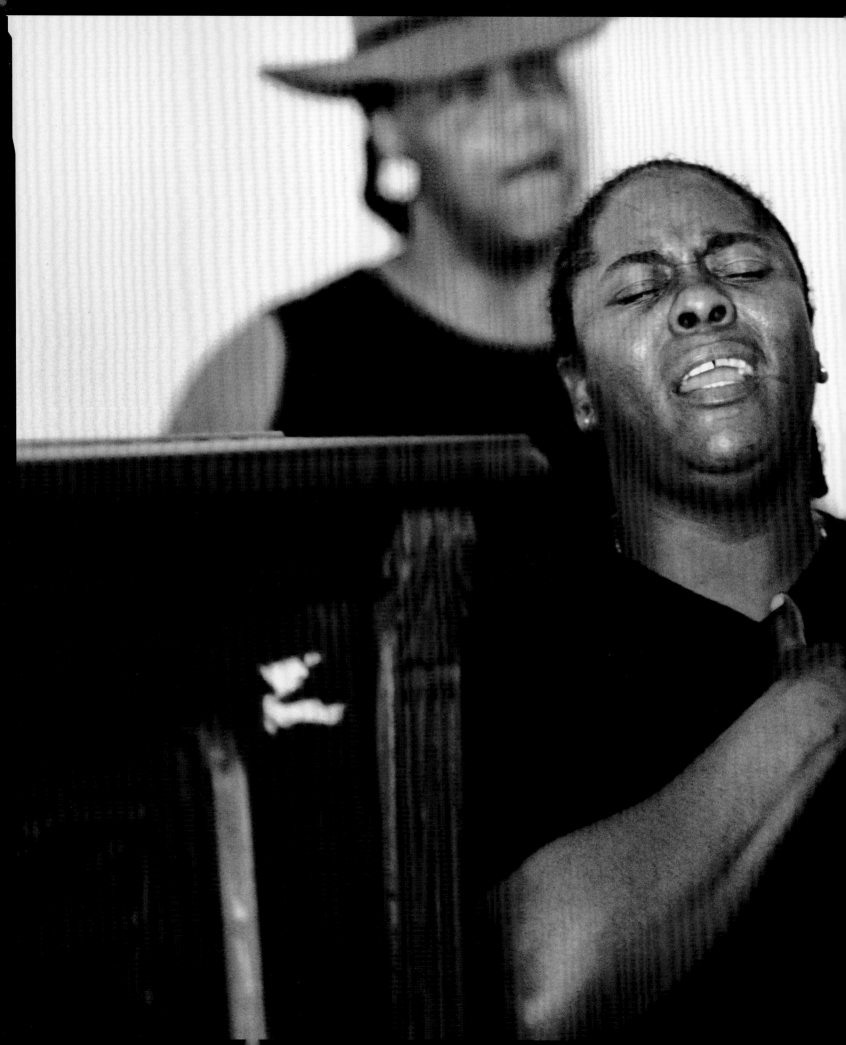

Loni, Transcendence

A female-to-male transsexual and professional iron worker, Loni has fought long battles with drugs and street life. Singing both alto and tenor, he says it was hard to adjust when he finally found a group of people who accepted him fully. "Being radically included felt weird, because I've always been an outcast, an outsider. Spiritually it has kept me grounded when I don't feel right inside. It's a place of refuge."

57

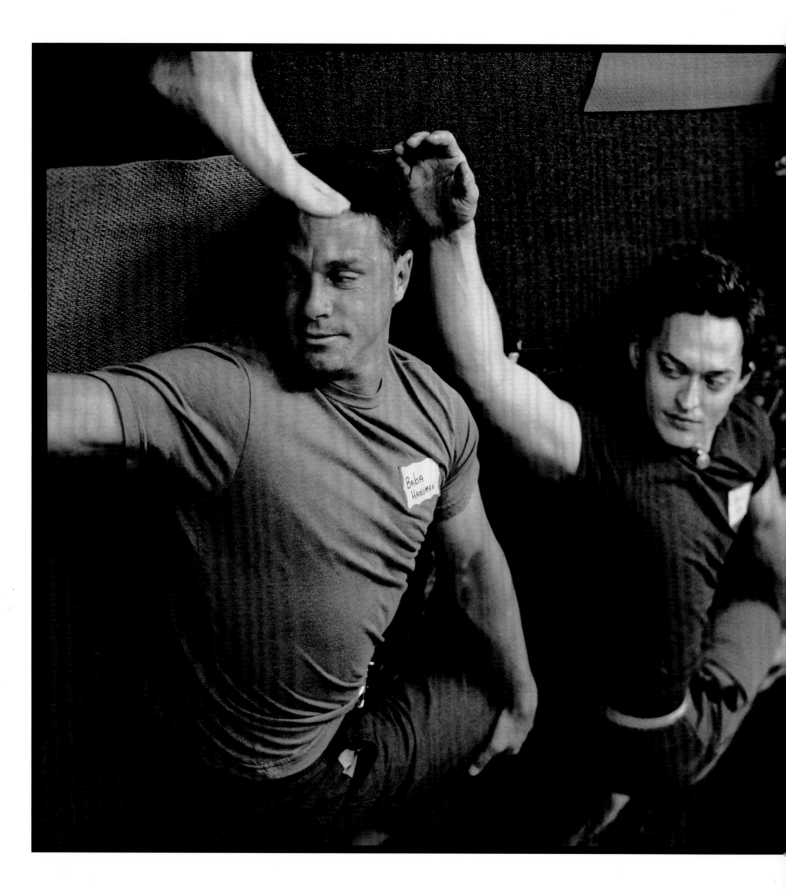

Baba Hanuman Jaya, Kashi Ashram

Baba Hanuman, an HIV positive gay man and landscape architect, takes part in Kali Natha Yoga, or "yoga of intent," during a weekend intensive at the ashram. This is a form of yoga that Guru Ma and the Kashi community have brought into hospitals and hospices to help those who are unable to practice at the ashram. The lack of judgment around the disease is as important to many at Kashi as the practical support and services it offers. As devotee to Guru Ma Jaya for several years, Baba Hanuman adds: "Having a living master that I sit under helps me keep things in perspective. Being HIV positive has allowed me to learn the preciousness of life, to be in the 'now moment' more. It's a beautiful dance I get to dance."

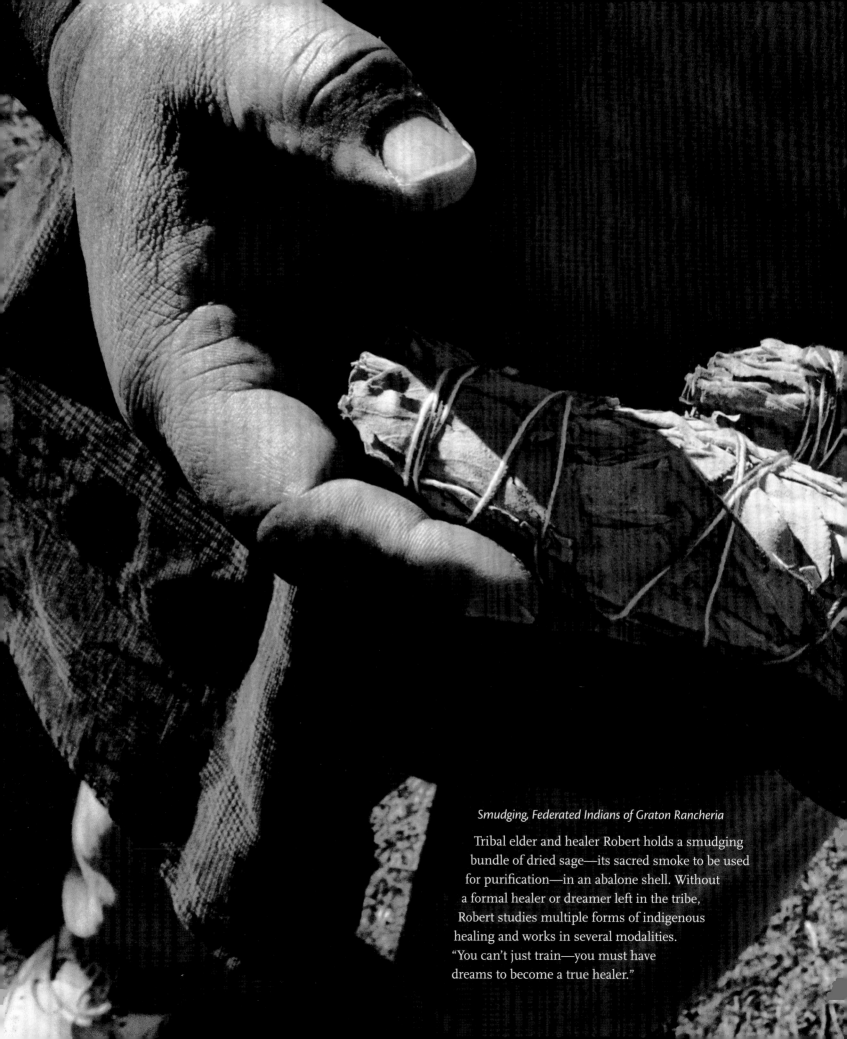

Smudging, Federated Indians of Graton Rancheria

Tribal elder and healer Robert holds a smudging
bundle of dried sage—its sacred smoke to be used
for purification—in an abalone shell. Without
a formal healer or dreamer left in the tribe,
Robert studies multiple forms of indigenous
healing and works in several modalities.
"You can't just train—you must have
dreams to become a true healer."

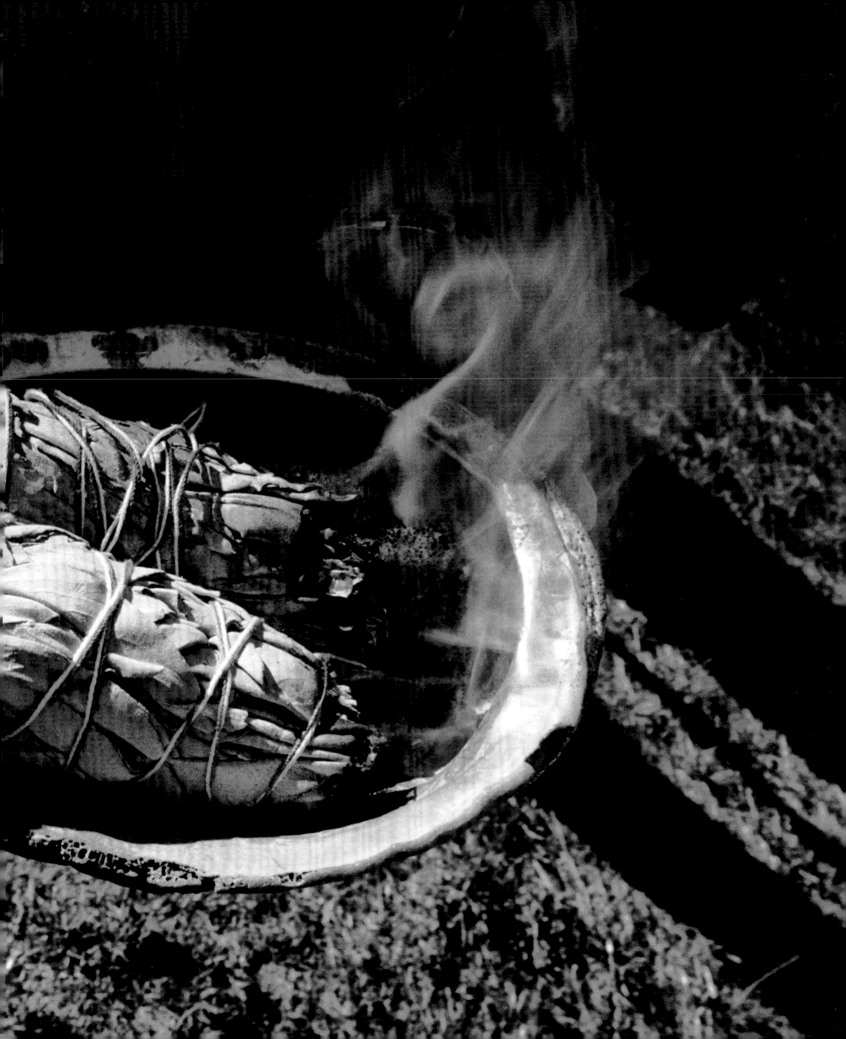

Bowing before Buddha, Buddhadharma Sangha

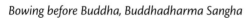

Seido Lee (center), a Zen master with a background in psychology, travels as a volunteer from Green Gulch Farm Zen Center in Marin County to San Quentin Prison every week to lead a practice he claims is the only program of its kind in the California prison system. A self-started group, now numbering up to twenty-five inmates, has constructed altars, meditation benches, and mats out of remnants from the prison workshop. Dharma discussions and meditations focus on such topics as patience, compassion, and love.

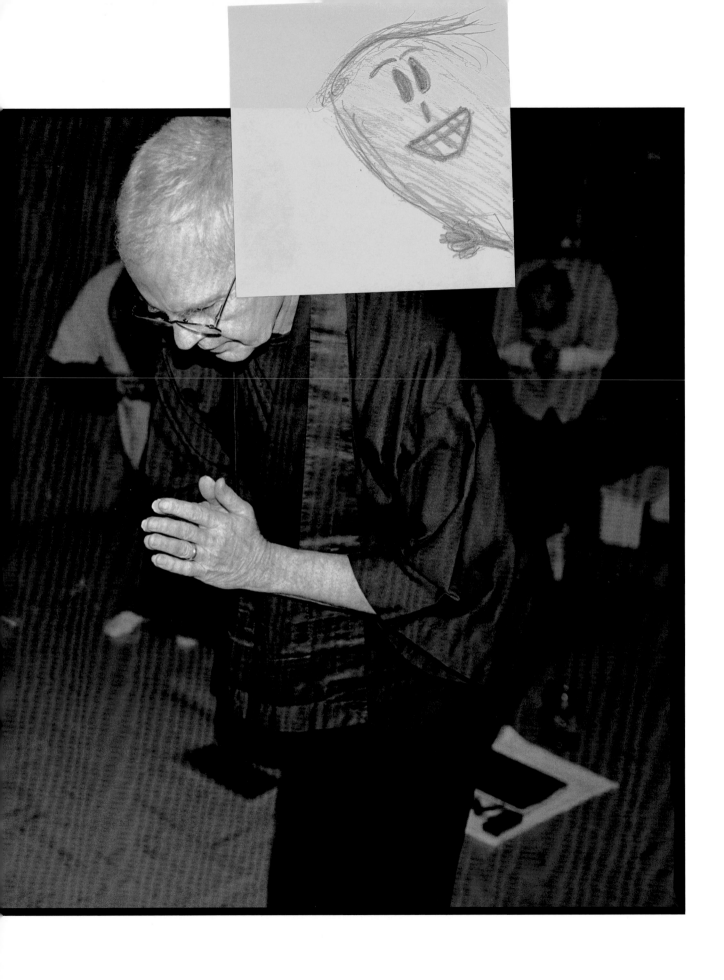

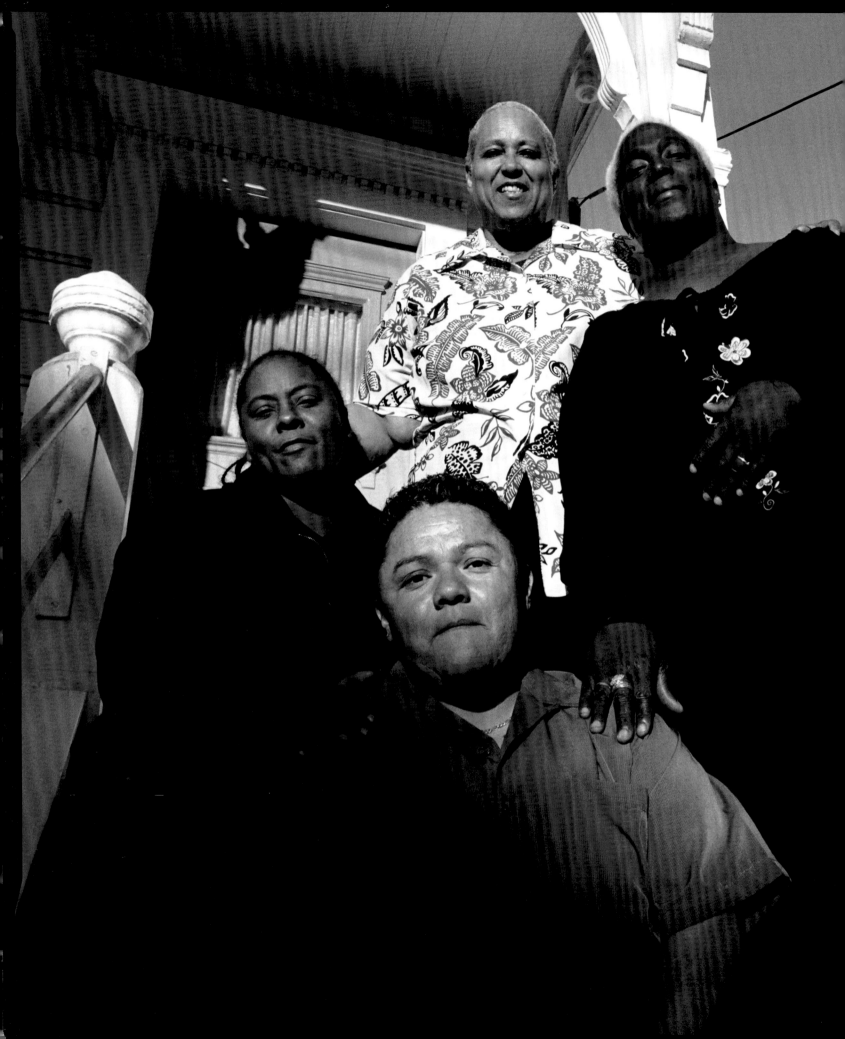

Quartet, Transcendence

"It took a while to get everyone to get beyond their fears and phobias about their voices. . . . We did sound awful at first, but during our first summer there was a paradigm shift, a choir director came on board, and things began to smooth out. We struggled to sing even two songs at first, but now we have two full CDs of our work." Choir members (clockwise from top) Vinnie, Bobbiejean, Ze, and Loni relax before a performance.

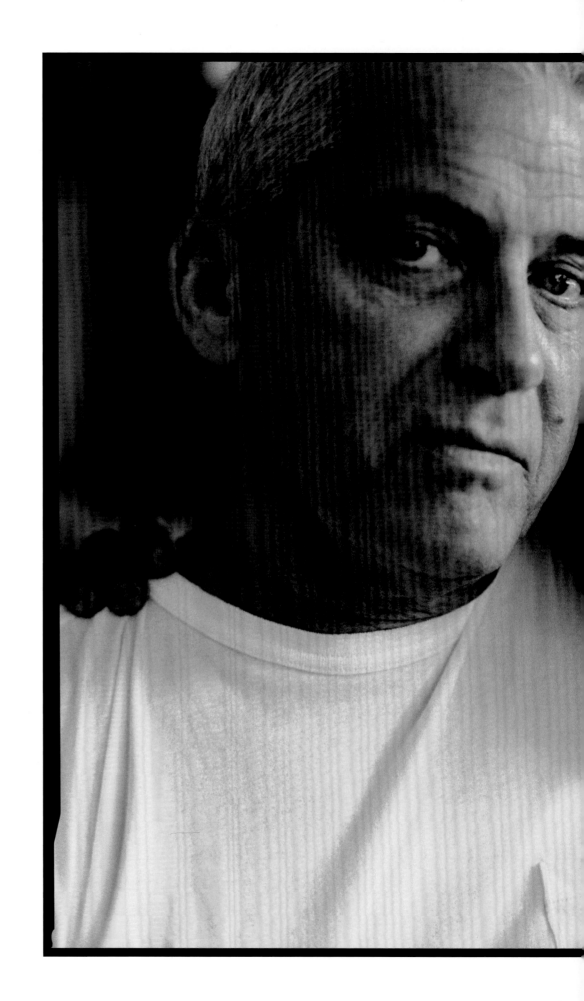

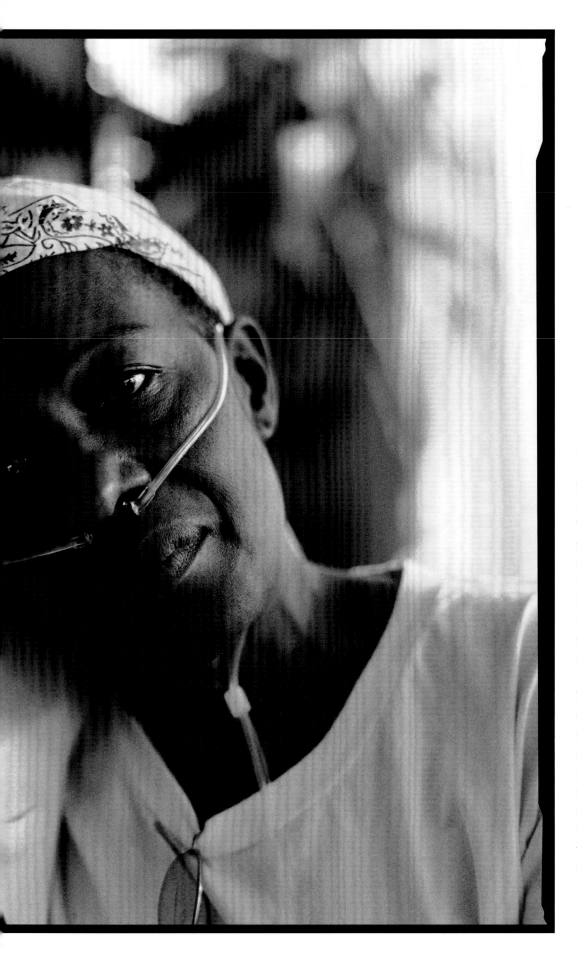

Laxman and Justina, Kashi Ashram

Laxman Das Jaya, a celibate vegetarian gay man who has been a devotee of Guru Ma's since 1974, helped start the West Hollywood ashram in 1992. In addition to being their yoga acharya (master yoga teacher), he runs much of the ashram's outreach efforts to feed the homeless. Justina has had full blown AIDS since 1995 and is battling end-stage congestive heart failure. After being diagnosed HIV positive, seeing one of her children killed, and having the others sent off into the foster system, she credits members of the ashram for pulling her back from the brink of suicide and helping her reach peace with the fact that she will die soon by "understanding that there will always be someone worse off than me, so there's no use being miserable."

Krystal, Santísima Muerte

Krystal, a transsexual sex worker from Puerto Vallarta, holds a devotional card of Saint Jude, the Catholic patron saint of lost causes. This is the one surviving piece of her religious altar, the rest of which was stolen from her as she crossed the Mexican border. Praying daily for health and safety, she remains devoted to the Holy Death, even though doing so is strongly discouraged by the religion she was born into, Catholicism.

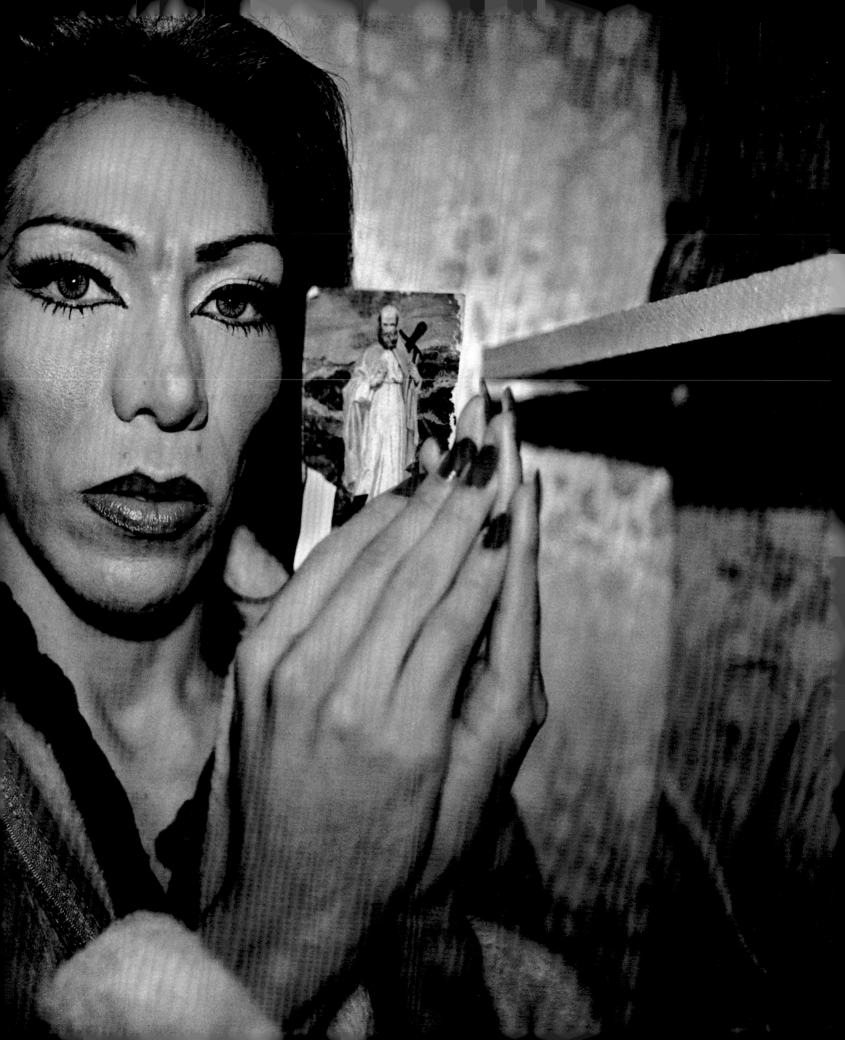

Juan and José, Deaf Branch of the Mormon Church

"I love God so much I just want to run to heaven!"
says Juan. Juan (front) and José (rear) are a pair of
brothers who were born deaf and lost their sight in
their teens due to Usher syndrome. Though they
read the scriptures in Braille, they rely on the help of
volunteer interpreters to take part in Sunday sacra-
ment service. José says: "Deaf and hearing people
are all the same. . . . In the past I was mad and sad
that I was blind and deaf, but now I am happier and
patient and just deal with it because I understand
that God knows me and my situation and will take
care of me."

Kali Baba and Vishnu, Kashi Ashram

"When I'm giving service, I'm being in the moment. It's not about me. It's about helping the other person. . . . During this plague, constantly carrying off friends and lovers, I often felt helpless." Kali Baba also adds, "Yoga keeps me going. Meditation keeps me going. There is something about group meditation that probably defies all the laws of physics—it's empowering, invigorating." Both HIV positive since the early 1990s, Kali Baba (front) and his life partner of over twenty years, Vishnu, were drawn to Guru Ma Jaya and the ashram because of her mix of humor and spirituality.

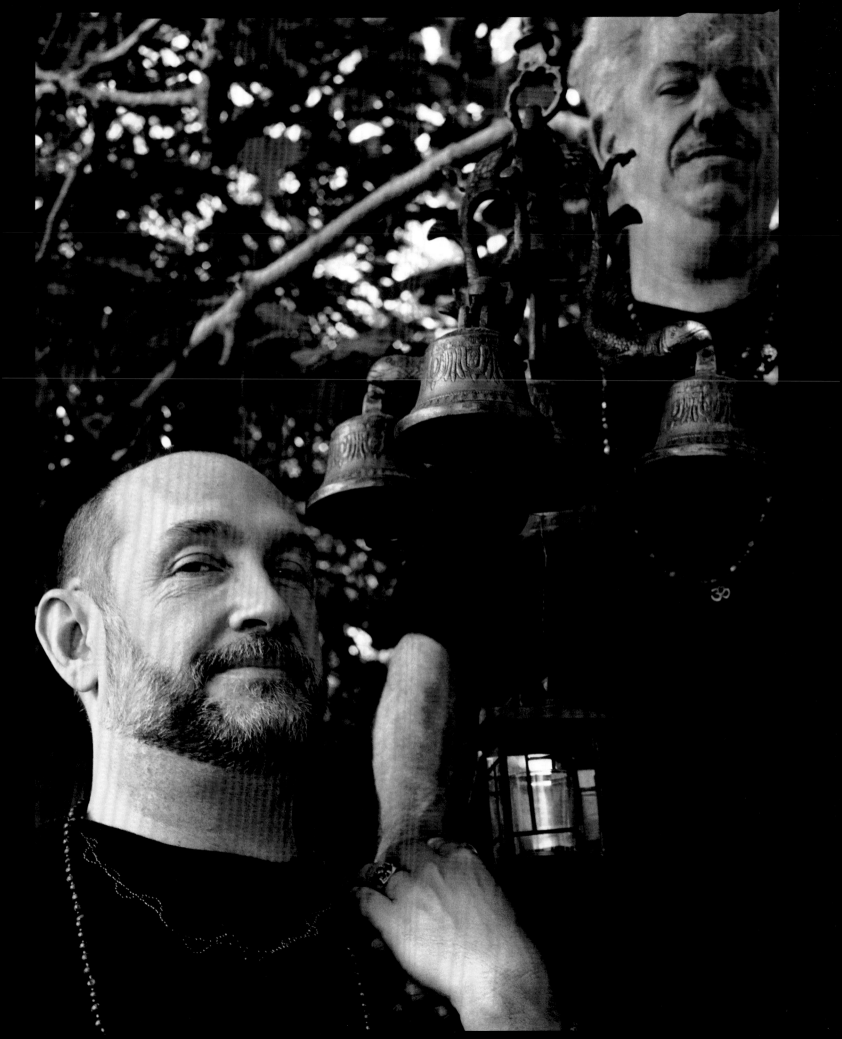

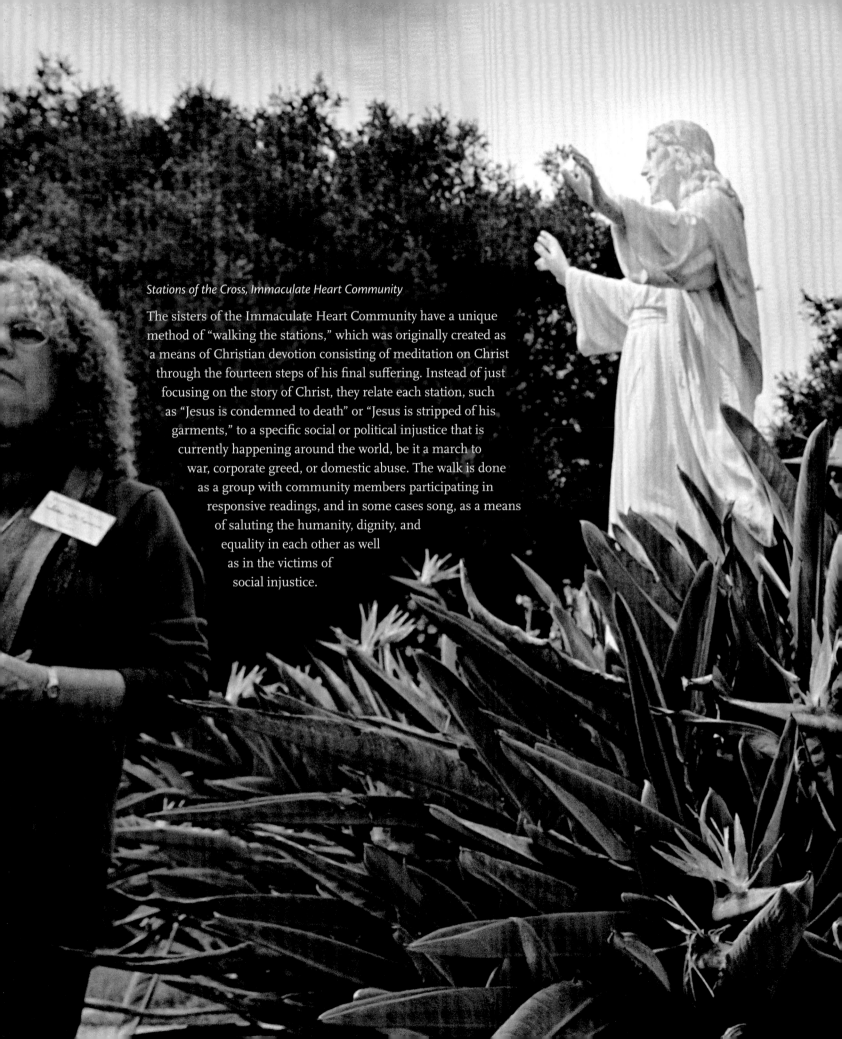

Stations of the Cross, Immaculate Heart Community

The sisters of the Immaculate Heart Community have a unique
method of "walking the stations," which was originally created as
a means of Christian devotion consisting of meditation on Christ
through the fourteen steps of his final suffering. Instead of just
focusing on the story of Christ, they relate each station, such
as "Jesus is condemned to death" or "Jesus is stripped of his
garments," to a specific social or political injustice that is
currently happening around the world, be it a march to
war, corporate greed, or domestic abuse. The walk is done
as a group with community members participating in
responsive readings, and in some cases song, as a means
of saluting the humanity, dignity, and
equality in each other as well
as in the victims of
social injustice.

Women Smudging, Federated Indians of Graton Rancheria

"Worshipping and celebrating like this is a blessing to us. It feels so right. Like we had never been pushed aside," says Anne, who smudges her sister Charlotte, ritualistically burning herbs such as sage, cedar, or juniper to create a cleansing smoke bath. Those participating in the Acorn must be as close to pure as possible. This principle excludes women who are menstruating and anyone who has consumed alcohol or drugs within the last twenty-four hours.

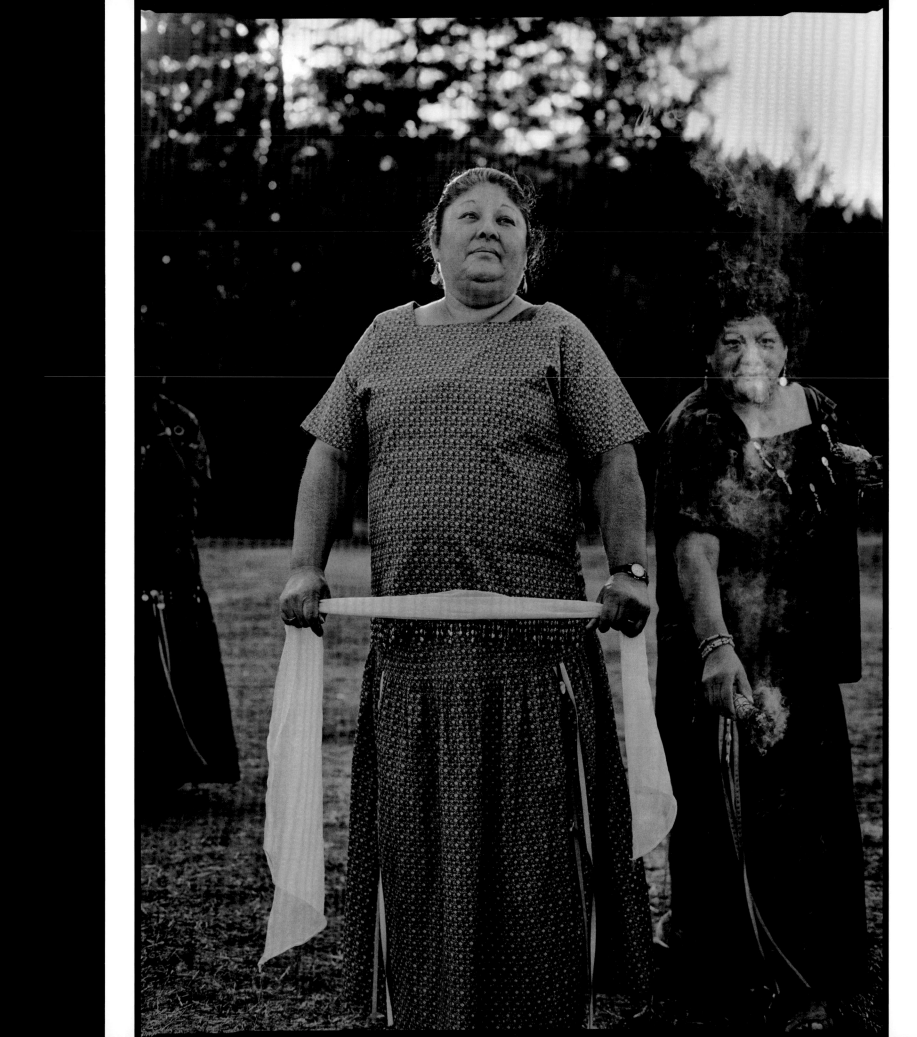

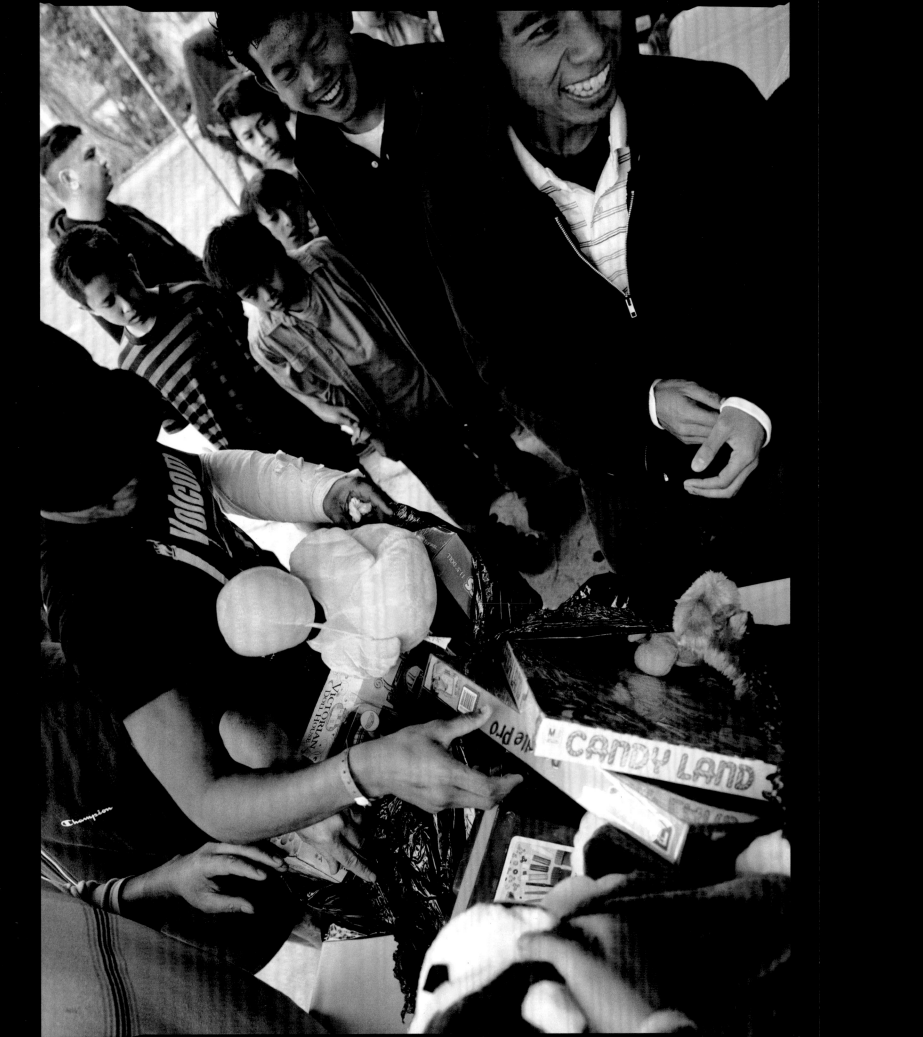

Toys at Feast of Eid ul-Fitr, Cham Muslims

The feast of Eid ul-Fitr celebrates the end of the holy month of Ramadan. After several weeks devoted to intensive worship aimed at developing sympathy for the deprived, cleansing the body, and gaining appreciation for God's bounty, the Cham take part in a potluck feast where trays of curries can be found alongside fried chicken. Afterward, toys donated by Islamic Relief are distributed to the community's children in a ceremony those present called "our version of Christmas." Though these Cham survived the killing fields of Cambodia, they are now fighting what many in the community see as a losing battle to hold onto the remains of their cultural identity: whereas this feast once attracted upwards of seven hundred people, only one hundred to two hundred attended this year.

Super Saturday, Teviston House of Prayer

Once a month three local churches pool resources and their congregations to create Super Saturday, an event aimed solely at helping this community. Free barbecue lunches, tutoring for children, and counseling for adults are offered. Without a prayer book in sight, the event is aimed at building community and trying to counteract some of the problems of intense poverty and drug infestation that plague Pixley and Teviston residents.

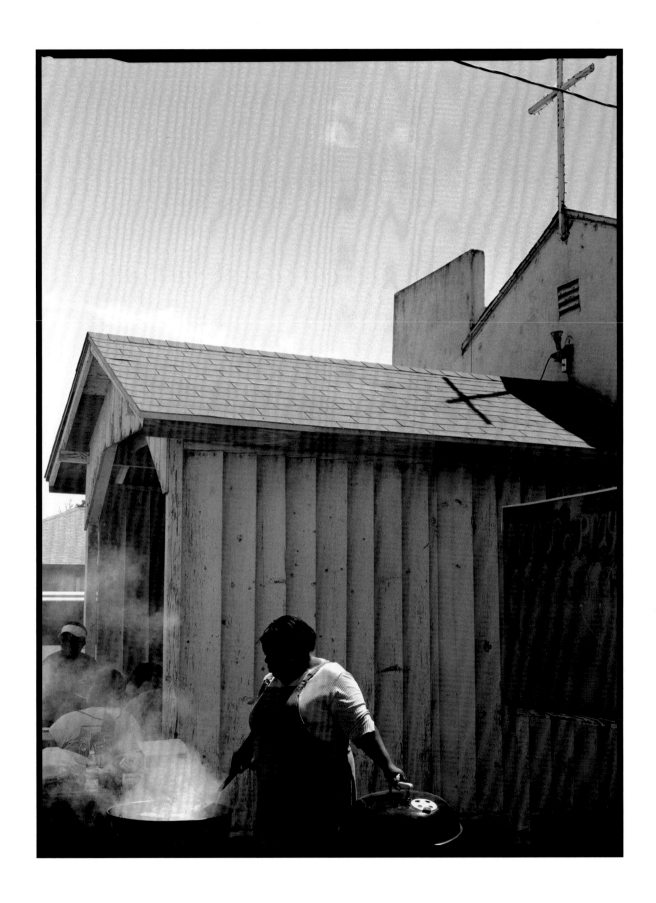

The Circle, Women of Wisdom

"The Spirit is powerfully present to us when we gather. Everyone feels the connection, inspiration. There is no preparation, only presence. There is no homework, only inspiration. There is no black-brown-white, just people. There is no preferential seating in this group to insiders or outsiders, just women. No Catholic-Protestant-Muslim-Jewish–Native American, just women of faith drawing on our common wellspring as women," says one of its leaders. Every month, this formal gathering of female inmates and women from the outside welcomes participants, no matter their faith, into what they call "their alternative circle of grace."

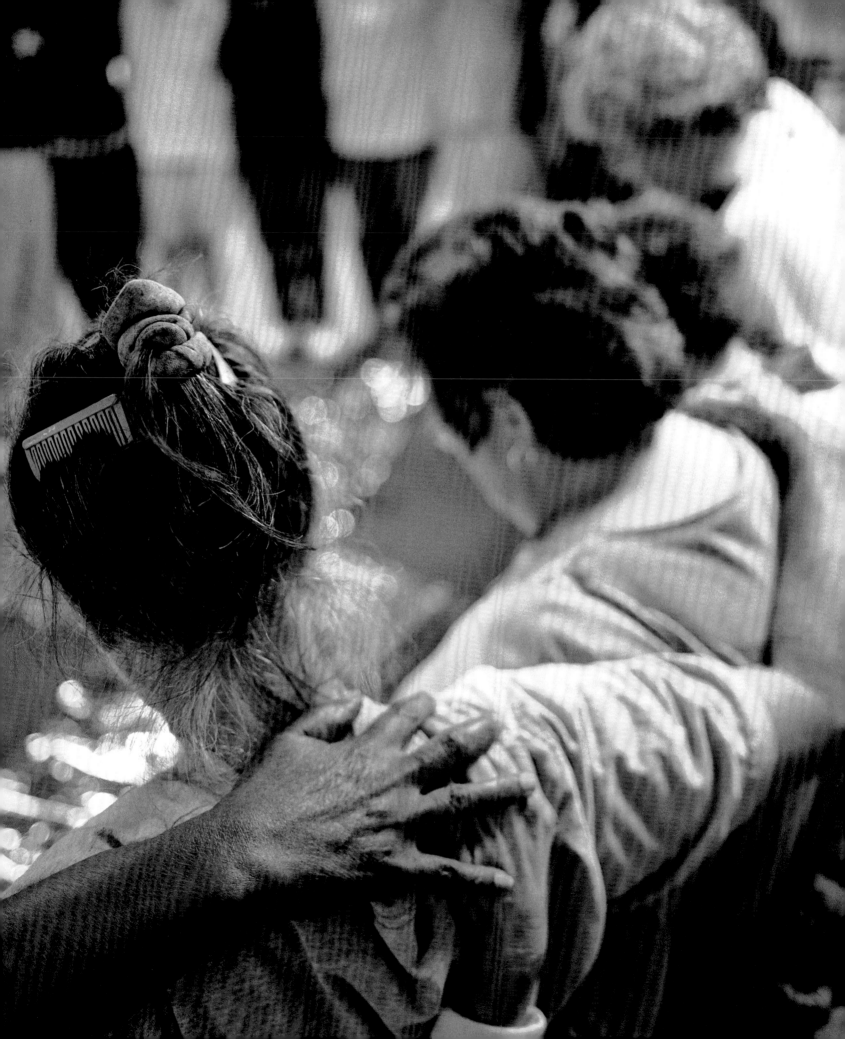

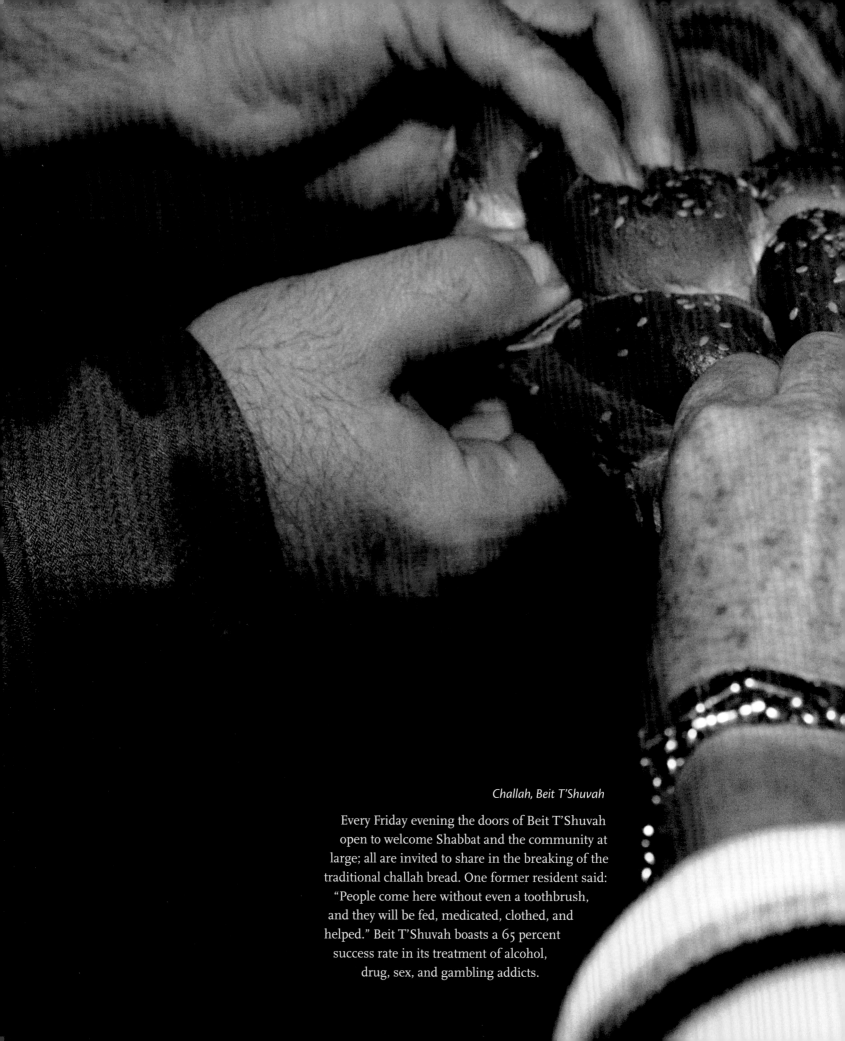

Challah, Beit T'Shuvah

Every Friday evening the doors of Beit T'Shuvah
open to welcome Shabbat and the community at
large; all are invited to share in the breaking of the
traditional challah bread. One former resident said:
"People come here without even a toothbrush,
and they will be fed, medicated, clothed, and
helped." Beit T'Shuvah boasts a 65 percent
success rate in its treatment of alcohol,
drug, sex, and gambling addicts.

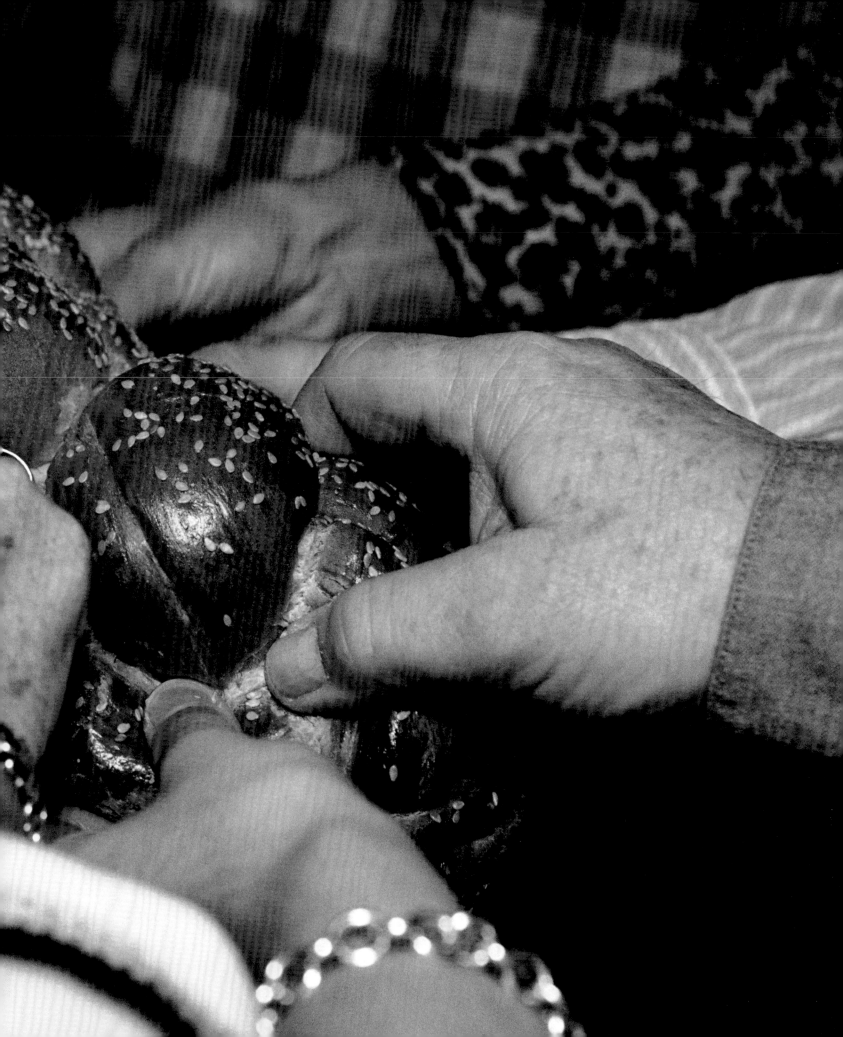

God made me

If God was with me when
I was on crack.
If he was with me when
I was in prison.
If he was with me when
I was committing crimes.
And kept me.
I think he loves me.
Everything I have been
God made me.

—BOBBIEJEAN,
TRANSCENDENCE

Susan in her cell, Women of Wisdom

the strength to fight
and to resit

Oh, my Lord of most high,
 hear my pleas for help, strength, and wisdom.
Help guide me down the path that has been
 placed before me.
Lord, help me to deal with all the trials and
 tribulations that will come before me.
Oh, my Lord of most high, give me **the
 strength to fight and to resist** the dark
 forces that surround me,
 the forces that know my every weakness.
Lord, give me the wisdom and strength to
 walk in the light
 and with those who love and care for me.
Oh, my Lord of most high,
 hear my pleas for your guidance and your
 strength and understanding
 so that I may grow stronger in the ways of
 the light.

—WA ZAN (WOLF),
BUDDHADHARMA SANGHA

walk in the light

Redemption

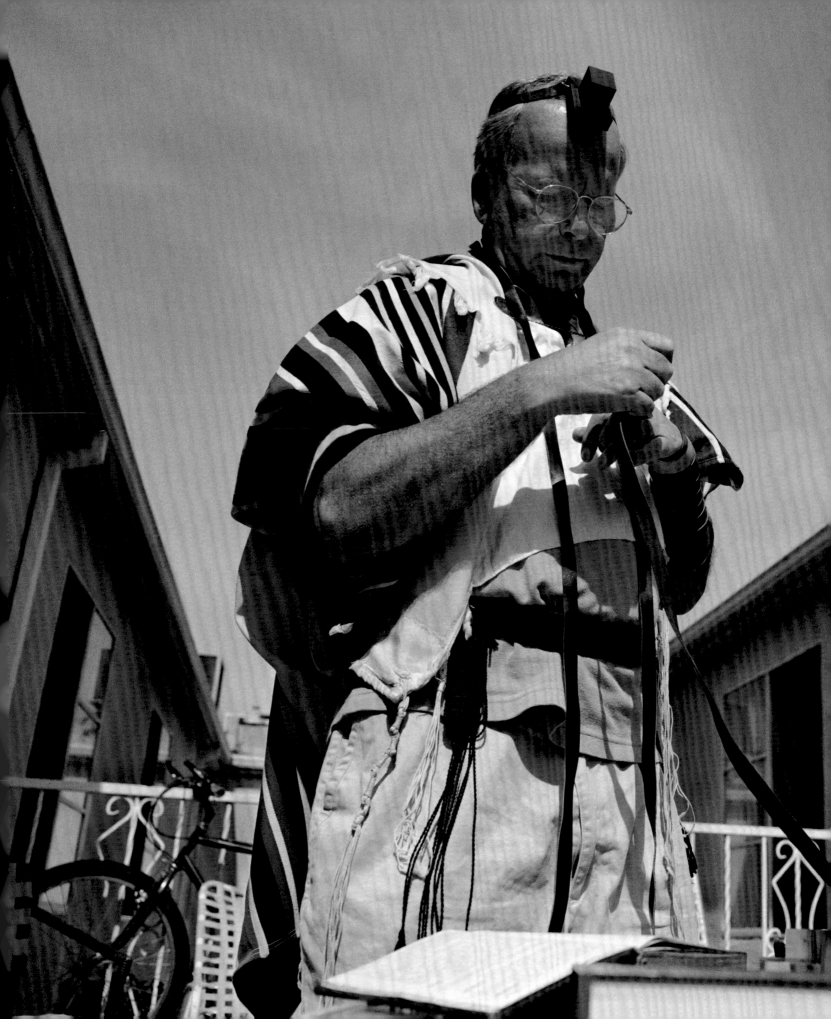

Rabbi Juda, Beit T'Shuvah

Rabbi Juda wraps *tefilin* for morning prayers, a ritual symbolizing the binding connection between Jews and God. His career as a well-respected rabbi spanned thirty-six years before he was given a computer as a gift from his affluent New Jersey congregation and became addicted to Internet pornography. He was arrested by the FBI and was ultimately sentenced to a nine-month term in federal prison. With his marriage disintegrating and a debt of $250,000 in legal expenses, he has spent over a year total, in separate stays, at Beit T'Shuvah dealing with his addiction. The rabbi says: "The most humbling decision of my life was going from giver to receiver."

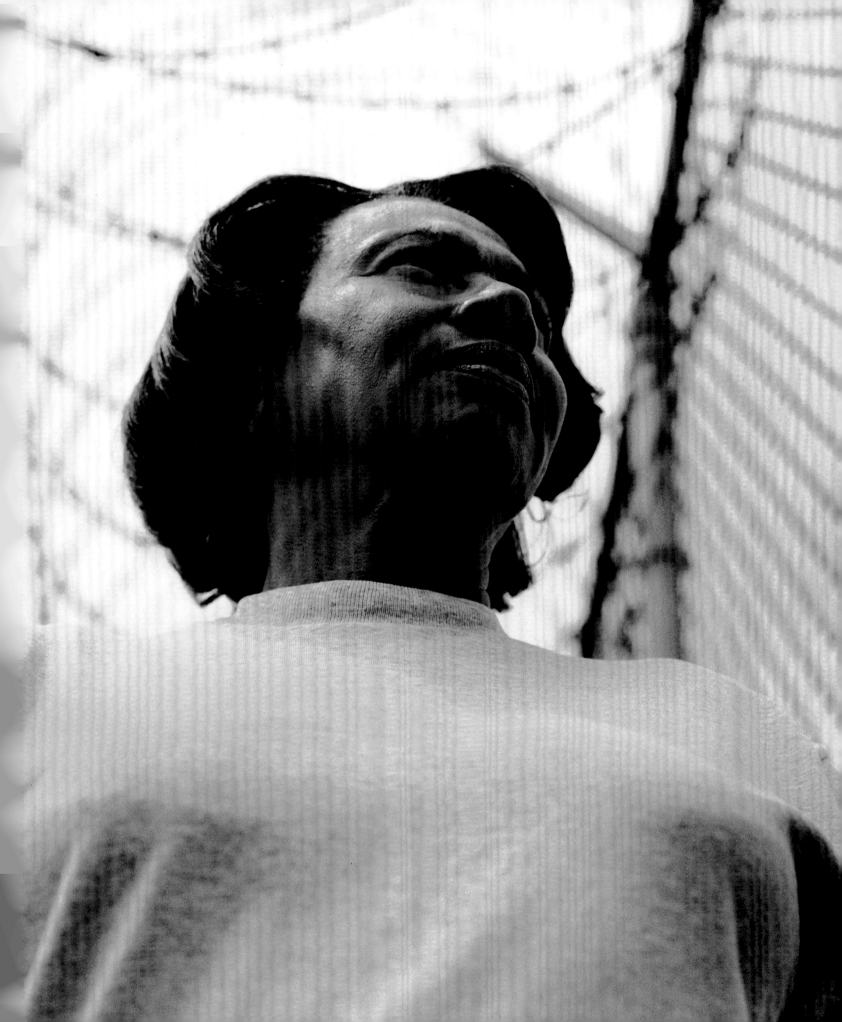

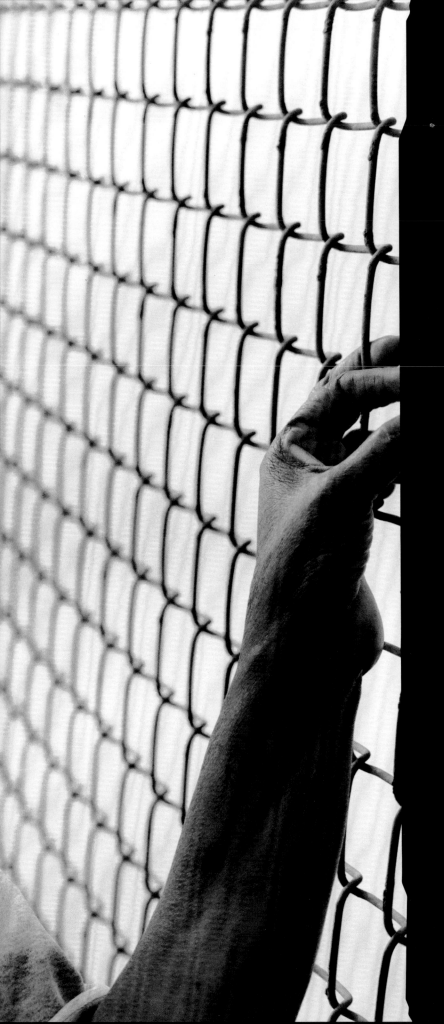

Sandra, Women of Wisdom

"In your visions, in your dreams, you can leave
your baggage behind. . . . Once I discovered
that I was worthy of forgiveness, and I was
able to forgive myself, and knowing that God
forgave me, this opened up everything for me
to accept myself and accept God's love." At age
twenty-four, Sandra was part of an abusive love
triangle that ultimately led to her taking the life
of her boyfriend's wife. She received a sentence
of seven years to life and has been in prison
for more than twenty-four years. Having been
found suitable for parole fourteen times, she has
been turned down each time by the governor.
"I'm from a very religious family. I distinguish
religion from spirituality because I found
spirituality here in this prison."

Cellies, Buddhadharma Sangha

"My sitting begins each morning at 3:00 a.m. I sit to embrace my judgmental views, my fears, my anger, my feelings of not being good enough. . . . Somewhere between the tears and the breath of the moment there is a stillness, a place where everything is just as it should be," says Vincent (below), a former Marine, now serving a life sentence for armed robbery. He and his cellmate, Mac, meditate and chant three times daily, read sutras (scriptures regarded as records of the oral teachings of the Buddha), and try to find serenity and mindfulness in their daily chores working forty hours a week in the prison's mattress factory.

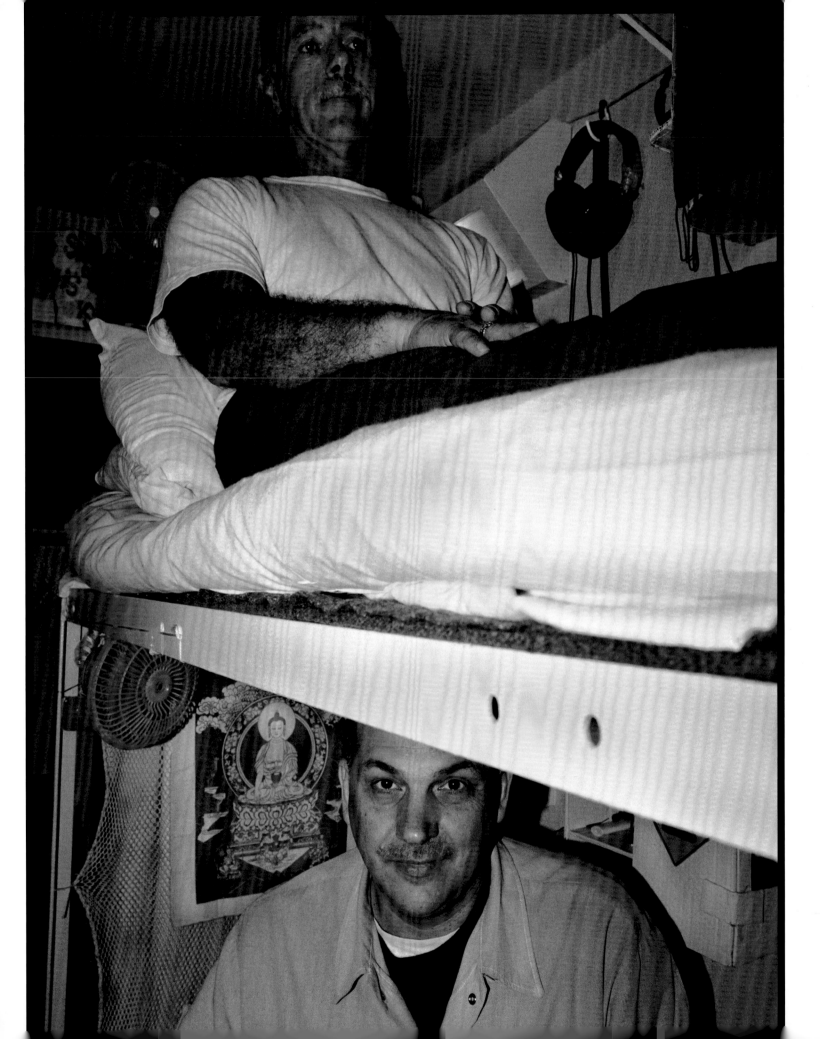

Harriet, Women of Wisdom

Harriet, the only nonlifer in the group, finds the dialogue with people from the outside is "what holds me together. . . . The volunteers that come in and say, 'It doesn't matter what you did. . . . We are here to help you.'" Harriet is a former educator and first-time offender. After she was charged with grand theft, but before she was convicted, she found herself ostracized from the Christian congregation she had been active in for years. "I don't think I knew what it was to be a Christian till I got here. I think I knew on paper, but until you know what it's really like to surrender, you don't really know what being a Christian is."

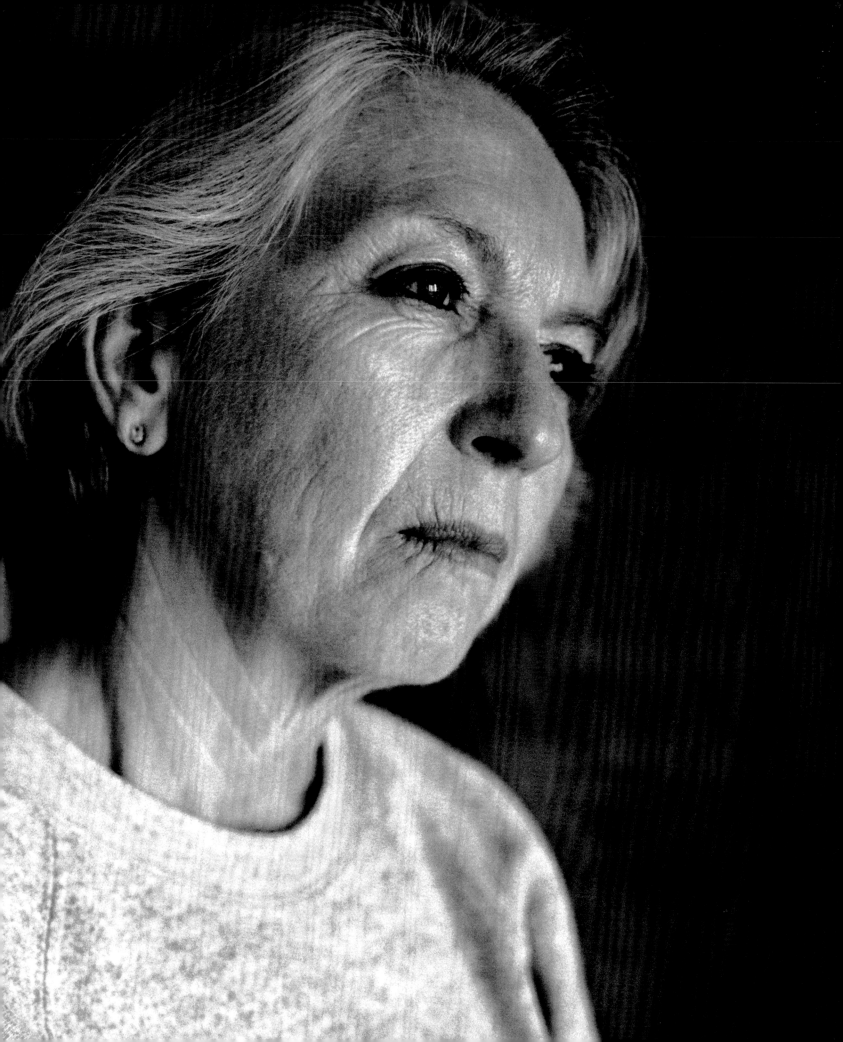

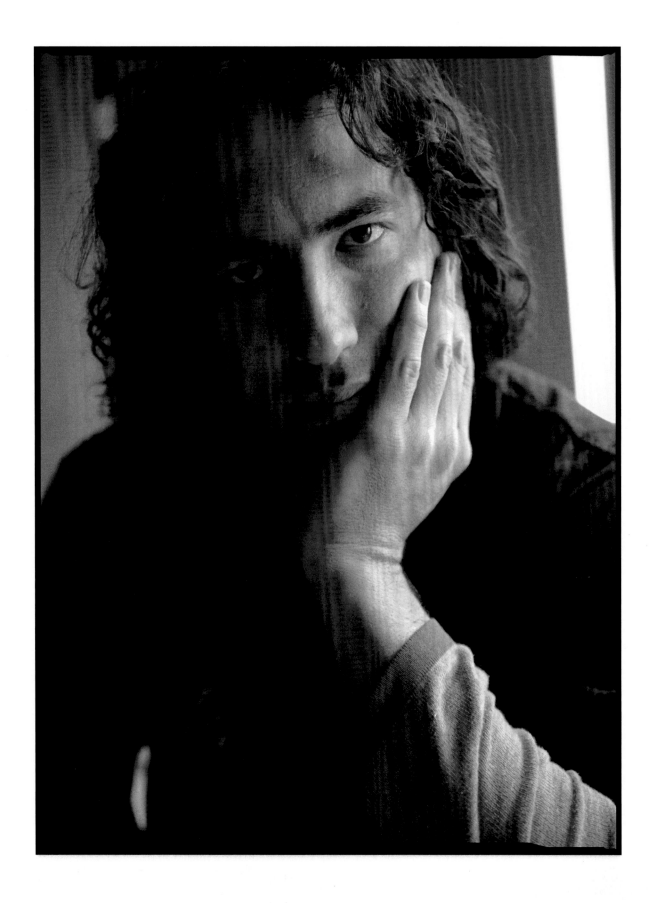

James, Beit T'Shuvah

James, a musician and composer, has battled drug addiction much of his adult life. "I got clean, only to bottom out right after, when a rich friend who had taken me in to help me get my life restarted gave me access to both a piano and heroin." After a subsequent suicide attempt, James' parents did an intervention, which brought him to Beit T'Shuvah. Going through the program, he sees the residents here as "a tribe."

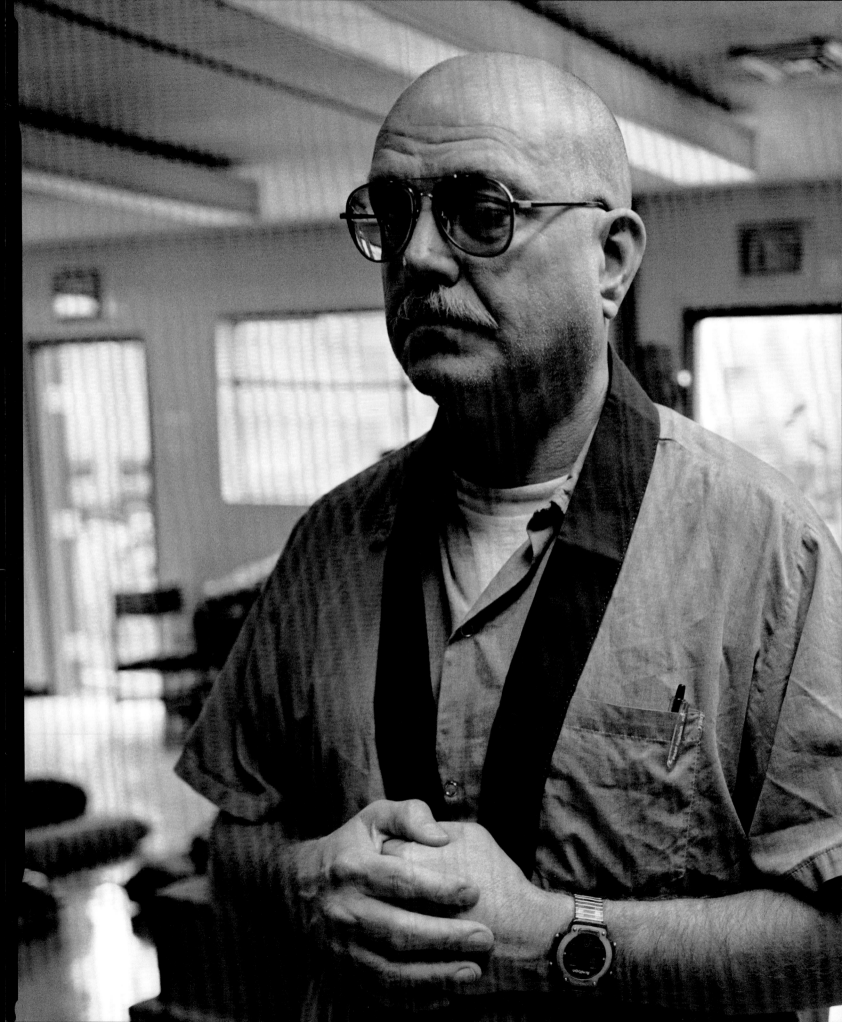

Walking Mediation, Buddhadharma Sangha

"Time in prison loses all meaning. It just isn't important anymore. Buddhist practice goes hand in hand with that loss/nothingness. It is never about escape from prison life for me, but a helpful means of remaining centered and a reminder that noble paths are a personal choice." Marty is a veteran of the Vietnam War. Serving a life sentence for homicide since age twenty-six, he takes part in the group's weekly walking meditations. Although raised Methodist, he has used the support and fellowship of this Buddhist group—noting the calming, inner peace and focus it grants him—to overcome alcoholism.

the new leaders
of our country

Heavenly Father—
Please lead us in the direction
we should go this turbulent
year—and be with **the new
leaders of our country** that
they may lead us toward love
and compassion.

—VELMA,
WOMEN OF WISDOM

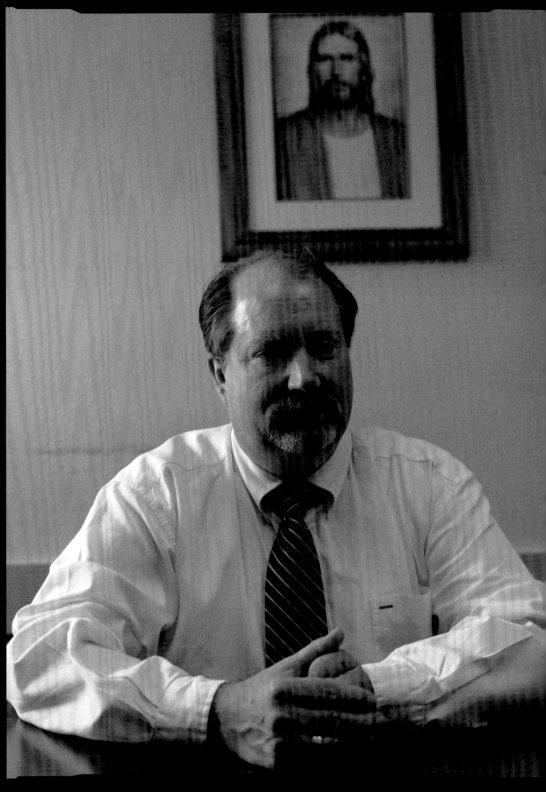

Richard, Deaf Branch of the Mormon Church

To have a guru—if you're lucky enough **to have been in love**—multiply that by one thousand.
It borders on ecstasy.
That's about as close as I can describe it on human terms.

—LAXMAN DAS JAYA,
KASHI ASHRAM

to have been in love

Leaders

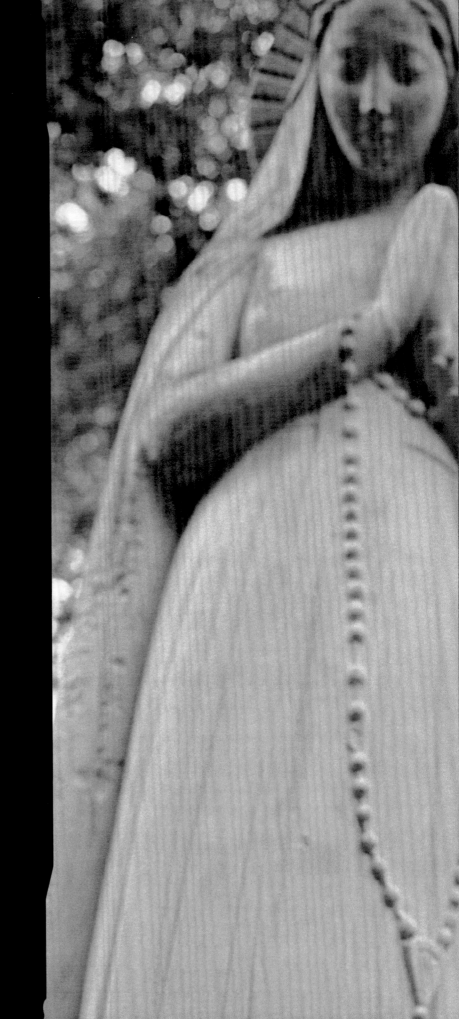

Marie, Immaculate Heart Community

"We're in a time of transition right now. There is some concern amongst some of us that maybe the newer people [entering the community] will not grasp the spirit as deeply as those of us who have been here a long time. I think it's going to be a different community in twenty-five years." Marie is the former codirector of the IHC, which, with over 170 members, still operates the Immaculate Heart High School, a well-respected Los Angeles school for girls. The community has always held equal education for women as one of its most important goals.

Greg, Federated Indians of Graton Rancheria

Tribal chairman, Greg calls his path to the tribe "an absurd Moses story—a lost child coming back. I was adopted and did not know my heritage. Ironically, I grew up around a lot of the Indian people that I know here in Santa Rosa but did not know they were relatives until I returned here in my midtwenties and found my father's people." A professional writer and university professor, Greg has been reelected to his post by the tribe over a half-dozen times. He explains: "The landscape was always our bible. It was a place where each rock, each tree, each creek, each river was a mnemonic peg on which we held story, morals, ethics, always reminding us of the power of life and that we are not the center of the universe, but a part of it."

Pastor Daniels and Lenora, Friendship Baptist Church

Pastor Daniels, a full-time truck driver, and his wife, a preschool teacher, drive some sixty miles each way from their home in Bakersfield to preach at this church in Teviston. It was started by Pastor Daniel's father, who also had a hand in bringing water to this unincorporated community, which is still without a public sewer, traffic signals, or a police force. When asked what keeps them returning to Teviston, Lenora replied: "Pastor Daniels' love for this area, his love for the families, and to keep the church alive." Friendship's current twenty-five members are composed of about half a dozen locals, with the balance traveling often many miles to worship during Sunday services or attend Wednesday-night Bible study.

Ashley, Transcendence

Raised male but born intersexual (of both
sexes), Ashley suffered through eighteen schools
while her father tried to "beat the woman out
of me." Eventually, she sent herself to music
school and transitioned into her transsexual
identity through her work in the music indus-
try. "What allowed me to move on with my
transition was to delve into the spiritual end
of it. . . . On the path to making an album, my
work became more spiritual, and that morphed
into the idea of a choir." Ashley is the founder of
Transcendence and has writen and performed
many of their instrumental parts.

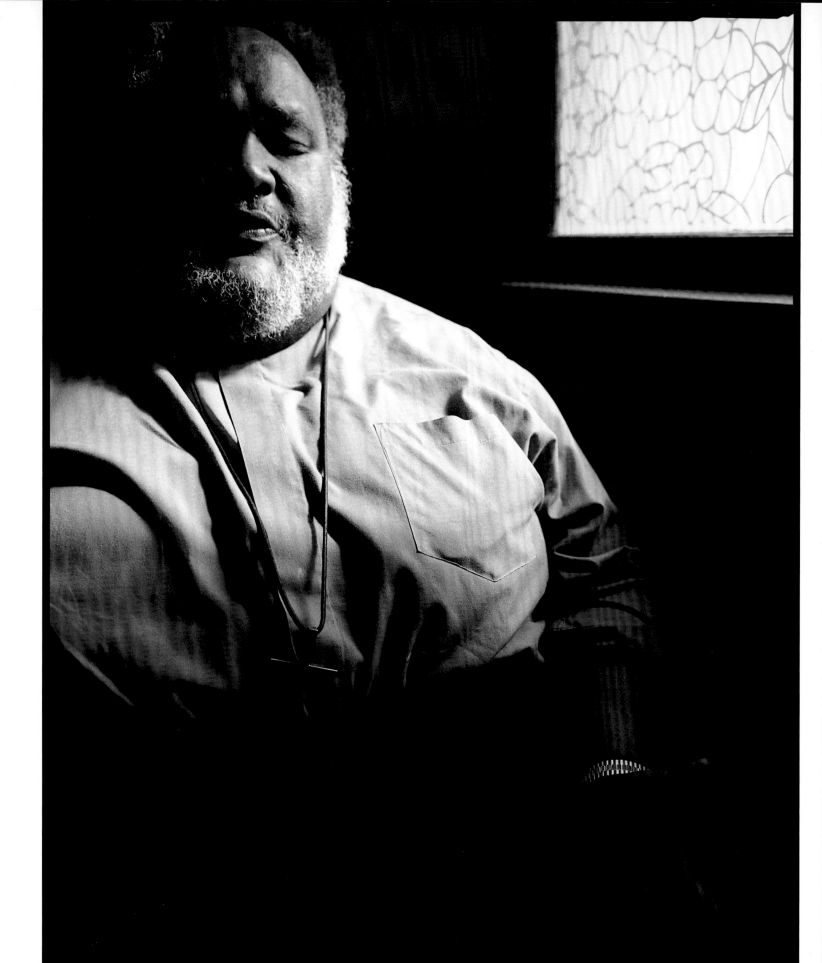

Pastor Smith, Teviston House of Prayer

"We survived because we were given a mission. Sometimes
there are only two people, but I accepted the calling. . . . I've
had four or five kids grow up and come back—it's home for
them. It's a foundation." After Pastor Smith's father died
when he was only seven, his mother packed up the entire
family and brought them to California's great Central Valley.
He has been pastor for Teviston House of Prayer since 1995,
commuting forty-five minutes twice weekly from his home
in Fresno. "A lot of Pentecostals came out of the fields, out of
poverty—they are not ashamed. They are proud people. All
they have is a boot and a shoe, but they'll share it with you."

Sister Suzanne, Women of Wisdom

"Women of Wisdom is not where we worship or study our religious traditions. This is a group where we experience ourselves as women who embody Wisdom and draw upon her direction and strength to lead us. She is tangible. Here [inmates] feel that they are not being taught something by the women on the outside. Here they are not working, they are being." Having begun working in prison ministry in the midseventies, Sister Suzanne first worked with incarcerated men, then moved on to juvenile offenders. Ultimately she reached her current position as leader of the nonprofit Women and Criminal Justice Network, which provides pastoral ministry, direct service, and advocacy programs for women and their children affected by incarceration.

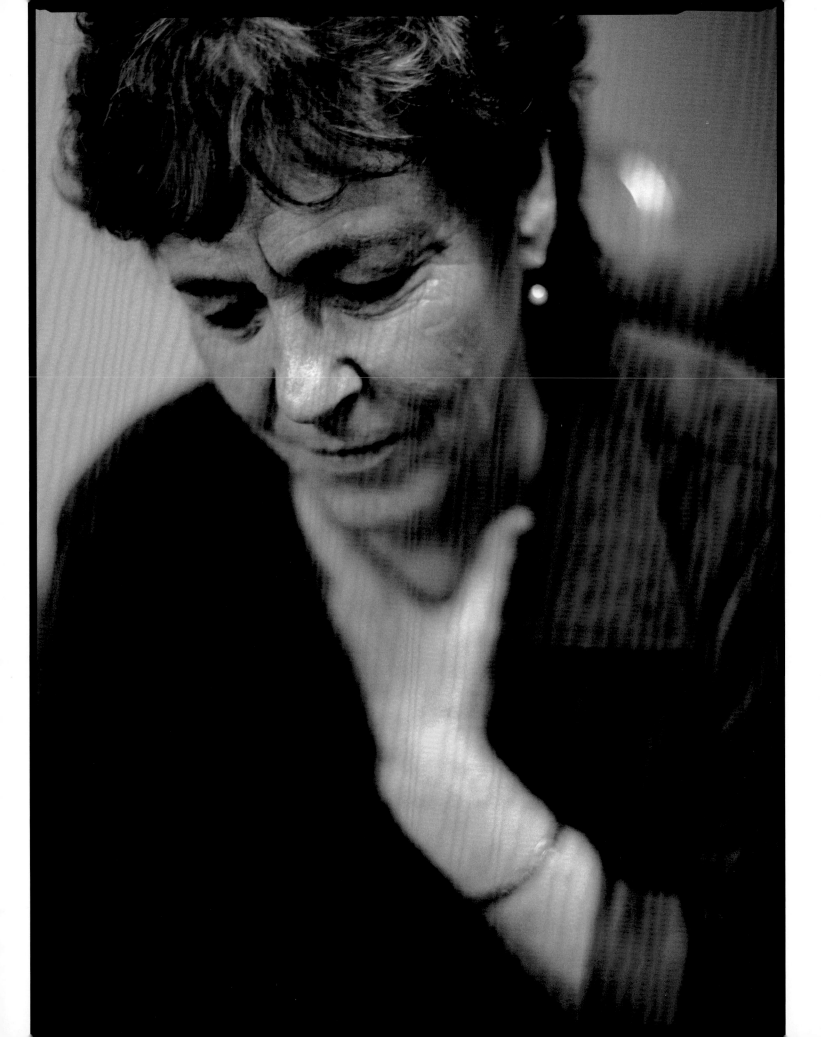

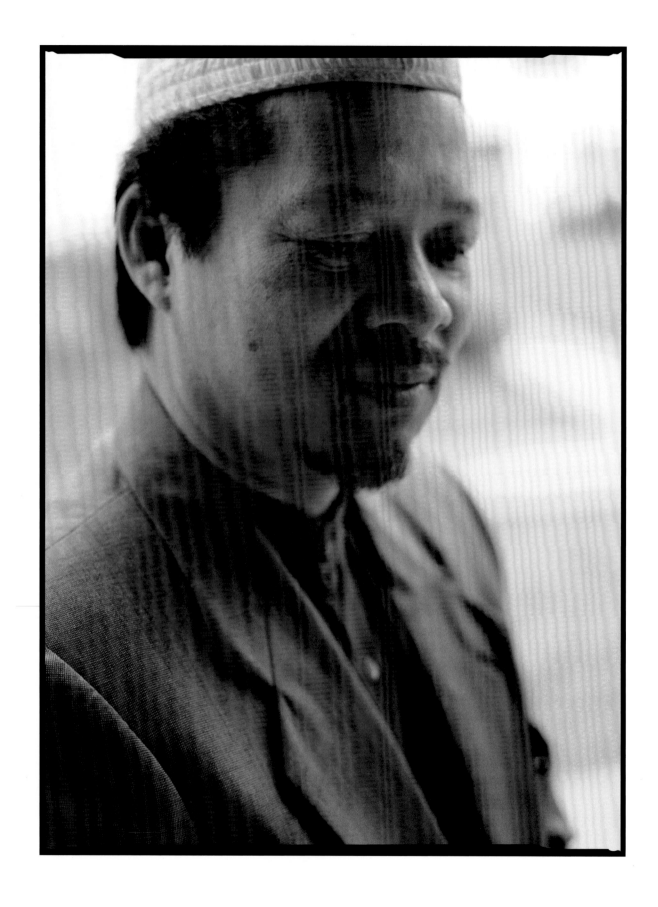

Brother Salim, Cham Muslims

"When I was in Cambodia, I was so weak from malnutrition I would crawl if I wanted to go from place to place. When my mother died, my brother and I could not bury her because we were too weak to dig the grave." Brother Salim, the imam and spiritual leader to many of the Cham in Santa Ana, lost nearly his entire family in the Cambodian genocide. After his first child died due to forced starvation, he fled on foot to Thailand, then to the Philippines, before ultimately being granted asylum by the United States. He eventually brought the surviving members of his and numerous other families to Southern California, where he has helped build a small, tight-knit community.

Pastor King, Shiloh Church of God in Christ

Pastor King has gone from picking cotton and grapes to janitorial work to his present occupation as minister of this Pentecostal congregation since 1998. Himself a victim of a mugging in Bakersfield, which left him permanently disabled in 1989, he sees his church as "a healing station, physically and spiritually. That's the whole object of this church—a saint's hospital. We want to see signs of wonder come back to our church—we want to see people get up out of their wheelchairs and off their deathbeds."

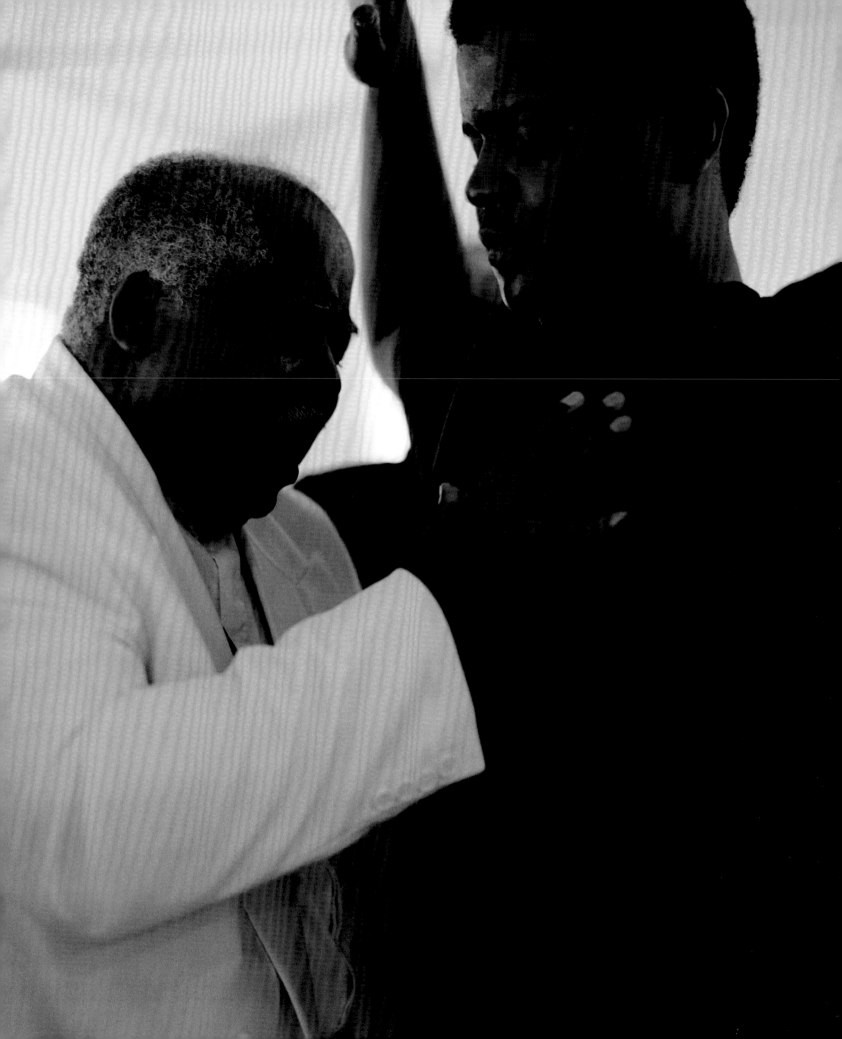

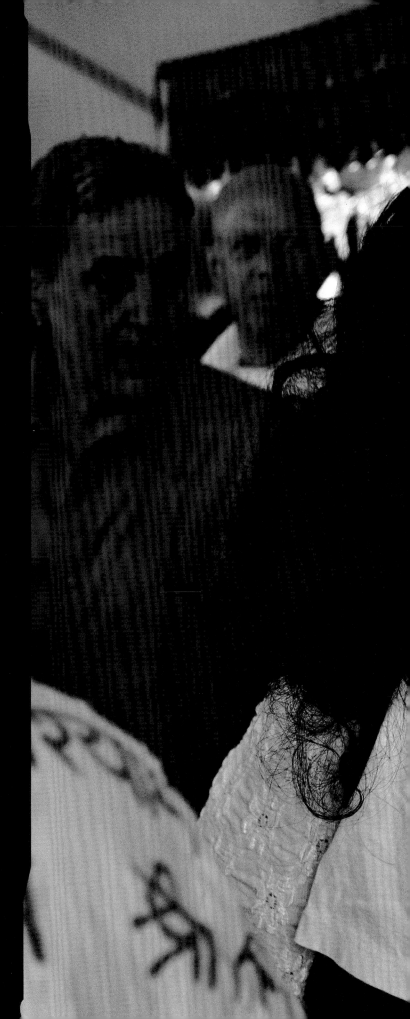

Guru Ma Jaya, Kashi Ashram

"I have had death drip all over me. If anyone can prove that one cannot get AIDS by kissing, hugging, just laying in the same bed and holding someone till they die, it would be me. But twenty years later, I still see the shuddering and fear of 'Don't touch me, you have AIDS.'" Guru Ma Jaya hugs a woman with AIDS at the ashram. Living as a Jewish housewife in Brooklyn until the midseventies, Ma started her spiritual journey after discovering the power of yoga, followed closely by a vision of Christ. Once described as "a cross between Mother Teresa and Bette Midler" due to her commitment to service and ribald sense of humor, Guru Ma's message over the last thirty years has been: "There are no throwaway people."

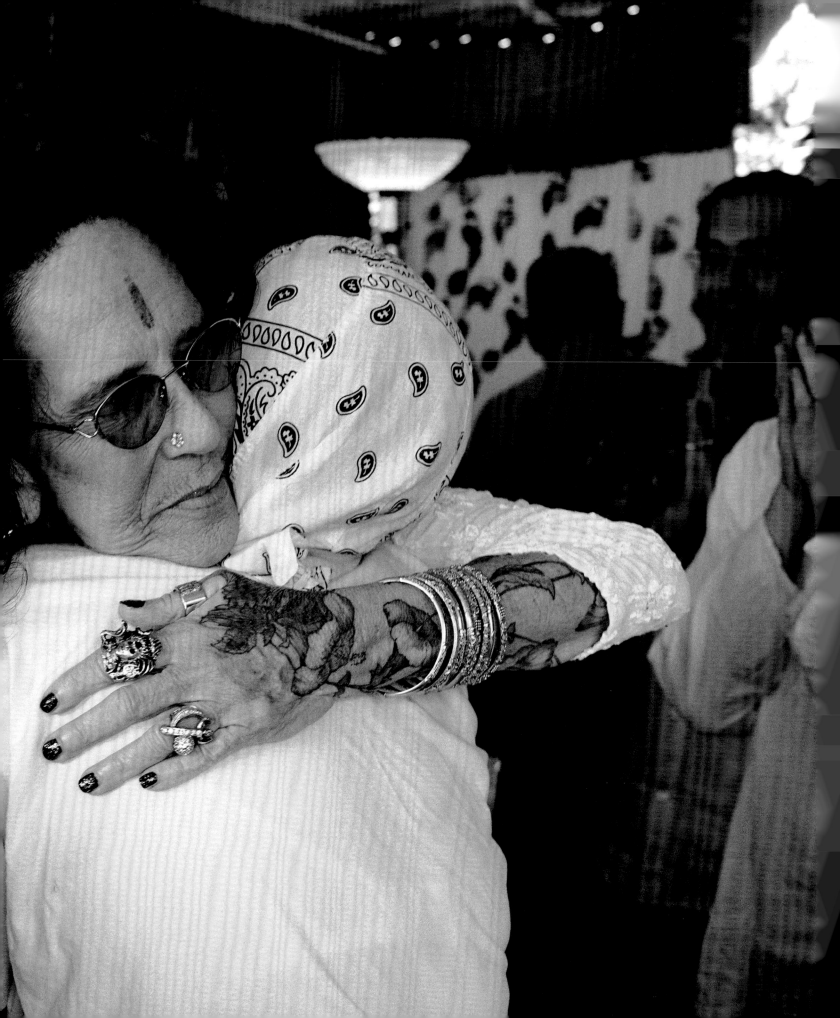

Rabbi Mark, Beit T'Shuvah

A former con man, alcoholic, gambler, and convicted felon, after his release Rabbi Mark doggedly pursued the spiritual path he had begun exploring in prison. Several years later, upon completing rabbinical school, he became the spiritual leader of this rehab center in which he and his wife, Harriet (Beit T'Shuvah's founder and executive director), "explode the stereotypes of our community." He says: "This is what I was born for. My job is to fight the Angel of Death. . . . I believe that every life is worth fighting for. Every life, no matter how lost or battered, can change. Every life can live in the pure essence of one's soul. Every soul can heal. Every one."

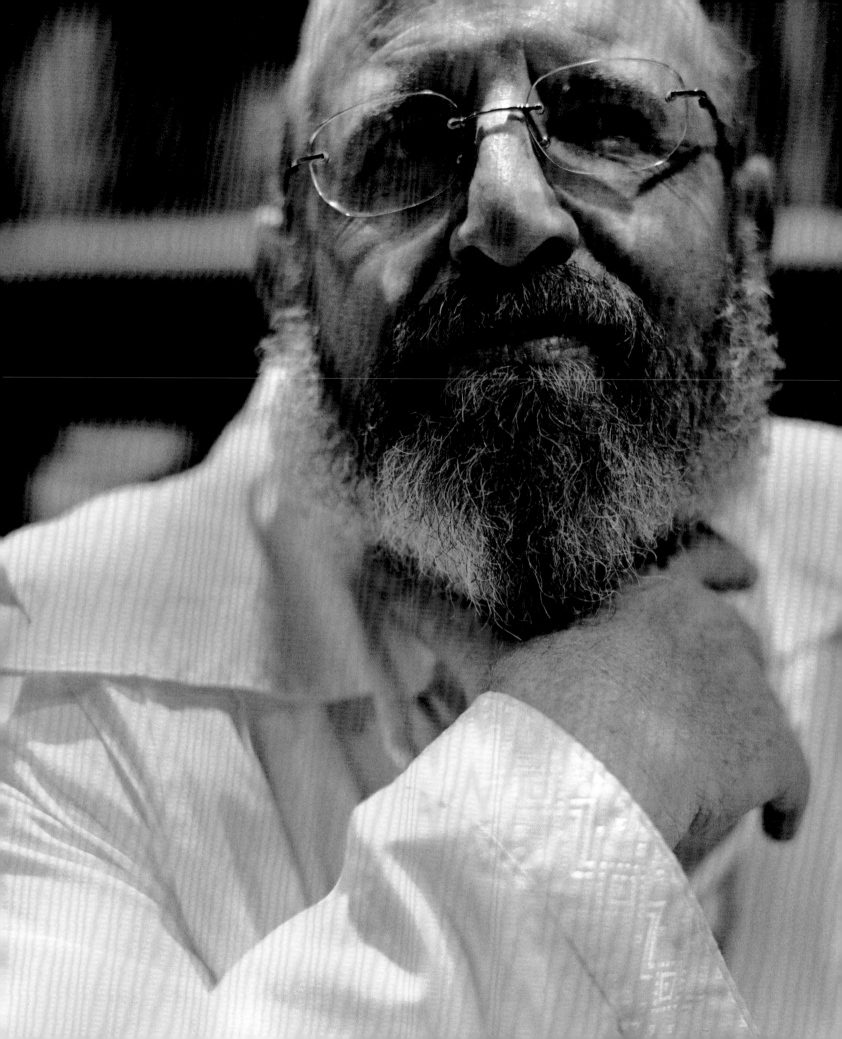

President Clark, Deaf Branch of the Mormon Church

"I was called to receive a handicapped body to enable others, hearing and deaf, to embrace and deal with the struggles of their disability." In the 1960s the Salt Lake City headquarters of the Mormon Church was seen as ahead of its time because it set up deaf branches and internal structures for deaf leadership across the country. Even so, deaf branch president Clark was "raised in a hearing world and isolated from the deaf community." Ironically, he grew closer to God through his deafness by being forced to read and "look around at his creations—mountains, clouds, waves, rivers, trees, stars—while not associating with people."

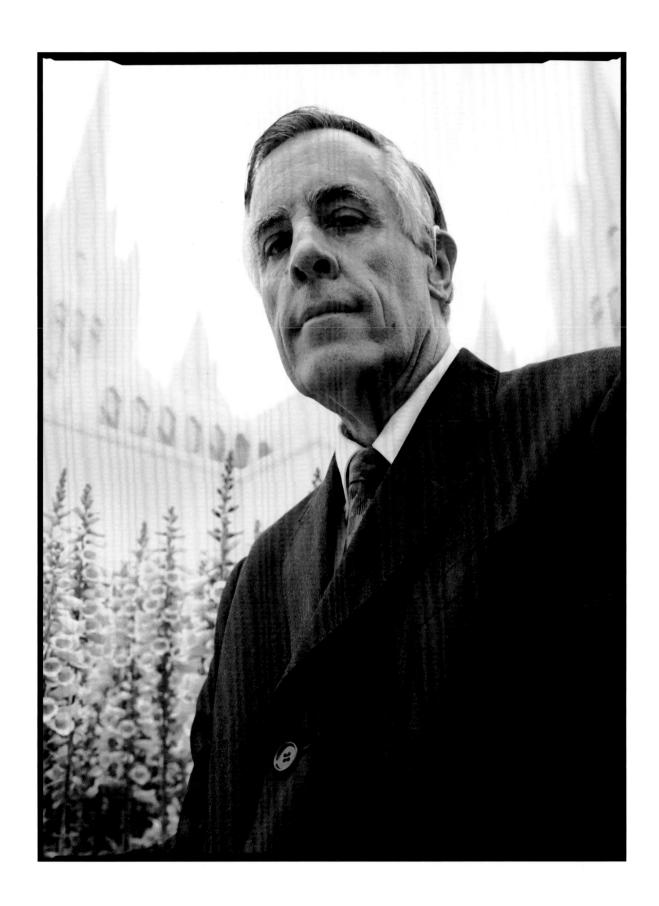

one day I will become

I pray that **one day I will become** a tribal member.

—CELINE,
FEDERATED INDIANS OF
GRATON RANCHERIA

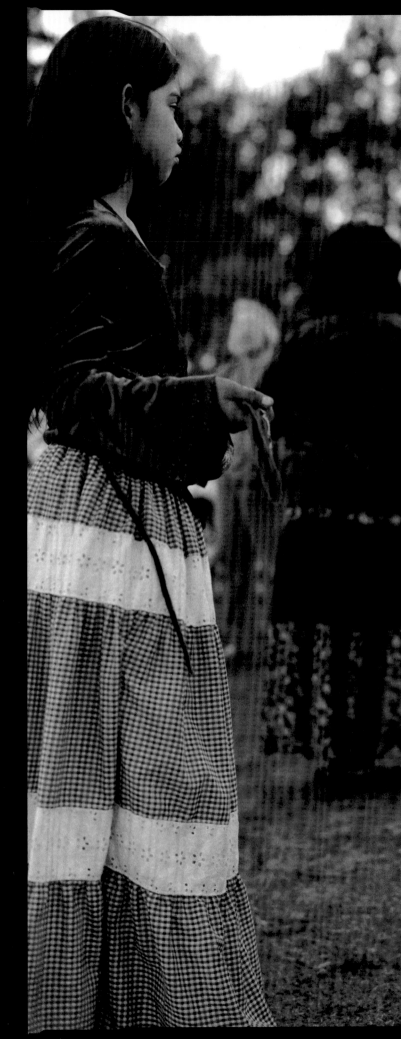

Indian girls prepare for dances at the Acorn Festival

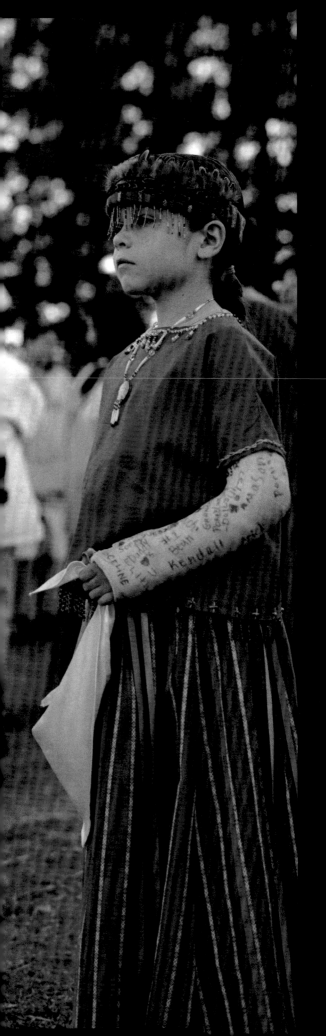

I pray for everybody to be nice to
each other and be friendly.
I pray for my family to be healthy
and good.
I pray that Allah helps me to be
smart and have good grades.
And last, **I pray** I can see my
mom soon.

—EMAN,
CHAM MUSLIMS

I pray

The
Future

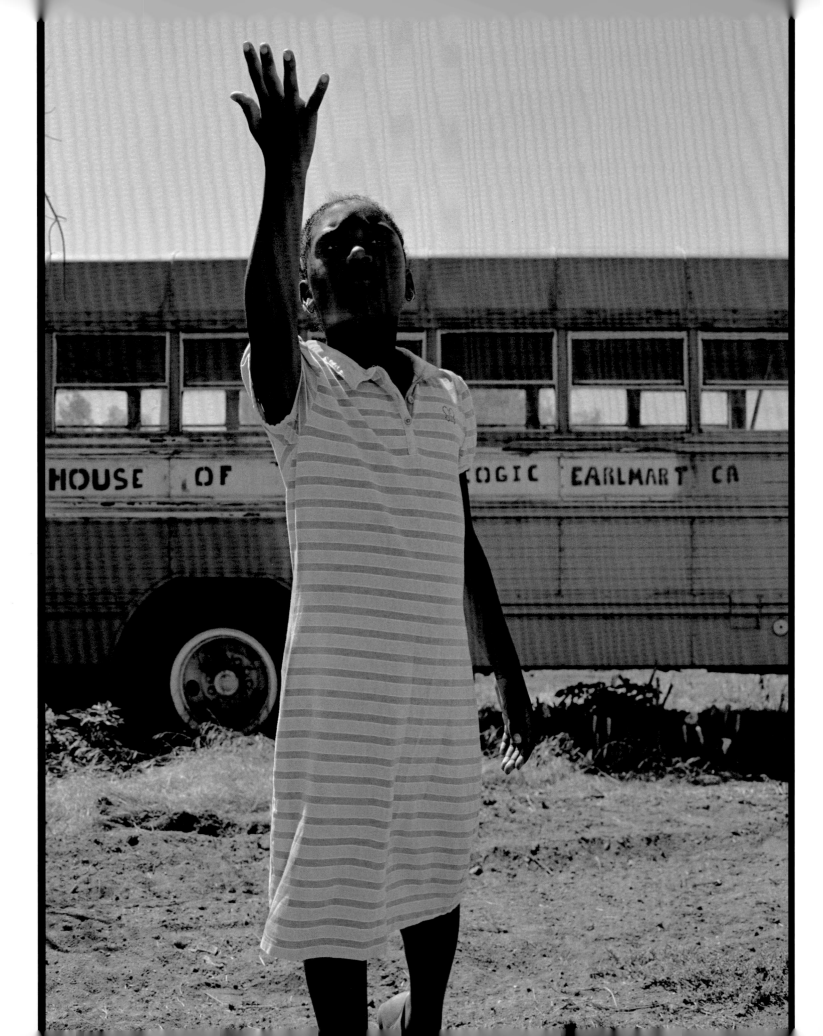

Praise Dance, Teviston House of Prayer

Jariah practices prior to performing a praise dance at Sunday service. This form of interpretive prophetic dance is described by some as "dancing for the Lord." Though certain individual moves are practiced, the complete dance is not choreographed, so that dancers can allow God to work in them, bypassing the intellect. Often performed to gospel music, praise dancing fuses contemporary modern and African dance.

Eman, Cham Muslims

Born to a Yemenite mother, Eman has not seen her since 2003, when she came with her Cham father to California because of what her parents agreed would be a life of greater opportunity than the one her mother's impoverished homeland could provide. Her mother chose to stay behind in Yemen and speaks with Eman only by phone. Though Cham and Arabic religious practices are quite similar, culturally, many women find an easier time integrating, contributing, and living as active members of U.S.-based Muslim communities than they might in many Arabic nations.

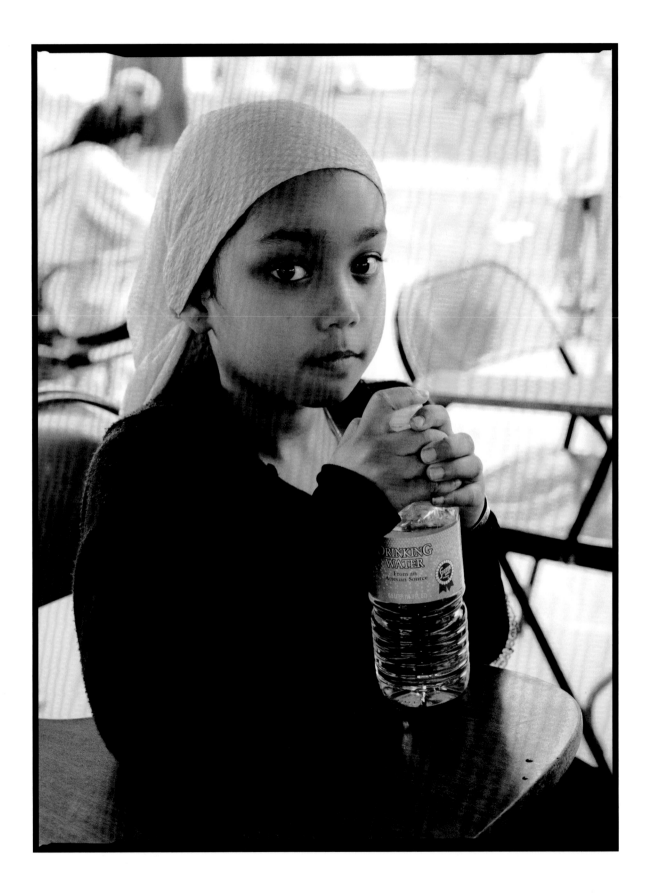

Janea, Deaf Branch of the Mormon Church

Janea stands backstage just prior taking part in a performance the hearing members of her church put on in American Sign Language every year to help bridge the gap between local Mormon hearing and deaf communities. She faced severe health complications at birth, which ultimately resulted in near-lethal infections and caused her deafness. Janea's parents feel certain "she is alive today because she was given a priesthood blessing." Her mother adds: "God thinks of [people with disabilities] as stronger and more able to handle what life throws at them. They have to deal with everything everyone else does in addition to their difference."

Maryam at Sunday School, Cham Muslims

Maryam attends the multilevel Sunday school, which shares space in the small mosque the community owns. With approximately 65 percent of Cham children marrying into other faiths, this education has become a last resort to try to educate the next generation of Cham about its ancient South Asian culture as well as about the Muslim faith. As a means of trying to fight the tide of American culture sweeping away their children, language, and customs, the teachers here have even considered adding a video game to their curriculum entitled *Mecca and Medina*.

One Cham elder sadly admits: "Because we don't have the resources to save both, if we have to choose between saving our culture or our religion, the religion will win."

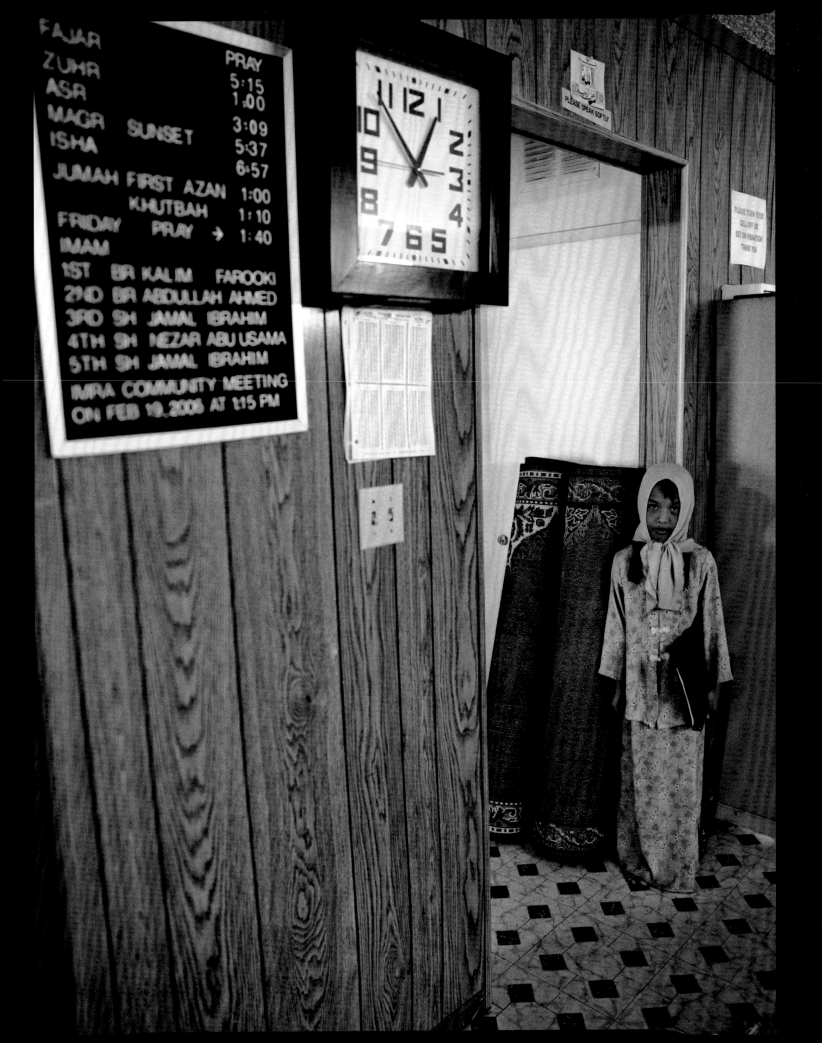

Indian Boys, Federated Indians of Graton Rancheria

Ezeqiel (front) and his cousin Jose, two of the youngest members of the tribe, take a moment between dances at the Acorn. Having been restored as one of President Bill Clinton's final acts while in office, the tribe now encompasses a hugely diverse population from the well educated to the very poor, from octogenarians to infants, presenting a unique opportunity for both elders and the next governing generation of the tribe to take part in ceremony and worship simultaneously.

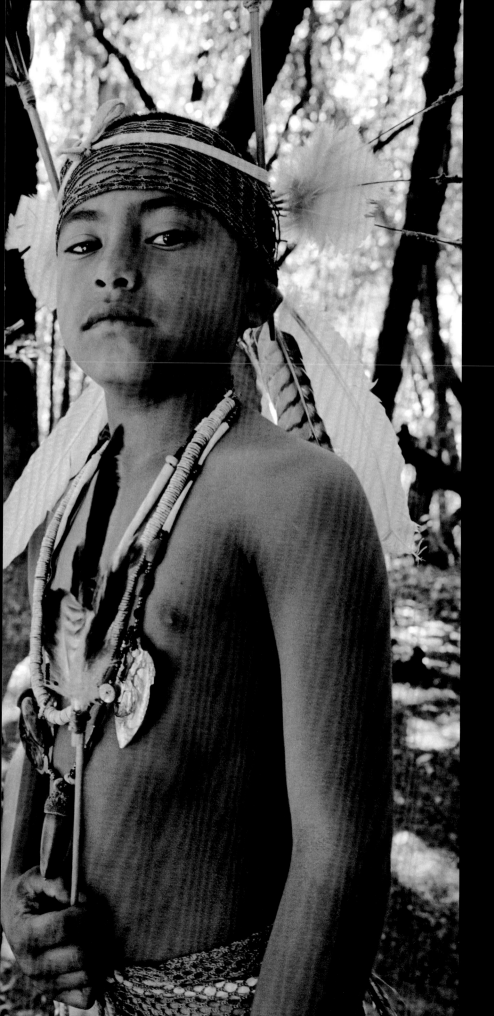

realize who you a

A GRANDMOTHER'S PRAYER

Child of my child
Do you **realize who you are**
Do you know where you come from
Softly sleeping in the light of the moon
How strong your ancestors were
Blessed by the Creator
Strong and brave
Carry that on for your people
Another generation away from
 the sorrow and the grief
Let it go now, put it to rest
And walk gently in this new world,
Know only its beauty all the days of your life.

—JOANN,
FEDERATED INDIANS OF GRATON RANCHERIA

Oral Histories & Essays

all-encompassing

Holy Death, unappeased and **all-encompassing**,

Hear the voice of this soul.

I beg you that your power guard me from your destructive fury.

Holy Death, I ask that your thundering power shall not explode,

So those I love can have long life.

Guard me with your hand from poisonous ire

And reject the furious muse that doesn't **recognize your presence**. Amen

—ANONYMOUS, SANTÍSIMA MUERTE (TRANSLATED FROM SPANISH)

recognize your presence

Queen of the Misfits *An Oral History*

BY HARRIET ROSETTO

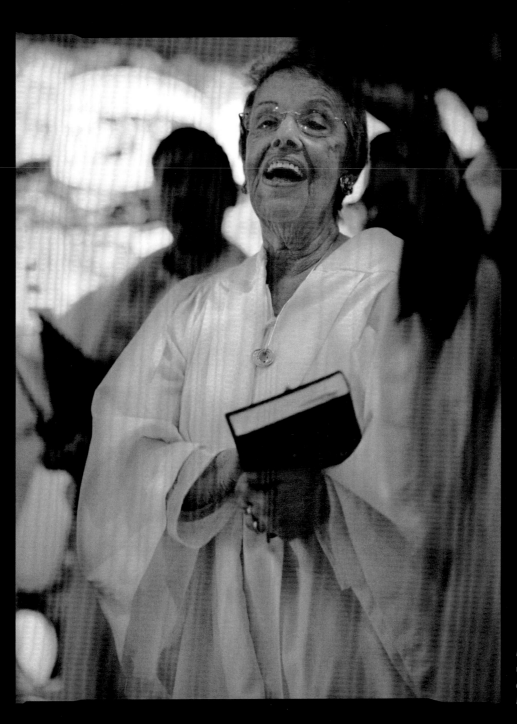

*Harriet sings
with the choir
on Passover,
Beit T'Shuvah*

I WAS A MISSIONARY CHILD, ACCORDING TO MY mother. Early on, I identified with the oppressed and sided with the underdog. I wanted to change the world. The women I admired and wanted to become were the rule breakers and crusaders for social justice—Eleanor Roosevelt, Emma Goldman, and Dorothy Day. In junior high school I was labeled a "nigger lover," a "Commie," and a "dirty Jew." Nobody liked me, and I didn't like myself. I was fat, klutzy, and lousy at sports and games. I adopted the identity of an intellectual snob as a defense but secretly longed to be a cheerleader. A cartwheel was out of the question.

I branded myself a misfit, fluctuating between wanting to belong somewhere and not wanting to belong to a club that would have me as a member. I found comfort in food, boys, and books and wallowed in existential despair—"Why bother, nothing matters, life is hard and then you die." This negative lens transformed my perceived inadequacies into a badge of superiority. Only stupid people were happy! Despair was my consolation prize for not being thin enough or pretty enough or popular enough or important enough. Superiority and grandiosity were my allies against self-loathing when I failed to lose weight or get organized or find the right boy or finish what I started or figure out how to make a difference in the world. I embraced sloth, soothed myself with indifference, and flirted with suicide.

Despite the life-and-death battle raging in my soul, I had enough of my mother in me to keep up appearances. I got into a good college in Boston and went with the charge to find a suitable husband before graduation. I met and married the requisite Jewish Harvard Law School graduate by the end of my sophomore year and moved with him to Minneapolis, Minnesota.

The outer me tried to play the part of suburban housewife, learning to cook and set a fine table with the Limoges china, sterling flatware, and crystal goblets from my wedding. I used the damask banquet cloth once and left it crumpled and crumby on the floor of the linen closet until we divorced.

The other me was a college girl, searching for truth and the meaning of life, falling in love with ideas and professors. I felt like a circus performer juggling my Marjorie Morningstar and Shirley Morgenstern personae, walking a tightrope between convention and rebellion. Which one was the real me? How could I put them together?

I felt as if my body was a battleground for the opposing forces within me; the one I thought I was supposed to be and the defiant one whose tastes, preferences, and choices were a constant fuck-you to the pretensions of the "good girl." They fought about literature, music, boys, clothes, food, and weight. One was fat and the other thin; one was slothful and the other ambitious; one read Dostoevsky, the other sneaked peeks at the *National Enquirer*; one listened to Bach, the other to Billie (Holiday); one was a gourmet New York foodie, the other slunk surreptitiously into McDonald's; one wanted to marry a nice Jewish professional, the other was turned on by bad boys; one wanted to save the world, and the other wanted to stay in bed. They disagreed about everything and ultimately canceled each other out, making it impossible for me to sustain any relationships or course of action. What one started, the other abandoned.

I married again and had a child. One part of me was über-mom, reading the "right" parenting books, buying the "right" toys, researching the "right" schools, making the "right" friends; the other part of me hated the responsibility of motherhood, smoked dope while my daughter napped, and carried on an affair with the elevator man in our Westside apartment. I divorced again and moved the elevator man inside. When I tired of him, he extorted my mother and stepfather at gunpoint, threatening to harm my daughter if they didn't hand over $5,000.

When he got out of prison he terrorized me. I moved to Los Angeles to try to figure out how an intelligent woman from a nice Jewish family, with a master's degree in social work, ended up running up 72nd Street in the middle of the night being chased by her ex-lover wielding a broken beer bottle and screaming, "I'll run you out of New York,

bitch." I had been so smug, so sure I was right; only I could see beneath the surface of his street self to his shining soul!

When it was all over the only "I told you so" from my mother was a plaintive query: "Harriet, where were your instincts?" I was stumped and committed myself to look for answers. I read all the relationship and codependency books, listened to countless tapes, signed up for lots of self-help seminars, flirted with Eastern mysticism, meditation, and yoga, kept journals, and mostly avoided romantic relationships.

Ironically, the relationship that caused me to hit bottom wasn't ever romantic. It was business. Once again I had followed a pied piper who seduced me with flattery and the promise of riches if I would leave my career and come to work for him in the real estate seminar business, selling "blue sky" to "hopies and dreamies" who would pay their money to us and never make a dime back. Al was a con man who taught me how to sell sizzle, scam banks with snootiness, rape homes of their equity, and cheat the legal system of judgments against him. He was giving everybody the finger, and I applauded him as Robin Hood until he did it to me. When the money started rolling in and I suggested that maybe I should get some of it, he found reason to fire me, leaving me homeless, penniless, and hopeless in Mission Viejo, California. I was forty-five, my only daughter was leaving for college, and I had no reason to live.

A close friend sensed that I'd hit bottom and put a business card in my hand. "Call this lady before you check out," she said. The card read: "Expect a Miracle: Janet Levy, Science of Mind Practitioner." Her Jewish last name reassured me, made me curious, and I called.

"What is it you want, dear? Why are you here?"

"That's my problem. I don't know what I want. Part of me wants one thing, the other part wants a different thing. *I* know what I want: I want to know what I want."

"Do you pray, my dear?"

"You must be kidding! I'm Jewish, I'm an intellectual, an atheist."

"Take my hand, Harriet. I'm going to pray for you: 'Father of the universe, take this woman by the hand and guide her to her rightful work. She knows she wants to do something meaningful, and she doesn't know what it is.' That's it, my dear. Now you pay attention."

Pay attention to what, I wondered. The answer came swiftly. A few days later I was reading the help wanted ads in the *Los Angeles Times* and was drawn to the smallest listing in the social work section: "Person of Jewish background and culture to visit Jewish prisoners." The hairs on both arms stood up. "Oh my God, that's it—that's me. It worked!"

I made a conscious, rational decision to see it as divine guidance, not coincidence. That decision changed everything. It gave force to a belief in a benevolent divine intelligence, an inner guidance system, a GPS for the soul that challenged the voice that said, "Why bother?" "Nothing matters," "What's the point?" and "Who are you kidding, anyway?" Although I couldn't call it God (yet), I recognized it as faith and realized that I had always had it, but had put it into negativity and despair. I redirected my faith to divine meaning and purpose.

I became a Jewish jail lady, visiting Jewish inmates in county jails and state and federal prisons. I was hooked by the end of my first day on the job. My first client could have been me, except that we were on opposite sides of the glass: she wore an orange jumpsuit and handcuffs, and I wore a suit and carried a briefcase.

She was my age, a Hunter College graduate and high school English teacher. She had a daughter, the same age as my daughter. Her husband had returned from Vietnam addicted to heroin. Eventually she joined him, at first only on weekends, until she, too, was hooked. When she lost her job, she started selling heroin to support their habits and their overhead. This was her first arrest. I knew that, but for the grace of God, our roles could have been reversed. I knew that the line between "them" and "us" was

an illusion. *They* are us. We are *them*. I found a story that defined me and my mission.

A great rabbi's disciples once asked how he could so readily understand the problems of gamblers and thieves and other troubled men and women who came from the darker places of life. The rabbi explained, "When they come, I listen hard to them. I look deep into their eyes, and I discover that their weaknesses are reflections of my own. It is not that I have done what they have done, but I sense within me their lusts, desires, weaknesses, temptations, and *machshavoth raoth*—evil thoughts. I find, in them, myself." The rabbi continued, "Once there was a man who came to me with confessions of his transgressions, and though I listened attentively I could find nothing whatsoever that I had in common with him. There was nothing of his sins that were in me. Then I knew the truth: I must be hiding something within myself of which I was not fully conscious."

From this new perspective, each and every day I looked deeply into the fractured souls of good people who had done bad things and bad people who had done good things—people who knew right and did wrong, who had the best intentions and the worst actions. Most of them meant well, yet they bit the hands that fed them, broke the hearts of those who loved them, and swindled the souls of those who trusted them. It was as if two distinct and warring factions lived within one body.

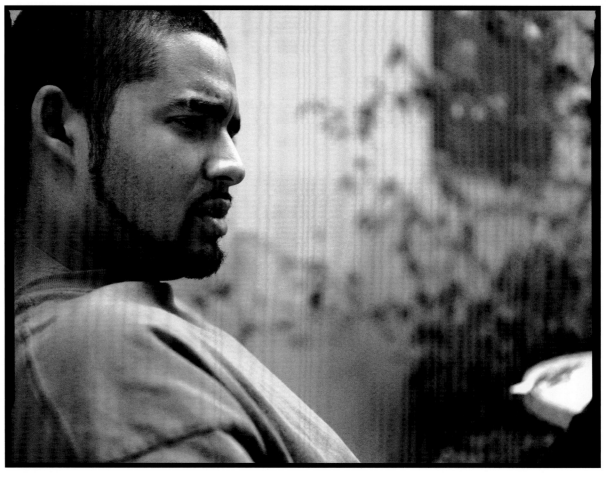

Beit T'Shuvah client Yesiah

I became acutely aware of my own incongruities as I struggled to balance within myself the extremes of good and evil I was witnessing. Where and what was the connection between intention and action? Was there an invisible spiritual corpus callosum that was supposed to unify our opposing parts so that we walked our talk? Or as Maimonides taught, "What's in our hearts should be on our lips." Was that the job of the soul? Did addicts not have one, or was it broken? Could it be mended? Were these broken people I was looking deeply into a mirror of the dark places lurking in all of us?

I recognized shards of myself in the lovesick women who followed their boyfriends into drugs, crime, or prison. Hadn't I fallen in love with the elevator man in my building, excited that he sold drugs and carried a gun? Among the women I visited was a grandmother who scammed a bank out of $300,000 to buy Ronald Reagan's house so she could leave it to her grandchildren and, at another time, a woman who abandoned her children for crack cocaine or left them alone all night while she gambled away the rent money. If thoughts of fraud or child abandonment were a crime, I'd be doing life without!

I was conning too, rebelling on the inside, conforming on the outside, passing as normal. How could I heal anyone else if I couldn't heal myself? I knew I would have to unify myself in order to reflect wholeness back to broken souls. I had to be able to contain their good and evil parts; to see *both* their pure souls and their treacherous actions and to be able to tolerate the ambiguity of my own love/hate emotions. This necessitated a paradigm shift from an either/or to a both/and perception of myself and others. *All* my relationships (including the one with myself) had been either/or: love *or* hate; deify *or* demonize; in *or* out of my life. I had been asking the wrong question about which was the real me; they were both the real me, and my job was to integrate them. Being a human being, endowed with the free will to choose between the will of self and

the will of God, was *the* inescapable spiritual challenge for all of us!

Epiphanies quickly evaporate; realizations don't bring results. I had to find a path to wholeness that I could follow. For me there was no quick fix, one-size-fits-all answer. My search took me to metaphysics, Twelve Steps, Jungian shadow work, Buddhist psychology, and Jewish wisdom. The spiritual principles they all share, which inform my inner life, are simple but they ain't easy:

I am imperfect by design: I will err.

I matter.

I have a holy soul.

My value is a birthright; it is not conditional or comparative.

I am obligated to find my unique purpose and to live authentically.

I can choose to be guided by principles, not personalities.

I can and must choose right action no matter what I feel or think.

I was a Jew by birth, and I have become a Jew by choice. The Judaism I practice is the construction of an inner life rooted in Jewish principles that allows me to maintain my outer life. I call it "mindful Judaism."

Yisrael (or *Israel*) literally means "he who wrestles with God." I understand this as a moment-to-moment struggle to do the next right thing when you don't want to, to act yourself into right thinking and feeling, and to balance the urgings of *yetzer ha-tov* (good inclination) and *yetzer ha-ra* (evil inclination).

I fell in love with Judaism's resolution of the paradox of good and evil. The rabbis taught that both come from God: God is One and therefore the "good inclination is good, and the evil inclination is *very* good." Accepting that all human traits are godly if they are expressed in proper measure relieved me of my secret shame, and I have witnessed the relief other people feel when they internalize this concept.

I was excited to learn about *t'shuvah*, the process of redemption, in an article by Rabbi Dr. Abe Twerski on Judaism and the Twelve Steps. God knew that his human creation—part animal and part angel, endowed with free will—would continually sin (miss the mark) and would need a path back to wholeness. The Jewish mystics believed God put t'shuvah into the world before the creation of man as an act of merciful recognition of human imperfection. I was hearing from lots of Jews in jail that they didn't go to Alcoholics Anonymous because it was Christian and you had to say the Lord's Prayer. Rabbi Dr. Abe Twerski, both a respected psychiatrist and an Orthodox rabbi, found references in Torah for all the Alcoholics Anonymous steps and principles, making it kosher for Jews. When I realized that the steps of Alcoholics Anonymous were almost identical to the steps of t'shuvah, I began to envision a home for Jewish men and women coming out of prison where they could make t'shuvah: admit their wrongdoing, make amends and restitution, and plan how not to reoffend, to make different choices.

"Find a need and fill it," I heard somewhere. The need was clear. I kept seeing the same people return to jail. The recidivism rate was 90 percent. Almost every one of them had sworn to me they would never go back to that miserable, dehumanizing place. A few of them had even shown up at my office the day they were freed, looking for a bed for the night. They were released with nothing—no money, no clothes, no car, no phone, no hope. No wonder they were "in the spoon by noon." I became as frustrated as they were as I called agency after agency who couldn't get me a bed for the night until I submitted a long-term treatment plan for the client.

I knew that this was the need I had been called to fill. I would start my own place, a homeless shelter for men and women coming out of jails and prisons. It would be a Jewish home, based on love and learning, where wounded people could heal their broken souls and reconnect with their families,

themselves, and God. It would be a place of integration, of Twelve Steps, Judaism, and psychotherapy, a place where they could learn to integrate the opposing parts of themselves and to reassimilate into a meaningful life. I would call it Beit T'Shuvah—House of Return/Repentance.

Under the auspices of Gateways Hospital and Mental Health Center, I applied for and received a capital grant of $145,000 to buy an old house in downtown Los Angeles. I didn't know, and no one told me, that if the house were occupied I would have to pay the tenants to move. I had no budget for this, and the number of tenants with their hands out increased daily! I showed up there on Christmas day, 1985, and offered them two months of free rent. There was no money for staff or operations, so I moved in and opened the doors. Then three men moved in. The first week they stole my jewelry (and helped me look for it!).

Obviously love was not enough. What did I need? The universe sent "Monk," a bow-legged, fifty-something, bald ex-con who looked like Mr. Clean. "I just got out after twenty-nine years in the federal joint; ain't ever had a job in my life, but I ain't goin' back to die in one of those joints. Don't even have a Social Security Number." "This is your lucky day, Mr. Monk Levey, you've got a job and a home. You are the resident manager of Beit T'Shuvah."

I was on a God high; whatever I needed appeared. Emboldened by success, I placed an ad in the *Los Angeles Times*: "Looking for a needle-in-a-haystack. Rabbi/social worker needed for halfway house." A letter arrived two days later: "Dear Madam, I am your needle." He was perfect: an ordained, MSW, kabbalistic Tevye. (Remember *Fiddler on the Roof*? Down to the Greek fisherman's cap!) I hired him on the spot. Small items started disappearing from residents' rooms. They accused each other until the rabbi was discovered in the women's dorm, taking toothpaste and underwear. I said to myself, "Very funny, God, sending a kleptomaniac rabbi to a halfway house for Jewish

criminals!" That was my lesson in the difference between magical and mystical. I needed to learn that things are not always what they seem to be and that the healers are also wounded. (I also needed to check references.)

I was then to meet the man who would ultimately become the rabbi of Beit T'Shuvah and continue on as such for the next twenty years. At the time, I was summoned to meet the inmate congregation at Chino State Prison for Men so they could tell me how to run Beit T'Shuvah. A convict named Mark Borovitz, the congregation's leader, their spokesperson, *and* the prison rabbi's clerk, was the most arrogant of the bunch! "Okay, smart-ass," I told him on my way out, "if you know so much, come and help me when you get out."

In November 1988, six months after we first met, he showed up at my front door. "I'm here to help," he said. He wooed me with his passion for my mission and for Judaism. Together we found Rabbi Jonathan Omer-man and the Jewish wisdom/ mystical tradition. We connected with one another via each of our personal covenantal relationships with God. Our covenant authorizes God to be the arbiter when conflicts arise. We married two years later and wrote our own vows, promising never to use our vulnerabilities against one another. Without God and a shared mission, I would never have been able to manage the challenge of being boss, wife, and "older woman" to a man of intense passions and not-always-intelligent emotions who has been described by his rabbi as a modern-day prophet and evangelical Jew. Mark was ordained by the University of Judaism in 2000. He is my spiritual partner and the coparent of Beit T'Shuvah. Together we have healed ourselves and helped to heal one another as we minister to recovering addicts of all kinds, their heartbroken families, and other lost souls, sharing our spiritual path with them. We have built and sustained a spiritual, faith-based community where miraculous transformations occur regularly.

The program was officially recognized by the White House Office of Faith-Based Community Initiatives. We are carrying our message of mindful Judaism to teens and their families in Jewish communities locally and nationally as protection against addictions and other self-defeating and self-destructive behaviors.

> I matter.
> You matter.
> I am not how I look or who likes me or what
> I own.
> My worth is intrinsic, not conditional or
> comparative.
> Perfection is a myth.
> T'shuvah is the path to wholeness.

Personally, no one has benefited from Beit T'Shuvah more than I have. I have found *shalem* (wholeness) through understanding the Jewish teaching that positive and negative inclinations both come from God. I have found a man who completes my soul and embraces my mission. I honor my commitments to myself and others. And I have found the place where I fit; I am proud to have been dubbed "Queen of the Misfits."

Harriet Rosetto is a licensed clinical social worker and the founder and director of Beit T'Shuvah in Los Angeles. She is blessed to have found her life's purpose and to share love and work with her husband, Mark Borovitz.

dear children

Please watch over your **dear children**.

Keep us safe in your arms.

Hold us close . . .

Until that day **when we see you face** to face.

In Jesus' name I pray, amen.

—ASIA, TEVISTON HOUSE OF PRAYER

when we see you face

Cham Muslims A Marginalized Minority within a Minority

BY AMIR HUSSAIN, PHD

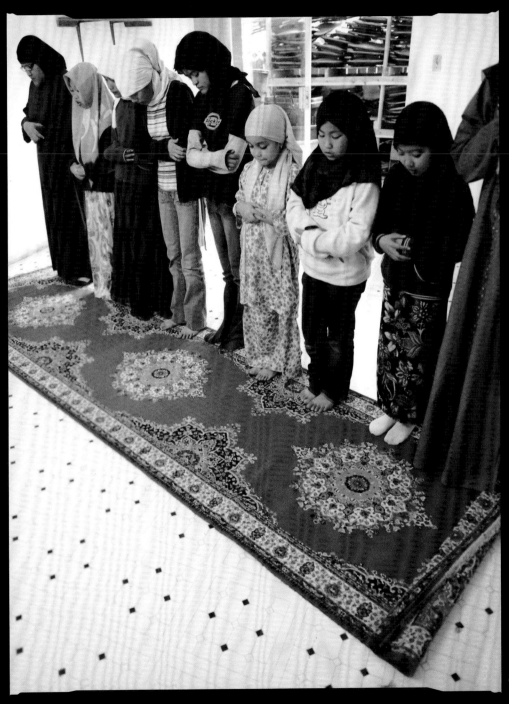

*Cham girls pray
at Sunday school*

Setting The Stage: The OC

WHEN MEASURED GEOGRAPHICALLY, ORANGE County is one of the smaller counties of the fifty-eight that make up California and the smallest county in Southern California. In terms of population, however, it is either the second or third largest behind Los Angeles and San Diego County (according to State of California Census 2000 or 2008 estimates, respectively). Think to yourself: What is the first image that comes to mind if you hear the words *Orange County*? An image of white, wealthy, irresponsible young adults from *The OC*, the popular television show that ran from 2003 to 2007? Or white, wealthy, irresponsible young adults from *Laguna Beach: The Real Orange County*, the reality show on MTV? Perhaps it was an image of white, wealthy, irresponsible young adults from *The Hills*, the spin-off from *Laguna Beach*? Or perhaps it was another one of the many fictional representations that are available on film and television?

In truth, the realities of Orange County are quite different from the stereotypes put across through popular culture. While almost two-thirds of Orange County is white, there is also a large Asian community that is usually not represented in media portrayals of "The OC." Indeed, Little Saigon (located in Westminster and Garden Grove) has the largest concentration of Vietnamese outside of Vietnam. And while the median family income in the county is over $75,000, some 10 percent of the population live below the poverty line (according to the 2006 American Community Survey of the U.S. Census).

In imagining local religious communities here, one usually pictures large Christian churches or ministries. These are certainly found in Orange County, which hosts, for example, the Crystal Cathedral (Garden Grove), Saddleback Church (Lake Forest), and the Trinity Broadcasting Network (Costa Mesa). In contrast to the stereotype, two of the largest Islamic centers in the United States are also located in the county, the Shi'a Islamic Educational Center of Orange County (Costa Mesa) and the Sunni Islamic Society of Orange County (Garden Grove). One group that almost no one identifies are Cham Muslims. They have a small but thriving working-class community in the county seat of Santa Ana. How many of you named these Indo-Chinese Muslims as your first image of Orange County? How many were even aware of their existence and could identify them as part of the religious life of Orange County? There is little doubt they fall squarely within the rubric of Rick Nahmias' photo essay. This essay examines their position as a marginalized community within the minority community of America's Muslims: a group doubly marginalized by ethnicity and class, one that is truly "disinherited."

The Cham in History

Since the story of the Cham is unfamiliar to most Americans, I begin with a brief historical sketch. Philip Taylor (2007) has written the standard introduction to the Cham people. They are descended from the Kingdom of Champa, which existed from the seventh to the fifteenth centuries in what is now Southern Vietnam. Little is known about the origins and early history of this kingdom, even among the Cham themselves. One member of the community whom I interviewed told me that "Cham as a country has been lost for five hundred and fifty years to the Vietnamese, so we know very little about our own history." What is certain is that they are a distinct ethnic group from Cambodians or Vietnamese. Their language is also known as Cham, and it is a unique language related to Malayan and Polynesian languages in Indonesia, Malaysia, and the Philippines.

Religiously, the kingdom was influenced by both Hinduism and Buddhism. At various times, the Cham rulers embraced Shaivite Hinduism and then Mahayana Buddhism as their religion. Wonderful objects still exist at the Cham Museum in Da Nang, Vietnam, from both traditions, including Shiva linga, Indian dancers carved in relief, and statues of the Buddha. One can also find some

of these objects at the My Son Temple complex in Vietnam, which has been designated by UNESCO as a World Heritage Site. Sadly, much of this temple complex was carpet bombed by the United States in 1969, one of the many casualties of the Vietnam War. (For deeper reading on the art of the Champa, Jean-Francois Hubert [2005] has written a marvelously illustrated book.)

By the tenth century, Islam had come to the Cham through Arab Muslim traders. The Cham became involved in both land trade along the Silk Road and maritime trade through Indo-China. Today, Sunni Islam is the defining characteristic of the Cham. Of this, Taylor (2007: 61) has written: "Of the varied forms of identification espoused by the Cham of the Mekong delta, none is of greater significance than Islam. A people who entertain notions of origins that are strikingly diverse, the Cham identify their faith resolutely in the singular. Islam is the single most important focus for organising space and time, structuring the shape of their settlements, and setting the pulse of local time."

Also in the tenth century, the Cham were in conflict with the Khmer from Cambodia and the Dai Viet from what would become Northern Vietnam. In 1471, the Dai Viet invaded, annexing the Cham and causing many to go into exile in Cambodia and Melaka. Thus began the marginalization of the Cham that would continue throughout their history. It was after this annexation that Cham royalty and citizens began to embrace Islam in greater numbers. By the time that all of the Kingdom of Champa was annexed in the nineteenth century, the majority of the Cham were Muslim.

The Cham were a rural people who lived in villages, fishing and farming in those villages located near rivers, farming and doing other work in those villages located inland (sometimes working as butchers for Buddhist communities where there were restrictions on who could or should slaughter animals). Today, the majority of the world's Cham live in Cambodia (about three hundred thousand) and Vietnam (about one hundred thousand), with a

small population in Malaysia (about ten thousand). There are approximately three thousand Cham in the United States.

The Killing Fields
When Marginalization Becomes Genocide

One cannot tell the story of the Cham without reference to the horror of the killing fields. The Khmer Rouge committed genocide in Cambodia from 1975 to 1979, with the Cham being one of the groups targeted for mass killing. Some may be familiar with this period through the 1984 film *The Killing Fields*, the name given to the areas where people were butchered and mass graves were located. The dictator, Pol Pot (Saloth Sar), wanted to return Cambodia to "Year Zero," a time of an imagined agrarian utopia to be inhabited solely by ethnically pure Khmer Communists. To accomplish this, the Khmer evacuated urban areas, including the capital of Phnom Penh. People were told to leave the cities and return to peasant life on the land. Starvation occurred, and rations were limited, turning food into a weapon. Anyone who was connected with the West was targeted: intellectuals (defined by having higher education or simply wearing glasses), undesirables (not unlike the Nazis' definition—for example, homosexuals or the disabled), Christians, Muslims, Buddhist monks, ethnic Chinese, Vietnamese, Laotians. Today, we would refer to the genocide as ethnic and religious cleansing. Estimates of the number killed vary widely—between eight hundred thousand and three million people—but the general consensus is that at least one million people were killed during this period of terror.

When the Khmer Rouge came to power, it was estimated that there were some quarter million Cham in Cambodia. The Cham were among those singled out by the Khmer Rouge as both an ethnic and a religious minority, despite the fact that as rural people they fit the "Year Zero" ideal. Again, there are no exact statistics, but the Cham estimate that some one hundred thousand were killed, starved to death,

Ismail at the apartment complex in Santa Ana that houses the Cham Muslim mosque

or died from disease by 1979. Of the genocide, Ben Kiernan (2001: 194) has written: "The worst to suffer were the Vietnamese minority (totally eliminated), the Chinese (half of them, about two hundred thousand people, perished), and the Muslim Chams, of whom about a third were killed."

In a chilling audio dialogue that is part of the *Golden States of Grace* project, Cham religious leader Brother Salim Ghazaly recounts watching five people die of starvation before his eyes, while he and the rest of his family were powerless to help. "But many other families were even worse [off]," he said, indicating the magnitude of the tragedy and the horror carried by the survivors.

How the Cham Came to Orange County

Some of the Cham were able to escape from the killing fields in the late seventies. They first fled west to Thailand, but had no idea of where they would go next. In 1976, the International Rescue Committee had begun to do work in Thailand, and some of the Cham were helped by them. The first priority for the refugees was to locate family members in the various refugee and displaced-person camps in Thailand. One can only imagine the turmoil of those times: thousands of people, many without a possession left to their names, desperately moving from camp to camp trying to find loved ones or simply glean word of whether family members were still alive.

Those who were given refugee status in the United States first came to Houston, Texas. From there, people settled in various areas, including one family that came to California in 1981. They reported back to their families, like countless other migrants before them who had journeyed to the Golden State, that the area was good and that the weather was better than in Houston. More people came, settling in Santa Ana, the seat of Orange County.

Today, the population of this community of Cham is between three and four hundred people. Though many of the working members are firmly ensconced in blue-collar professions, the community, through a zealous devotion to tithing, was eventually able to purchase two units in a fourplex condominium complex. They knocked down the common wall between the two apartments, creating enough space for a prayer hall. This is known as Masjid Noor ("the mosque of light") of Santa Ana and is the home of the Indo-Chinese Muslim Refugee Association. It is enlightening to note that the first community building established by the Cham was a mosque, a place of religious worship. In writing about the production of Cham localities in Southeast Asia, Taylor (2007: 84) concluded that "nowhere is the influence of Islam more evident than in the social construction of space. Islam provides the principles for the identification of Cham settlements and the organization of residence, education, and community authority. Islam is promoted as the exclusive basis for community affiliation, overriding familial- or neighborhood-based identifications." This is also the case for the Cham in Orange County. It is their common religion that binds together the group. The Cham community enjoys good relations with the other, more mainstream Muslim groups in the area, who helped them with the fundraising to purchase the condominium units described above.

Marginalization within a Minority

In an interview, Brother Salim Ghazaly described one of the important differences between the Cham and other immigrant Muslim communities in the area. The majority of American Muslims are immigrants or the children of immigrants, who came to America by choice to live out the American dream of a better life than was possible in their countries of origin. In addition, the majority of American Muslims are also professionals, who are as educated and as wealthy as any other well-to-do American group. A *Newsweek* cover story (July 30, 2007) on Islam in America highlighted a 2007 Pew survey, which found that 26 percent of American Muslims

had household incomes above \$75,000 (as compared to 28 percent of non-Muslims) and 24 percent of American Muslims had graduated from a university or done graduate studies (as compared to 25 percent of non-Muslims) (Pew 2007a).

By contrast, the Cham, who were rural farming people in Indo-China, are less educated and predominantly working class, arriving exclusively as refugees rather than as skilled immigrants. In this way, they are themselves minorities among the nation's Muslims, or a minority among a minority. The Cham are refugees with no country of their own to which they can return and consequently no country of origin to help them. As such, life for the Cham is difficult. They cope, as mentioned earlier, by identifying strongly with their religion, Islam. Many of us (and here I self-identify as an immigrant Muslim) who are American Muslims have numerous sources of aid. We can, of course, rely on God Almighty. However, if God does not provide for us, we can get help from family members, ethnic associations, or professional colleagues. For the Cham, there are no such "outs," only reliance on God and themselves. Thus their lived religion is crucial to them, while it may remain on the margins for other American Muslims. One sees among the Cham, for example, a high rate of ritual observances, including attendance at daily congregational prayers.

Life is also difficult for the Cham here because many American Muslims, like many Americans in general, have no idea of their existence. The Cham have no wealthy relations in their adopted country (or back in their homeland, for that matter) who can support them. Moreover, to American Muslims the concept of social services for members of their own community is relatively new. Palestinian Muslims receive support in Israel and in the Palestinian Territories, and Indian Muslims receive support in Gujarat. But American Muslim social service organizations have been in existence only since the mid-1990s. As such, American Muslims will give more readily to help Muslims around the world than in their own country. An

additional problem for the Cham is the usual immigrant refusal to acknowledge reality: immigrants do not want to admit to the host country the problems in their own community. One hope that the Cham have is that other American Muslims, and indeed other Americans, will become aware of them and be able to help them with both moral and financial support.

The Cham have a strong desire to assimilate into American society. According to Brother Salim, the Cham see themselves as American. He ended our interview by saying: "This is our home, and we want to succeed in it. There is no turning back." This assimilation is, of course, difficult for the immigrant generation of Cham. First, they are marginalized by their religion, which is negatively portrayed in American society. One sees this, for example, in a poll by the Pew Forum on Religion and Public Life following the terrorist attacks in London in July 2005. In that survey, 36 percent of Americans felt that Islam was more likely than other religions to encourage violence in its followers, while those holding unfavorable opinions of Islam increased slightly (from 34 percent to 36 percent between 2003 and 2005) (Pew 2007b). In 2006 the Council on American Islamic Relations (CAIR) recorded 1,972 civil rights complaints from American Muslims, up almost 30 percent from 2005 and the most ever recorded by CAIR in its twelve-year history (CAIR 2006). Also in 2006, a poll by the *Washington Post* and ABC News showed that 46 percent of Americans had negative views of Islam (up from 39 percent after the 9/11 attacks) (Deane and Fears 2006). Second, the Cham are marginalized by their status in the United States as an ethnic minority. Third, the Cham are marginalized linguistically. It's bad enough, to the American racist, that the Cham don't "look American," but what is perhaps worse is that they don't "sound American" (meaning, of course, that they may speak no English, may speak accented English, or—heaven forbid to those who still relish their Freedom Fries—may speak French). Fourth, they are marginalized by their working-class status,

Cham boys at the feast of Eid ul-Fitr

especially in places such as Orange County where conspicuous consumption is an accepted value.

As with other immigrants, some signs point to the possibility that the younger generation is in a different position. Sometimes, the young Cham who were born in the United States experience a greater degree of assimilation. They were born here, with no memory of any other home. They are educated here into American, and not foreign, cultural norms. They speak without the accents of their parents. However, sometimes it is precisely these markers of position that make their assimilation more difficult. They know the ideals of American society, but also have direct experience with its harsh reality. They are left to negotiate two different worlds:

Cham identity in the home, American identity in the school and workplace.

One hopes that eventually other Americans will see them in the way that they see themselves, as part of the tapestry of American religious life. One of the foundational myths of the United States was that it would be a country where hard-working immigrants would be welcomed. The Cham are this, of course, as well as survivors of a Communist genocide, thereby enveloped in a much more recent myth of the United States as the bastion in the struggle against Communism. They are "good Americans," representing the best face that the United States has to offer the world, a home for refugees that was once celebrated on the plaque at the base of the Statue of

Liberty with these words: "Give us your tired, your poor, your huddled masses yearning to breathe free, the wretched refuse of your teeming shore." The Cham, disinherited as they are, are as much a part of the OC as the spoiled children or wealthy housewives portrayed on television.

Amir Hussain is a professor in the Department of Theological Studies at Loyola Marymount University, where he teaches courses on Islam and world religions. His research focuses on contemporary Muslim communities in North America.

Works Cited

Council on American Islamic Relations (CAIR)
 2006 *The Status of Muslim Civil Rights in the United States, 2006: The Struggle for Equality.* http://www.cair.com/CivilRights/CivilRightsReports/2006Report.aspx.

Deane, C., and D. Fears
 2006 "Negative Perception of Islam Increasing." *Washington Post*, March 9. http://www.washingtonpost.com/wp-dyn/content/article/2006/03/08/AR2006030802221.html.

Hubert, Jean-Francois
 2005 *The Art of Champa.* Bournemouth: Parkstone Press.

Kiernan, Ben.
 2001 "Myth, Nationalism, and Genocide." *Journal of Genocide Research* 3 (2): 187–206.

Pew Forum on Religion and Public Life
 2007a http://pewresearch.org/assets/pdf/muslim-americans.pdf.
 2007b http://people-press.org/report/358/public-expresses-mixed-views-of-islam-mormonism.

Taylor, Philip
 2007 *Cham Muslims of the Mekong Delta: Place and Mobility in the Cosmopolitan Periphery.* Honolulu: University of Hawai'i Press.

true compassion

May we all live long enough
to become wise enough to understand **true compassion**
towards all life.

—KAN SHIN MITSU KO (MAC),
BUDDHADHARMA SANGHA

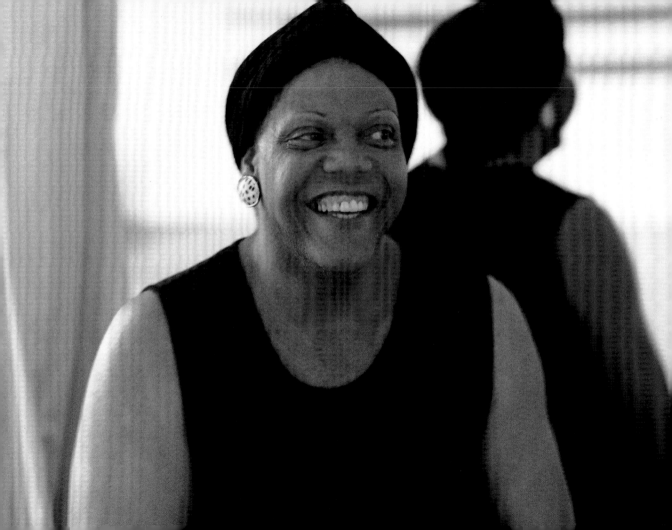

HOW DO YOU REMAIN PRESENT IN A WORLD that doesn't want you to be present at all? How do you know that you have meaning? That you have worth? That you're okay whether you've painted yourself and are looking fabulous or you haven't shaved and have stubble on your face? That you are okay in whatever guise you are, whether you're a transgender person or not?

It's a blessing to be a transgender person, a marvel to be somebody who can look like and identify with lifestyles on both sides of the fence, to be able to understand the maleness and femaleness of everybody, to appreciate the contradictions. For me, being transgender helped me discover my unique relationship to humankind and to my God.

Sorting out how I fit in with spirituality and reconciling my relationship to God with my identity as a transgender woman has been a slow process. I grew up Catholic, which meant that Sunday was the time to dress up and go to church and make amends for the havoc that I had caused during the past week. But for me it was aggravating because it was like going to the gym: *kneel, stand, bow, curtsy, sing, kneel, stand*. I didn't need to go somewhere on Sunday in my best clothes and then do a workout. But that aside, it gave me a jumping-off place from which to discover my own relationship to God, spirituality, and religion.

Growing up, I always felt different. I always wanted things I wasn't allowed to have: dolls, jewelry, gloves, fragrance. This was the early fifties, and I had no name for how I felt, no explanation for my attraction to boys and the feeling it gave me. The Catholic Church was the first place I witnessed homosexual activity. Hearing from a fellow altar boy about the moves made on him by our priests excited me. I tried to get them to want me, but to no avail.

Easter was a hard holiday for me when I was growing up. My mother always bought my sister a new dress, new purse, cute little white shoes, white socks, and a bonnet. I got a little three-piece suit and a hat. (Oh how I wanted the little dress with the purse and those little shoes!) The holiday was transformed for me on Easter eve 1959. I snuck away from my family's home on the South Side of Chicago and headed over to my friend's house. An old drag queen named Damon dressed me up right. She had me in stiletto heels, a sheath dress in a light color, lion's mane full wig in mixed blond. When she finished with me two and half hours later, I looked into her full-length mirror and began to cry. I was absolutely beautiful. I was firing on all cylinders. (Before this, my friends who used to help me go in drag dressed me in flat shoes, flat hair, bangs too short, harsh makeup, and a dress that made me look like I was part of a wall.) This time, as I stared into my reflection, I found me. And I never looked back.

Early in my transition, it was very hard to find the hormones and the doctors to help turn this little boy into the woman of my mind, heart, and soul. There was a black market for female hormones located in an amusement park called Riverside Park. Someone had to introduce you to the person selling the hormones, and if they liked you, they would let you make the purchase. They had different types of pills and a liquid hormone that came from Europe.

Slowly, very slowly, the hormones helped you feel like the woman you felt inside. Like Marilyn Monroe or Dorothy Dandridge (with a dick). It was not a simple thing in the fifties and sixties to find others who were of your ilk and wanted to be different from their sex at birth. At first I felt like a drag queen, but then I realized my desire was to be in a dress all day long. I wanted to work, live, and love as a woman. I wanted to be the first black Christine Jorgensen. Soon it was on and kicking: the hunt for doctors, for friends and a social life, for places to dress and feel safe outside of performing onstage as a drag queen. Once I started dressing as a woman in public, the reality of putting my life at risk with each step I took away from the safety of my home came into focus.

As transgender people, we have a unique existence. There's a part of us that bonds with the

cosmos, and in return the universe looks out for us. I'm not saying that it always keeps us safe and that people don't beat us up or kill us. I think that having something to believe in outside of ourselves can help us get through the stuff that we have absolutely no control over. It's not because of us that this is happening—it's because of the rest of the world's attitude about us. As a sixty-plus-year-old transgendered male-to-female woman in this world today, I have experienced some amazing things that I would never have expected back in my youth, when I was trying to sort out who I was, what I wanted, and who I wanted. It was really, really difficult. I think the greatest success is that I have remained relatively stable through all the ups and downs and horrors life has thrown my way. I've somehow been able to deal with it all. I've been able to believe in myself and tell myself that everything has a purpose, that I'm here and I'm a benefit to *somebody*, whether I know that person or not or how I'm a benefit to them. One of the things that got me through tough times was realizing that God helped me be here and so I figure he'll help me get through being here.

My parents expected my cross-dressing and lifestyle to be a phase, hoping it would end soon. My aunts and uncles behaved as if my mother and father had no firstborn. No me. My beloved sister, before her death, loved and hated me, and that was okay with me; that's just the way she was. I loved her tremendously.

I feel completely blessed to have a family. I never thought that I'd be allowed to raise children because of the fear that people have of transgender folks. However, God let me have a son, a healthy, strong, big boy. And I was able to parent seven other boys—foster children, runaway kids, and friends of my son's. My parents were not happy over the news of my parenthood. They thought I was the spawn of the devil and God shouldn't have let me become a parent to any living thing, from a dog to a child. My son's mother and I separated early in his life, and I was blessed that she decided I could raise my son alone. How great and exciting

the experience of being a parent to my son was, how marvelously challenging. Some folks were real cool with us; others were not so kind. At this time in the 1970s, there were not many single dads parenting alone—and then, adding to that, I had a beard, boobs, and balls. Acceptance and tolerance were hard to find.

In having a child, I found the key was to be open and honest with him and with myself. Not to hide who or what I was. I answered all of his questions about me in a vocabulary that he could understand. He has always loved me as his father and calls me Dad, no matter what my attire. Some of my other kids felt more comfortable calling me Mom, and I was fine with whatever they felt comfortable with. I have always felt good about my relationship with my son, Christopher. I felt blessed in the protection that seemed to surround him and me. Society didn't approve, and in a couple of cities—San Francisco and Denver—they tried to separate me from my children. But, thanks to God's hand, the system saw fit to leave my children with me. It was a pain-filled journey, but God gave me the strength to get through it and get my children back. I have a large chosen family and am blessed to be an elder transgender woman with children, grandchildren, and great-grandchildren.

Being a transgender person alters our perception of things, as if we're looking at the world through tinted glasses. So the things everyone else sees, we see in a different color. We see it for all the different things it could be, rather than only the way it's presented on the surface. It gives us a perspective that is unique. To our community, the world and the things that go on around us are exciting and wonderful to wake up to every day, being who we are. And at the same time, it is hard and scary because we can leave our home and never know if we're going make it back safely; someone can see us out doing our thing, trying to live our lives, decide that we should not have a life to live, and take it from us. It's scary to live like that every day, and if not for the feeling there is a God, sometimes you wonder

why do it. Being transgender isn't something that people just pick out of the clear blue sky and go, "Oh, well, let me do this." You become transgender because you need to, because that is who God made you to be.

When we tell our families who we are and where we're headed, the first place they immediately run to is the Bible. And it's amazing that they don't take the time to realize that there are transgender folks in the Bible:

> To the eunuchs who keep my Sabbaths, who choose what pleases me and hold fast to my covenant—to them I will give within my temple and its walls a memorial and a name better than sons and daughters; I will give them an everlasting name that will not be cut off.
>
> Isaiah 56:4
> (see also: Matthew 19:11–13, Acts 8:26)

There have been people like us since the beginning of time. If Adam and Eve were the very first two people on this earth, then they had to have had a lot of damn kids, and you can't tell me that out of all those children one wasn't a transgender person or that someone didn't feel as if they were born in the wrong body and then attempted to do something about it.

In this world, most churches condemn transgender people. How dare we want to be who we are instead of who we were born as? People rarely take the time to realize that what you're *born as* is a physical thing and who you *are* is a spiritual and emotional thing. And sometimes they don't line up nicely like things on a slot machine: *apple apple apple*. Sometimes it's *apple banana strawberry*. But you can still win. It may not kick out the big prize, but you can still get something.

This isn't something that just washes over us and then disappears. I remember in my youth my parents told me, "Well, that's fine for right now, you'll grow out of this." Well, I'm sixty-something years old . . . and I'm still waiting to grow out of it.

And I'm not the only one. There's a world full of people who feel and think and believe as I do. I'm not the one in a million; I'm just one of a million. And there's a comfort in that, there's a security in that. I'd like to feel as if we could exist and be who we are comfortably in the world, not be the object of ridicule, not be these things that folks want to pounce on and destroy.

I am antireligion in the sense that I feel it's absurd that each religion feels as if they're the "right" religion, the only ones getting into heaven. I think that's a fallacy that folks are holding onto because they want to rule the world from that viewpoint. You say you're right and everyone else is wrong long enough, and eventually people believe you. But the whole point of spirituality is there's an interconnection between people and other beings. Whether you believe that we all came from Adam and Eve or from two amoebas, we're all a part of one another—there's an interlinking that we can't see but if you let yourself, you can feel it.

One of the hardest things that we fight in being transgender is not so much a belief in a God but being able to accept ourselves. Everybody's telling you that God hates you, that you're an abomination, that you shouldn't exist. That's the best way that they can get at you, through words—harmful, damaging words that stay with you. You'll heal from getting beat up, but you'll never forget what they've said. In going through that, it becomes hard to realize that, yes, God gave me life, and, yes, I'm still breathing. The only thing that you can do in the face of this adversity is live your life, enjoy your life, be the best person that you can be, do what you need to do to survive. When the dust settles, transgender people can stand up and say, "I'm still here. I haven't gone anywhere. You all have not erased me." That can be a comfort and can give you some peace of mind. That can make things better, really better.

I am a member of Transcendence, the first all-transgender gospel choir. It is a wonderful and marvelous thing that a bunch of us have banded

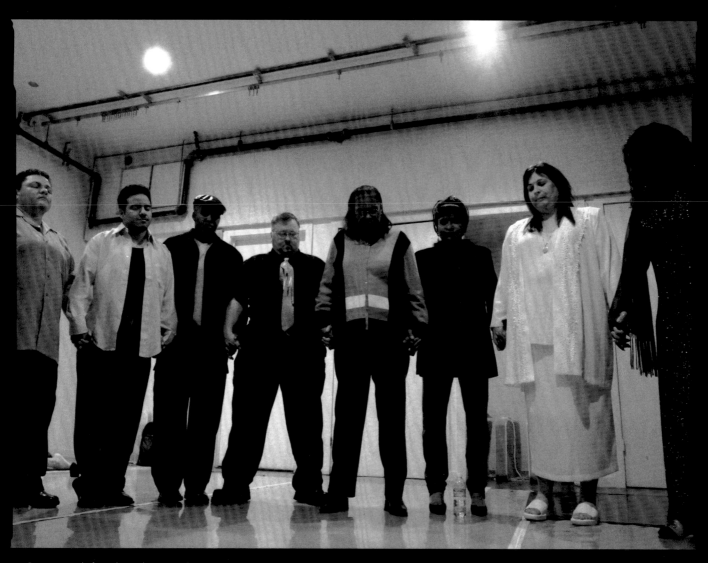

Group prayer before rehearsal, Transcendence

together to let the world know that not only can we believe in God, but God believes in us. It's been an interesting journey being in the choir, going places and singing, watching folks' attitudes about us change once they hear the faith and the heart in our voices, the uniqueness of our sound. The marvelous and multiple ways we represent. It makes me feel safer, gives me comfort, makes me feel more a part of what's going on, part of a wonderful and long-lasting journey.

I think that if folks took the time to think about it, they would see that God would have to be a transgendered person, because the Bible says that in his image, God made man. That's a great thought, so God is man and God is woman. In thinking that God is transgender, it makes me feel that people should accept their duality—both their maleness and their femaleness. I wish people could accept that. Accepting the duality, not hating people whose form of expression is different than what yours would be.

One of the things that I remember reading while I was in prison—when I was going through all my religious fervor, trying to figure out what was going on in the world—was about an American Indian religion that had a god for everything: for trees and flowers and rocks and the sun and rain. That is such a wonderful thing to think about—that every form of life, even the most minute, has something that's looking out for it, caring for it, keeping it going, making it real. It is devastating that American Indians were killed or forced to assimilate and that we've lost that perspective to a perspective of one god, one religion, one people, one sexuality. Maybe through transgender people we can work on getting some of that back, finding the security in knowing that there are multiple points of view. We can have variances. We can live with interpretations. There is no one set way to go into our next existence and be safe.

We're a wonderful representation of what humankind is, what it can be, regardless of how rough it appears. Once you start to explore and discover yourself, there's a certain serenity that comes over you in being the transgender person that you need to be. A certain safety. And it's safe not so much in physicality but safe in your soul. Safe in your love of God and his love of you.

We all know from the moment we're born, we start dying. As you get older it isn't a matter of realizing that you started dying; you simply can see it so it becomes about making yourself secure and safe in your existence and sorting out best how to do that. Getting older has made me think more about God. How to atone for things I've done wrong. Where I've come from, where I'm going. Until I'm no longer here and then maybe the thought of me or something I've said or done will help someone deal with the bullshit they have to go through in their life and will help make it better.

Today, I thank God that I've made it long enough to see and enjoy the new freedom (although limited) of the younger transgender girls and boys of today. Information can be found everywhere, on the Internet, at meetings, through friends you meet on the street. There's information about what doctors are good, what doctors to avoid, the cities you can live in and socialize in in your desired dress. It is a miracle to see and be a part of this new millennium. Even with the dangers still present, still lurking, still alive, seeking to destroy us, this society is better than it used to be. Communities are improving. Churches are letting us in to become members and ministers. They are now acknowledging that God loves transgendered people too. That God made us and we are his children. He has created a new day. I hope to spread his word and let people know it's okay to love us—we are God's children, and he blesses our existence.

Miss Major is the eldest member of Transcendence Gospel Choir. She fights for the human rights of transgender women of color inside and outside of prison and is the mother, father, grandmother to many.

all things are possible

My Heavenly Father,

I look forward to a time when there will be peace throughout the earth.

When no one will have to ask how are you doing,

 because sickness will be no more.

When there will be plenty of grain upon the mountaintops for all to eat.

When the color of one's skin won't matter.

When all will live together in unity.

My dear God, through your son Jesus Christ **all things are possible**.

Amen.

—GLYNNIS,
WOMEN OF WISDOM

A Prisoner's Quest for Grace *An Oral History*

BY VINCENT JINRYU EISHU RUSSO

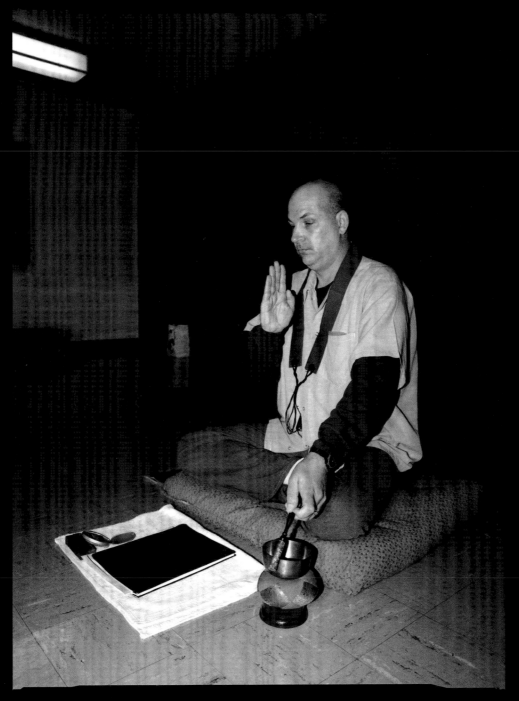

Vincent,
Buddhadharma
Sangha

EACH OF US IN LIFE EXPERIENCES SUFFERING and many obstacles. My life experience of incarceration is not much different from the experiences of the "free" people I practice with each week. Because when one deeply penetrates our essence, we are all human beings.

In looking back into the past, I now understand that at a young age, I had learned to stuff my feelings of alienation, fear, and loneliness. Some of this was due to a father who brought the Korean War home with him and who was trying to do his best without the proper tools to deal with his own pain and fear.

As I grew older, I continued to stuff these feelings, using drinking and other substance abuse to numb myself. I was looking for something, yet could not readily find it. In my search, I began to look outside of myself and toward concepts of permanence, love, and other materialism to make my life complete. On December 22, 1978, I walked into a liquor store armed with a gun. I robbed the store; moved Scott, the store's clerk, from inside the store; and once far enough away I shot him at point-blank range five times. The ripple of each bullet as it penetrated Scott was the beginning of one more ripple of violence in society. That night I ended Scott's dreams for a peaceful and productive life. I caused suffering, not only to him, but to his family and friends, to the town he lived in, to my family and friends, and to countless others. This suffering continues to cascade into the future. The effects of my crime can fill pages.

Instead of taking responsibility and turning myself in to the Marine Corps, where I served as a sergeant and military instructor, I fled with Ann, my partner, and Elizabeth, my one-and-a-half-year-old daughter. On that day, a shift occurred and change began. The very foundation of my spirit had been shaken. This epiphany came because of my face-to-face encounter with the violence that I had so long promised to myself I would never perpetrate; within two years, the stuffing of problems ended. Over the next six years, while on the run, I learned to reconnect with and appreciate life. As I watched my children grow, they touched my heart and my own humanity was awakened.

In 1985, I was finally arrested and sentenced to Folsom State Prison. While in county jail, someone was chanting, and when I inquired he told me he was a practicing Buddhist. This was the first time I read a Buddhist sutra—the original teachings of the Buddha.

Folsom State Prison was a place where fear, anger, hurt, and loneliness were the norm. I have never witnessed so much violence and inhumanity. My first clue that Folsom was a hellhole: we were told to sit on a bench, an individual next to me stood up, and I instantly heard the familiar sound of a round being chambered into a rifle. Looking up, I saw a correctional officer on a walkway above, at the ready. Welcome to Folsom.

What was the value of a human life in prison? One day on the yard, an individual was stabbed. Instantly the whistles began, everyone dropped to the ground, a gurney appeared, the victim was laid upon the gurney, and the person accused of stabbing him was handcuffed and removed. Once both had cleared the yard, a correctional officer on a catwalk yelled, "Play ball!" and everyone returned to what they were doing. A few weeks later, the man in the next cell was stabbed over one hundred times. He was transported to an outside hospital and died two months later. These were uneasy times in life. I would often sit in my cell, facing a wall, hiding my feelings, dreaming about the perfect life, the house with the picket fence, the new car, and the cat, but instead, in my day-to-day reality, all that I saw was a hell realm.

Years later, in 1990, an individual who had just received a statue of Amida Buddha asked me to practice with him. Although I refused, he lent me several books; one was about meditation. Meditation at this time was the latest craze in prison, and one day I decided to try it. While working at the Volunteers of Vacaville, a program that repairs Braille writers and transcribes books onto tape for

the visually impaired, I shut the door to the shop and sat down on the floor, crossed my legs, and for the first time prepared to meditate, setting my watch for five minutes. After what seemed like an eternity, I stopped . . . my mind was racing . . . it was too uncomfortable. When I checked the clock, less than two minutes had passed. Exhausted mentally, I decided it was time for lunch; this practice of meditation was just too much effort. I then walked into the break room, where my lunch had been moved. Immediately, I confronted the person responsible for moving my lunch. A little while later, a light went on: if I could not sit with myself, how could I ever be with others? This was the beginning of change. From then on, I began to sit every day.

Unfortunately, as time went on, instead of letting go of my ego, I learned to compartmentalize it. When I did not meditate, everything went bad. When I did, I felt like a bubble had been created, something separating me from everyone else. Later, while writing to an advisor at Zen Mountain Monastery, I was able to see just how self-centered this way of thinking truly was. Practice is opening up and being with the experience, not sheltering oneself from it. This was to be learned only in time.

In 1997, I arrived at San Quentin hoping to find a meditation practice. Unfortunately, none existed. Gathering a few like-minded individuals, I wrote a proposal to the Buddhist Peace Fellowship. After much effort and planning, on September 5, 1999, the Buddhadharma Sangha of San Quentin had its first dharma talk. Seido Eishu Lee de Barros, a dharma teacher in the Shunryu Suzuki Zen lineage, became San Quentin's first Buddhist volunteer coordinator.

Under Seido's tutelage, the sangha members have continued to grow both spiritually and personally. San Quentin's Buddhadharma Sangha was created so that like-minded individuals would have a safe and peaceful place to practice. Each person would have access to a meditation teacher, who could help in the practice of clearing one's mind. Unlike the larger religious groups at San Quentin, we use

space borrowed from both the Jewish and Muslim communities. Each Sunday we sit as a community. This community is unique because we stress the importance of keeping your own religious practice. We do not want more Buddhists, just more Buddhas. I like to think that each person who enters is a broken wheel, and through self-inquiry and the practice of meditation, each person can return to their own true, pure, luminescent state. Those who practice have a willingness to change. Our community is here for only one purpose: to allow any individual who wishes to practice meditation that opportunity. All one has to do is make a conscious choice to cross the door's threshold each week and work on one's own stuff. What happens eventually is a desire to end the cycle of pain and suffering in one's life and in the lives of others.

On February 24, 2002, San Quentin held its first *jukai* (lay ordination) ceremony. Six men requested to follow Buddha's precepts. In September 2008, six more men also requested jukai. This is change. What is unique about San Quentin's sangha is that men of all beliefs and religious traditions—atheists, Christians, Druids, and Muslims—sit and practice together. In 2006, San Quentin held its first *ango* (peaceful reside). During the ango, the members of the sangha set their own goals to read more about their own religious tradition each day. The goal is to use the teachings of Buddha in coordination with each person's own tradition and to bring about a more peaceful, compassionate human being. To me the three refuges are: Buddha—finding your own peaceful, luminescent, true nature; dharma—teachings that perpetuate that peaceful nature within; and sangha—a group of individuals who have experienced much suffering and are now supporting each other to create a more peaceful and harmonious life and community.

One of the greatest gifts Seido, our roshi, has given us is an all-day *sesshin*, or sitting. When the sangha held its first meeting on September 5, 1999, the prison was on a partial lockdown. Just two weeks prior, the whole institution had been on lockdown.

During the partial lockdown only one group of men was allowed to participate that evening. In 2006, San Quentin was once again plagued with violence, and lockdowns ensued. During an all-day sitting, one group of men was still locked down. Many throughout the institution were trying to figure out how to make San Quentin whole again and to reestablish some of the trust that had been lost through the racial melee. Out of this all-day sitting, a suggestion was made that the men of San Quentin create a Day of Peace. When the idea was initially proposed, everyone had a suggestion of what this day would look like based on their own knowledge and information. Through a wonderful process and mixture of individuality that stretched across all strata of the prison, the concept of a Day of Peace was created. A Day of Peace where everyone could come together, listen to music, eat, and contribute to the message of what peace means personally. On April 28, 2007, this became a reality, being one of the most successful events at San Quentin. It was so successful that it was repeated in 2008, where this time the theme was reconciliation. The 2008 Day of Peace included workshops on restorative justice, and violence prevention. The speakers included Mothers Against Senseless Killings and Oakland's Healing Circle. All this was done in an effort to end violence and create a more peaceful society.

The Buddhadharma Sangha is like a ray of light beaming from San Quentin. It has at its very core what Buddha taught over twenty-five hundred years ago: that everyone can change. This community has since its inception been the catalyst for change and human growth, set in the midst of great suffering and in prison chaos. Change continues to take place through insight and the shedding of old habits and beliefs. Sitting among my brothers in blue, there is support. Change starts, one individual at a time. As each person makes positive changes in their lives, there is a great step and movement toward the saving of the world. As an individual changes from violence and aggression to compassion and wisdom, everything changes and the world becomes a more peaceful and brighter place. San Quentin's community members emanate as Jizo, the Japanese name for Ksitigarbha, a popular Mahayana Buddhist bodhisattva. As Jizo, we sit in the midst of great suffering, listening with compassion and hearing the pain and suffering of others, no longer perpetuating that pain ourselves.

For those incarcerated, there is a tremendous effect on the outside. For the most part, many have children, parents, spouses, and friends with whom they remain in contact. As one changes, there is awareness, and that light of awareness begins to illuminate everything. Dogen Zenji, the first Japanese ancestor of Soto Zen, stated, "Take the backward step." Taking the backward step means becoming aware of the triple world: thoughts, feelings, and actions are all interrelated. Simply stated, this is where what we think and feel translates to our daily actions. The men of San Quentin are learning this process; sometimes there are tears—yet the process is cleansing. Meditation allows the possibility of awareness, empathy, remorse, and patience. Rather than just reacting, one learns to stop, breathe, and listen. The skill develops as we try to understand before being understood. This is a major departure from the way some of us grew up. In the midst of life, one learns to hold up a mirror. Each of us knows deep within what is the correct course; we just need to listen and to recognize our true nature.

Rick Nahmias brought to San Quentin the concept of *Golden States of Grace*. For a Zen Buddhist, grace exists before the mind creates dualities; through practice, the mind simply learns to focus on the present and does not try to mold the world to individual desires. What is right for each person depends on that person. As a person, I can only empathize and be fully present. The focus of my practice today has become twofold: self-growth (especially learning from other positive individuals) and helping others.

Self-growth is learning about my triggers, prejudices, and negative judgments. Once I am aware of these obstacles in my life, once the light shines

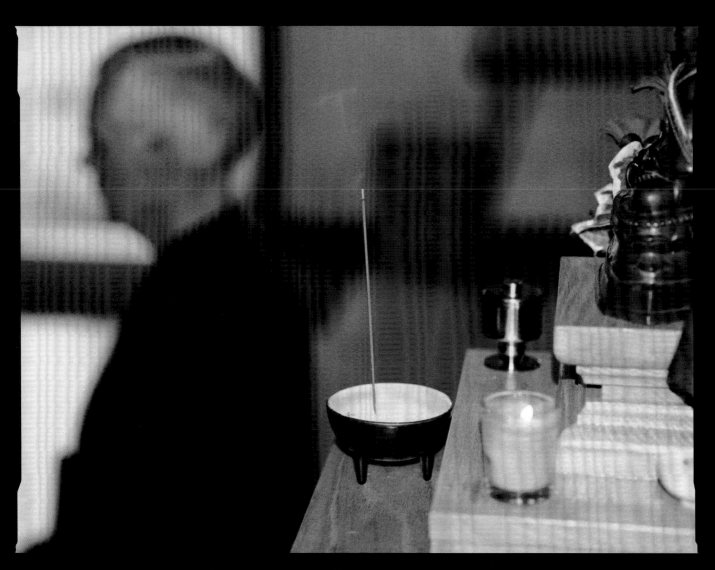

Seido Lee leads a sitting in front of an altar made by San Quentin inmates, Buddhaddharma Sangha

on these ancient tendencies, change is possible. No longer can someone trigger my thoughts, actions, or feelings; now freedom and liberation from my old patterns of behavior exist. This is the growth that meditation has offered me and that others have found in their practices as well. My personal belief is that once a person decides to change, then the seeds of these thoughts will grow and blossom. Self-growth is fundamental to change; yet it remains so difficult. As a young man, and until I came to practice, my life had little self-direction.

Today, rather than being tied to a set of rules of do's and don'ts, I follow the sixteen bodhisattva precepts, a set of practical guidelines. If one steals, lies, or uses intoxicating substances, not only does that person suffer, but others will suffer as well. Following a path with open eyes and with inner awareness allows for wiser decisions. The complementary side to self-growth is service; each of us has the ability to give to others. It can be as simple as a smile or just stopping and listening to someone in need.

I now realize that there was a lot of baggage and hidden pain in my life. I found the most destructive ways to deal with this inner pain and turmoil, escaping reality, running from life by engaging in substance abuse. The substances I used as a multidrug abuser only masked my rage, anger, fear, and hurt. In this misery, I believed only in my ego-centered, materialistic self. Although I was crying out for help, destructive tendencies kept me isolated from others. In this isolation I hurt those who loved me and caused tremendous suffering to those around me, including my children; today they too pay for my actions of 1978. After years of watching my wife, Ann, bring my two young ponytailed daughters through the gates of several California prisons, I came to a realization that my behavior needed to change. There was a shift in thinking. I began to get it; it is not all about me. Instead, I began to help others, especially my fellow incarcerated brothers.

I cannot tell you today what the future has in store for me. I have dedicated the recent part of my life to helping others. I do not see this as a way to cleanse the past or to gain some sort of future merit. It simply is the right thing to do, the right thing for *me* to do. After years of incarceration, I have come to see a way that the wider Buddhist community could help practitioners behind prison walls. When inmates are released, they need a lot of spiritual help making the transition to the outside world so they do not fall into past delusions and attachments. There are many faith-based postprison programs available to believers in the theistic religions, but very few for Buddhists. If released, I intend to encourage the Buddhist community to get active in this area. My goal is to promote an organization I call SOAR, for Sangha Organization for Ahimsakas' Reentry (into society). I want to establish a safe haven for released inmates of any religious affiliation who desire to make a positive change and take responsibility for their actions.

On June 19, 2008, I walked across the graduation stage here at San Quentin, earning a bachelor's degree. I began my speech by stating that as I walked across the garden plaza I heard the familiar sounds of San Quentin's chirping birds. They always bring an inner smile. Each of us in life has gone through great struggles and obstacles. Some of these obstacles we place upon ourselves; others were placed upon us long ago. San Quentin, though, reinforces the concept of interdependence: what each of us says and does has a tremendous effect on others. Each of us must continue to work on our own hindrances and obstacles if we are to grow as truly compassionate human beings. Now, though, it is our turn to serve others and to be like the chirping birds of San Quentin. Martin Luther King Jr. stated it best: "Everybody can be great because they can serve; . . . you only need a heart full of grace, a soul generated by love."

While I mentioned my graduation, what I left out were some of the deeper feelings. My son, Vincent James, fourteen, graduated on June 6, 2008. (VJ was conceived on a family visit while I was incarcerated.) As with his sisters, Elizabeth,

thirty-one, and Kea, twenty-seven (who was born after the crime and before my arrest while on the run), I was not present at this major event. In April 2007, my wife, Ann, had passed away. This had left VJ living with my older daughter. Unable to be at his graduation or witness any event that my children have participated in, deeply hurt me. Especially as they showered me with unconditional love and support when all three attended my graduation. It was bittersweet.

As you read this, you may be left with the impression that somehow those of us at San Quentin have achieved some plateau of higher thinking. Just recently, at the conclusion of work, I had the opportunity to be "stripped out." Stripping out of the factory is an everyday occurrence. This consists of entering a room, removing all my clothing in front of other men, placing my clothing on a countertop, where it is then searched by a correctional staff member; then walking naked through a metal detector (as in an airport), only to retrieve my clothing at a different counter. Going through this daily embarrassment for the last eleven years has left me aware of my internal discomfort over being part of this inhumanness and degradation. On this particular day, I placed my glasses in my shoe, but after I received my clothing back, the glasses were missing. Being a good bodhisattva and not wanting to stop the process, I asked if anyone had seen my glasses, but received no reply. I exited the strip-out room without my glasses, thinking life was going to be difficult. Without my glasses I would be unable to read, et cetera. Immediately I began to notice the breath, watched the fear enter into my bones. Single-pointed mindfulness: my only quest was to find the glasses. I peered in the windows of the strip-out room in search of the missing spectacles. To my surprise, a door was flung open and a correctional officer stood before me, yelling. I stopped, breathed, and responded, "I am just looking for my glasses." He was not sympathetic. My single-minded focus and obsession soon got me spread out against the wall. His agenda and concerns were clearly stated; mine, ignored . . . the breath and the feelings that were arising became my focus. Sometimes I just become too focused, more like a pitbull.

The next day someone found these glasses in the strip-out room. I can see again.

Vincent Jinryu Eishu (Benevolent Dragon Endless Effort) Russo received jukai Buddhist lay ordination on February 24, 2002, and became shuso *(head student) on June 6, 2006. In March 2008 he received a Bachelor's of Specialized Studies in Classics and World Religions/Psychology from Ohio University.*

share these gifts

Father God,

By your love and forgiveness I learned to love myself

and to treat myself

with kindness, compassion, and respect.

Also, you taught me not to look to others for

completion and fulfillment.

I would like to **share these gifts** you have given me.

—NORMA,
WOMEN OF WISDOM

La Santísima Muerte
Migration, Transgender Sex Workers, and Our Lady of Death

BY LOIS ANN LORENTZEN, PHD (WITH CYMENE HOWE AND SUSANNA ZARAYSKY)

Minni at her altar in her single room occupancy

VERONICA, A MALE-TO-FEMALE TRANSGENDER sex worker from Guadalajara, Mexico, prays before the altar to La Santísima Muerte (also known as Santa Muerte) that she has carefully constructed in her single room occupancy hotel unit in San Francisco, California. Her chosen saint holds a globe in one hand and a pendulum in the other. She wears a robe covering her arms down to her wrists; there her fingers are exposed as bone. Over her skeletal head rests a halo. Appearing as she does, like the Grim Reaper, the Holy Death is an unconventional icon whose presence is, unsurprisingly, not welcome in the traditional Catholic pantheon.

Fieldwork with transgender sex workers in San Francisco, California, and Guadalajara, Mexico,[1] shows that the belief systems created by transgender sex workers as they cross geopolitical borders and gendered boundaries serve to create spiritual agency within structural systems that are hostile to sex work, transgender persons, and border-crossing individuals from the south. Transgender sex workers in Mexico and the United States are acutely aware of the ways in which they are marginalized and thus seek alternative communities and develop spiritual practices that are shared among one another, not to disavow the Catholic traditions they may have learned as children, but to reshape their faith and the meaning they bring to devotion. Transgender sex workers in both the United States and Mexico create a mobile, devotional subculture among themselves by sharing, translating, and crossing borders to reevaluate the role of particular saints and religious practices in their lives. La Santísima Muerte mirrors their own structurally precarious positions in society; but more than this, she reflects their spiritual ingenuity and ability to creatively embrace saints whom they believe light their particular way in the world.

La Santísima Muerte reveals the most important axis of spiritual solidarity among Mexican transgender sex workers: it is her feminine form, challenging death, that plays the most dramatic role in their religious lives. Santísima Muerte, of all the saints, is most like the women themselves and closest to their experience. One learns about Santísima Muerte from friends and colleagues, receiving images, statues, and altar-preparation rules from fellow sex workers. Her secrets are circulated among the small network of women who struggle against many odds on a daily basis. Santísima Muerte is a shared deity, not condoned by the church, but sanctioned through a reciprocal process among transgender sex workers themselves. The Holy Death functions, effectively, to network and knit together transgender sex workers through their shared devotional practices in a spiritual solidarity.

Sexual Migration and Borders

The Mexican transgender sex workers who travel across the border to work in San Francisco, often facing dangerous conditions along the way, come to the United States with very specific goals in mind. Overwhelmingly, the women in this study came to earn money for gender-transformative surgeries and to earn start-up capital for businesses they hoped to begin in Mexico. Most stayed in San Francisco for at least a year, traveling back to Mexico to visit their families when they had the funds and freedom to do so. Paying a *coyote* approximately $2,500 each time they cross from Mexico to the United States, they make their way to San Francisco by bus or get picked up at the border by friends. Sometimes sex workers lend money to their fellow sex workers who hope to cross into the United States, and they are never far out of reach from their friends who remain in Guadalajara, using inexpensive phone cards to call other sex worker friends back in Mexico.

Theirs is a circuitous process of traversing the border, which, like many crossings, is transformative. A shift in status (documented versus undocumented) and a shift in support mechanisms (language barriers, family networks, social services, and political agency) must be weighed against the net gain of earning dollars in place of pesos. It is partially in response

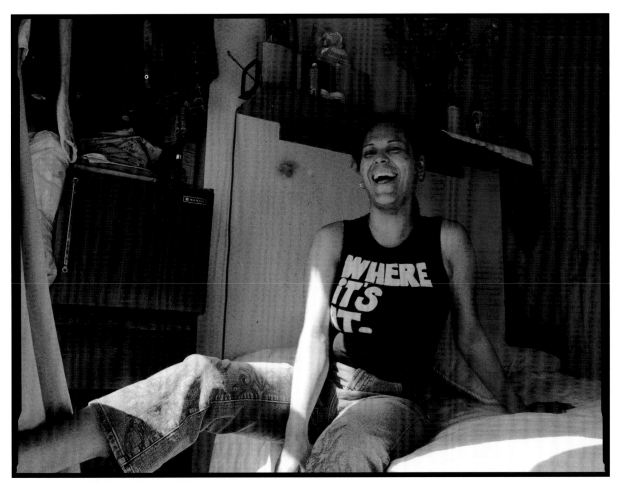

Vanessa, who spends most nights working the streets, relaxes during the day

to border crossing that transgender sex workers craft the devotional lives that they do; it is not simply their identification as transgender or as sex workers that stimulates their interest in unorthodox saints, but their transitions across the border as well.

The border is a geopolitical marker and highly regulated state boundary. But the Mexico-U.S. border can also be understood in less literal, more metaphorical terms, as a site of shifting identities, conflict, cooperation, and creative responses to a hierarchically organized world. As many authors have demonstrated, the border, in numerous ways, magnifies contradictions as well as human accommodation. And borderlands, as Gloria Anzaldúa (1987; 1990) describes, cannot be simply territorialized in a literal

sense, but must be understood as an experiential phenomena for those marginalized by their border-crossing status. The border, more broadly conceived, is both a conceptual and concrete place where identity, practice, and cultural forms are reconfigured. The border crosser is understood to straddle both worlds, on either side of the border, comfortably. The feeling of being completely at home, though, may be more elusive (Alonso 1995; Calderon and Saldivar 1991; Vila 2000). For transgender sex workers who move back and forth between the Mexico-U.S. border, complexities of gender, sexuality, illegal work, and lack of documented presence in the United States impact, in very real terms, their mobility. Additionally, in more abstract terms, as "so-called

border people" they "are constantly shifting and renegotiating identities with maneuvers of power and submission" (Alvarez 1995).

The concept of "sexual migration" (Cantú 1999; Parker 1997) furthers our understanding of migrant sex workers as it draws attention away from strict economic interpretations of migratory motivations. Instead it focuses on international migration that is partially or fully inspired by the sexuality of those who migrate and their understanding of the role of their sexuality vis-à-vis their future goals. Sexual migration may evolve from the desire to continue a romantic relationship with a foreign national, or it may be connected to hopes of exploring sexual desires or, in some cases, gender-identity transformation. Sexual migration may also be necessary to avoid persecution or, in some cases, simply as part of a search for more hospitable environs and a higher degree of sexual equality. In the case of Mexican transgender sex workers, a very clear combined dynamic is at work; it includes economic migration (crossing the border in order to earn dollars) but also the more subtle sexuality migration (crossing the border for sexual reasons).

While neither Guadalajara nor San Francisco are literally, physically, on the border between the United States and Mexico, the border looms large in the lives of the transgender sex workers with whom we spoke, shaping their sense of who they are, depending on which side of the line they may stand at any given time. If we understand the border as a dialectical entity that affects the lives of those who traverse it, we can see that, as a metaphorical and geopolitical marker, it influences the unique spiritual practices developed by those who cross, accommodate, and cross again.

La Santísima Muerte:
Fearless in the Face of Death

Santísima Muerte, a symbolic representation of death blended with Catholic characteristics, surfaced in Mexico's religious landscape to much popular acclaim. Very little is known about the Holy Death's origins; her followers and scholars promote divergent theories.[2] Some claim that she first appeared in Veracruz in the nineteenth century to a healer and ordered him to create a cult (Quijano 2003: 7; Freese 2005: 10). According to her followers, a flood of miracles, which continue to the present, followed her appearance. Others claim that the cult of death existed in Mexico for three millennia and that Holy Death draws from pre-Hispanic beliefs and practices (Araujo Peña et al. 2002; Freese 2005; Quijana 2003; Aridjis 2003). They point to death figures revered by Maya, Zapotecos, and Totonacas, but especially to the ritual practices of the Aztecs and the Mexicas. The Mexicas worshipped two gods, Miclantecuhtli and Mictecacihuatl, who reigned over the region of the dead. According to these scholars and followers, the strong cult of death practiced among the ancient Mexicas merged with Catholicism in the form of Santísima Muerte, or Holy Death. Other devotees claim that Holy Death came from Yoruba traditions brought by African slaves to the Caribbean and syncretized with Roman Catholicism to become the Cuban Santería, the Haitian Vodou, or the Brazilian Palo Mayombe; these religions were passed to Mexico, with the addition of the specific emphasis on death, to create Santísima Muerte. Other Mexican anthropologists insist that Holy Death's origins can be traced back to medieval Europe. During plagues and epidemics, European Christians made offerings to skeletal figures, and these traditions were brought to the Americas (Freese 2005: 12; Castellanos 2004). Most scholars do agree, however, that Santísima Muerte should not be confused with the Day of the Dead, although it is tempting to make the connection. While Holy Death may be venerated on that day, she "appears to be a distinct phenomenon emerging from a separate tradition" (Freese 2005: 4).

Although scholars may find the preceding theoretical debates over Santísima Muerte's origins intriguing, the women in our study didn't know, or seem to care to know, the story behind their

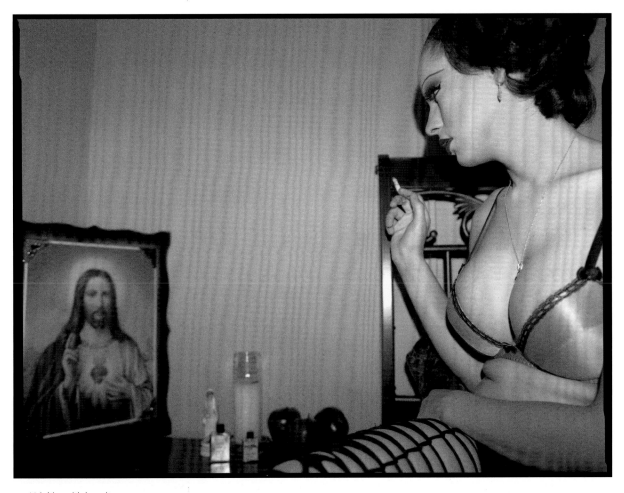

Yajahira with her altar

beloved saint; her role in the precarious present is what matters to them. She is called the Holy Death because she looks like the incarnation of death and symbolizes its eventuality. Some of the sex workers explained that Santísima Muerte is the one who first saw Jesus Christ after his Crucifixion and welcomed him into the world of the dead. Like Saint Jude, Santísima Muerte has a following among those in risky professions and those who live on the cusp of danger and death.[3] The transgender sex workers explained how much they valued this "saint" as she helps them dodge death on the streets by evoking, through her form, the symbolism of death. Artemia says, "She helps me in the street, to stay away from risks. . . . She exists, she exists, of course, we are all going to die. Death exists and she protects me from all of the dangers around me." In a kind of homeopathic way, Santísima Muerte injects just enough death to ward away its coming. The fact of death also represents vindication for socially ostracized sex workers. Veronica says, "La Santa shows us the final road for all humans; . . . we are equal in her eyes."

Devotees of the Holy Death must first be accepted by her. Pocahontas, who was living and working in Guadalajara at the time of this study, learned about Santísima Muerte from her friend and fellow sex worker Arianna. Pocahontas emphasized that not everyone can enter into the realm of Santísima Muerte: "Sometimes people give statues

of Santísima Muerte to their friends thinking that she will help them, and it doesn't always work. The candles die out when she doesn't like somebody; she is very selective."

If Santísima Muerte is indeed a fickle and demanding deity who will not allow just anyone to worship her, then it is clear that one must be an "insider" worthy to approach her; the logic Pocahontas puts forward is in stark contrast to what many of her friends and colleagues have experienced in the church. In addition to their decision to transition gender and their chosen work, one thing that all of the participants in this study shared was the experience of having been raised in what they described as "traditional Catholic Mexican families." They learned the Ave Maria (the Hail Mary) and the Padre Nuestro (the Our Father) as children, going to church each week with their families. They celebrated the Catholic holidays of Christmas and Easter in addition to saints' holy days. Following the Mexican and larger Latin American tradition, they were baptized, took Communion, and confessed at church.

Mexican transgender sex workers often maintained the Catholic traditions they learned as children, despite their sense that they were, or would be, ostracized from the Church because of their gender and sexual identity. According to some interpretations of scripture, homosexual behavior is a sin, as is prostitution. Knowing this, young transgender people are wary of presenting themselves publicly as such, much less showing up at church in gender-crossing clothes. Entering into the gay community in Guadalajara, they risked being ostracized from the church, being condemned by the priest, or, at the very least, being whispered about in the pews. Not surprisingly, these fears drive many transgender people away from church services.

Several women commented that the church was hypocritical toward what they called "the gay population." Arianna, a transvestite, said that she originally wanted to be a priest, but did not feel comfortable with the antihomosexual sentiments of the church.

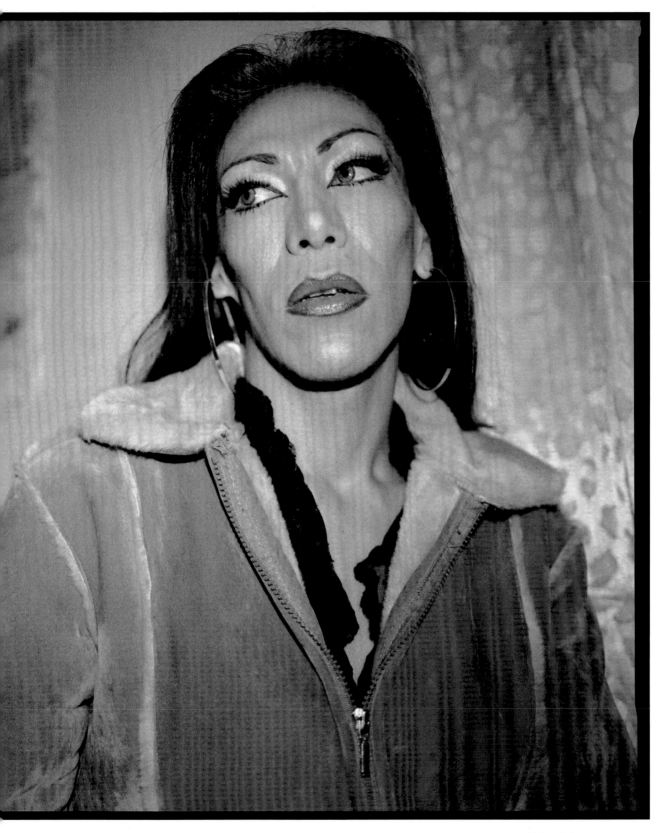

Krystal in her single room occupancy

I am Catholic because I grew up in the religion. I don't practice it, but I'm a believer in Catholicism . . . but the religion prohibits me from being homosexual. I wanted to be a priest. And I knew that in the seminary there were homosexuals—but the church wanted to show the outside world that they were against homosexuals. I prefer to get paid for my work. If I work in the seminary, I would be performing sex on others and I would not be paid.

Rodolfo Contreras, deacon of the Apostolic Reformed Catholic Church in Guadalajara, is a former Jesuit and was a gay activist. Contreras' work with the gay community provided him insights on the topic of religion in the transgender community.

Outreach to the transgender community will be a slow process because transsexuals feel dirty and unworthy and these feelings don't go away with just one talk with them. When people in the community hear the word *religion*, they automatically close up. The orthodoxy of the Catholic church has made them feel like they are unworthy and that they do not have the right to be present at a religious service. The church has generated guilt, embarrassment, and marginalization.[4]

In contrast, Santísima Muerte not only accepts you as you are (transgender, sex worker, immigrant, and so on), but she may not even be interested in being worshipped by those who do not dare to live such challenging lives. "All the church I need is with the ones La Santa selects," declares Blanca, a sex worker. In this sense, Santísima Muerte is only for those who are worthy among a population that has historically been deemed unworthy by religious and social norms.

Most followers see no contradiction between their Catholic religion and worship of La Santa; indeed, they use practices similar to those of Christianity, including processions, prayers, and altars. They have various rituals dedicated to the Holy Death. In

a brochure about the Holy Death that one of the sex workers provided, the instructions call for devotees to maintain a separate altar for the Holy Death rather than combining it with the altars for other saints or devotions. The Holy Death, it seems, is a demanding deity. Most of the sex workers gave offerings to the Holy Death in order to show their gratitude.

Altars that transgender sex workers construct for Holy Death are adorned with flowers, candles, incense, and money. Those who venerate the Holy Death keep statues to place on their altars. They buy Holy Death figurines of different colors, with herbs and rice at the bottom to signify good luck. The feminine figurines are draped in a robe, with a skull for a head. Each color signifies a particular desire to be manifested or solution being sought:

Red: destruction as well as passion and love.
White: purification.
Green: money and legal problems.
Orange: protection.
Yellow: healing and friendship.

To prepare the altar for Santísima Muerte, the devotee lights candles while praying to her. The candles symbolize different effects: white candles for something good, red for love, and black for ill wishes. On the white and the black candles, they write a prayer in both Spanish and English. For example:

Prayer to the Holy Death
 Oh conquering Jesus Christ, that on the Cross were defeated, like you would tame a ferocious animal, tame the soul of _____. Tame as a lamb and tame as a rosemary flower he shall come to kneel before me and obey my every command. Holy Death, I plea of your immortal powers that God has given you toward mortals, place us in a celestial sphere where we'll enjoy days without nights for all eternity. In the name of the Father, the Son, and the Holy Spirit, I plea for your protection.

Grant all my wishes until the last day, hour, and moment that your divine majesty orders us to appear before you. Amen.

With prayers that evoke Jesus and God, it is not surprising that the transgender sex workers who pray to the Holy Death see her as simply another Catholic saint. They do not differentiate between Holy Death and the more traditional Catholic saints. Rather, she is simply another possible intermediary between themselves and God. Valeria makes no distinction between Holy Death and Saint Jude, for example, even though the church rejects Santísima Muerte. Artemia wears a pendant and has prayed to Santísima Muerte for nine years. She says, "I started praying to her like to any other normal saint, like to Saint Jude or to God. . . . I pray every day before I go to work on the street at night." However, the Holy Death is not considered by the church to be a viable saint or divine intermediary; Catholic orthodoxy does not permit the veneration of death (although many symbols, including Crucifixion imagery, do just that). Deacon Contreras of Guadalajara was clear in his position that "the cult of the Holy Death is one of idolatry. In Catholicism, one is not supposed to adore death."

In spite of official opposition to La Santísima Muerte, devotion has grown dramatically since 1965; Santísima Muerte now claims some two million followers in Mexico. The rapid growth of the movement over the last decades has led to conflict between devotees of Holy Death and the official Roman Catholic church. The Catholic church condemns her veneration, on the one hand; on the other, her devotees have declared August 15 the Dia de Santa Muerte, her official day. The Iglesia Católica Tradicional México–Estados Unidos (the Traditional Catholic Church Mexico–United States) founded the Sanctuary of Holy Death in Mexico City in 2002 and registered as a religious organization in 2003. In April 2005, the government revoked the church's status as a religious organization in a twenty-five page resolution, claiming that the group

did not meet the qualifications of a religion, removing it from the list of organized religions, and citing theological doctrine dating back to the Council of Trent in 1570. The legal action resulted in demonstrations throughout Mexico City and increased press attention, yet had seemingly little effect on the numbers of people participating in Holy Death religious activities. Following the ruling, David Romo Guillén, founder and archbishop of the Traditional Catholic Church Mexico–United States, stated, "To the people here, Death offers friendship, hope, and miracles. We're the church of the people, down here among the people . . . and that's why the Roman Catholic church sees us as a threat" (quoted in Hawley 2004).[5]

The popularity of Holy Death can be explained, in the simplest terms, by the fact that the Holy Death is most useful and most revered by those in risky jobs or those who constantly operate close to death. The risk of death and violence on the streets, in the single room occupancy hotels, and in the brothels of Mexico and the United States are readily clear to transgender sex workers, and they seek protection. Yajahira, a transgender sex worker in San Francisco who is documented in *Golden States of Grace*, explained that because Santísima Muerte has such proximity to what they most fear, death, she functions as a strong spiritual force in their lives.

> For me, the Holy Death is about a preparation for death, to welcome death. You know that some people are homophobic. Some people are claustrophobic, others are afraid of spiders, closed rooms, darkness, et cetera. . . . This is a preparation for death. It's about not being afraid of death, about not being so attached to the fear of death.

Vicky, a sex worker who worked in San Francisco and returned to Guadalajara, explained her faith in this way: "The majority of gay people are in danger, and the Santísima Muerte takes care of people

in danger; she helps us survive." Pocahontas and Arianna mirror this sentiment and are unswerving in their faith to Santísima Muerte because, they explained, she saved Arianna from a deadly fire.

> One night, I [Arianna] dreamed that I was going to die in a fire. This really happened to me after the dream repeated itself several times. And it really happened. I was in the hospital, and I was doing really poorly. Pocahontas took the statue of Santísima Muerte to the hospital, and that's what saved me. With the help of Santísima Muerte, I recovered very quickly.

La Santísima Muerte may protect her devotees, but she is also a deity more demanding than most. Two sex workers, Donna and Paula, explained that they tried to "work with" Santísima Muerte for a month. They bestowed flowers to her every day and lit candles; still they felt no results. None of their wishes were granted, and so they decided not to pray to the Holy Death any longer. Donna and her boyfriend both prayed to Santísima Muerte at the same time, but only her boyfriend was successful in having his wishes answered. Donna decided to stop praying to Santísima Muerte, but she did not know what to do with her statue.

> I was told that I could not throw away my Santísima Muerte statue and that I could not abandon it, so I gave it away. I gave it as a gift to a spiritual cleanser. Because if you throw her away, it is bad; I was told that I had to give her away.

Proper conduct around the Holy Death must be maintained, including a respectful presenting of her image as a gift—she cannot simply be tossed aside. Superstition is likely at work here, Donna perhaps fearing that the Holy Death might have retribution in mind for those who devalue her. But beyond this, the belief that Santísima Muerte must be shared and exchanged in a reciprocal process suggests that the Holy Death functions, in some small way, to

network and knit together transgender sex workers through their shared devotional practices.

Santísima Muerte is even, for some, a marriageable partner. Vicky explained that she had "married" the Holy Death because the Holy Death had performed so many miracles for her. And, she further explained, she was not happy with men anymore. In marrying the Holy Death, Vicky appears to have altered the church's usual prerogative—transforming the traditional marriage between a nun and Jesus to one of different, though related, intentions. Moreover, Vicky's marriage to the Holy Death is, from one perspective, perhaps the first lesbian marriage between a human and a deity.

Santísima Muerte provides a critical meeting point for spiritual solidarity among Mexican transgender sex workers. She is close to their experience, teetering on the edge between the here and the hereafter. Most importantly, Santísima Muerte is, in many ways, indigenous to the community of sex workers; word of her comes from friends and colleagues, images of her come as gifts from fellow sex workers, her secrets move among a small network of those who struggle against many of the same odds on a daily basis. Santísima Muerte, because she is not easy to please and because she is particular about her devotees, is an icon that makes the chosen ones feel special, wanted, and worthy. Worship of the Holy Death does not represent a cultish obsession with this mortal coil; rather, devotions to Santísima Muerte reflect a highly mobile spiritual solidarity among the women who pray to her.

Conclusions

The ways in which people select, perform, and perform again their devotions provides insights into their views of the world and also insights into their individual understanding of themselves. Rituals, in other words, "provide a metacommentary on the world" (Bruner 1986: 26) and shine light on the unique cultural and social dynamics that make up

our rapidly shifting global landscape. Our work with Mexican transgender sex workers in Guadalajara and San Francisco has demonstrated that devotional practices that are shared and circulated within this population are not renegade rituals to marginal icons. Instead, the belief systems created and maintained by transgender sex workers as they cross geopolitical borders, as well as gendered borders, create spiritual solidarity among a group of people who often find themselves on the margins of a society that is hostile toward sex work, transgender persons, and border-crossing individuals from the south.

In establishing alternative spiritual communities, transgender sex workers do not intend to disavow the Catholic pantheon or the traditions they learned as children. Rather, they are employing strategic ways to resist marginalization through their faith practices. The novel forms of spirituality that these women create are drawn from their national and natal traditions and circulated among themselves as a way of building a sense of shared practice.[6] Their secret weapon against a hostile world is Santísima Muerte. She is a jealous deity, prone to revenge, and discriminating in her choice of devotees; these are precisely the reasons she is so valued. Santísima Muerte is fundamentally a shared deity, not condoned by the church, but legitimated through a reciprocal process among transgender sex workers themselves. The Holy Death effectively works to network and knit together transgender sex workers as they identify with her marginality and embrace her fearlessness in the face of death.

The devotional worldview created by people like Veronica, Artemia, Arianna, Pocahantas, and Vicky is incomplete without an understanding of the larger structural, legal, political, and economic circumstances that impact their daily lives. We have maintained that the border has many effects, not the least of which is the ordering of identities and citizenship. As a paradigmatic geopolitical boundary, the U.S.-Mexican border, and the larger "borderlands" it engenders, cannot be simply territorialized in a literal sense, but rather must be understood as an experiential phenomena for those marginalized by their border-crossing status.

These women cross the border, often with their *santos* in hand, with very complex goals and strategically laid migratory agendas. In both Mexico and the United States, each of the participants in this research found themselves socially marginalized because of their gender transgressions and/or by the sexual labor they do. Sexual migration—the process of crossing nation-state divides in order to pursue a sexuality-related component of one's life (whether a relationship or a search for more liberatory terrain) resonates with the experiences of Mexican transgender sex workers.

The spiritual solidarity created by the women in this study echo what Hamid Naficy has described: "Rituals provide the terrain in which the consciousness of communal boundaries is heightened, thereby confirming and strengthening individual location and positionality as well as social identity" (Naficy 1991: 295). The devotions described by transgender sex workers codify a sense of shared community that emerges from the highly mobile and uncertain circumstances in which they find themselves. By definition, they require religion that travels well. But La Santísima Muerte is not simply a *santa* easily stowed in luggage. Acknowledging the inevitability of death, La Santísima Muerte creates a spiritual grounding for the uprooted, a feeling of solidarity among the ostracized, and a sense of stability for individuals who are always on the move.

Lois Lorentzen is chair of the Theology and Religious Studies Department and codirector of the Center for Latino Studies in the Americas (CELASA) at the University of San Francisco. She has written numerous articles and books about immigration, environmental issues, and Latin America.

Cymene Howe is an assistant professor in the Anthropology Department at Rice University. Her research centers on sexuality, gender, media, and human rights in Latin America and the United States.

Notes

1. We want to especially acknowledge the extended fieldwork and interviews conducted by Susanna Zaraysky over the course of two years in both San Francisco and Guadalajara. The ethnographic and interview material here is based on her excellent rapport with interviewees and her careful observational insights. Inquiries about the research process should be directed to her at nisamsuzi@hotmail.com. All names of interviewees have been changed to protect their identities. Interviews with twenty-nine transgender sex workers in both the United States and Mexico were conducted in Spanish and audiotaped unless the interviewee requested she not be recorded. This research was sponsored by the Pew Foundation and administered through the University of San Francisco's Religion and Immigration Project.

2. Surprisingly little academic literature exists in English about the Holy Death movement. The religion and its followers have received attention in the popular press in Mexico, in Latin America, and even in the United States, yet scholarly treatments in either English or Spanish are sparse.

3. Santísima Muerte is particularly popular in Mexico among police, drug traffickers, gang members, prison inmates, and sex workers—in short, those who live close to death. Her larger social base, however, is among very poor people who may be excluded from the formal economy. Although she is popular among some artists, intellectuals, politicians, and actors, Holy Death's primary constituency is among the marginalized.

4. Contreras interchanges the words *transvestite*, *transsexual*, and *transgender*, but he is referring to the same population.

5. Archbishop David Romo Guillén and the Traditional Catholic Church Mexico–United States also promote condom use for men and women, as well as the day-after pill. The doors of the church are open to gays, lesbians, transvestites, and transgendered. Priests are allowed to marry (Romo himself is married with five children), women can become ordained, and divorce is not censured. These practices, in addition to worship of Holy Death, place them in opposition with the Mexican Roman Catholic church.

6. Similarly, Martin Manalansan describes new iterations of a traditional Filipino religious tradition, the Santacruzan, as it has changed in its transnational form. "The combination of secular, profane, and religious imagery as well as the combination of Filipino and American gay/mainstream icons provided an arena where symbols from the two countries were contested, dismantled, and reassembled in a dazzling series of cross-contestatory statements" (Manalansan 2003: 133).

Works Cited

Alonso, Ana Maria
 1995 *Thread of Blood: Colonialism, Revolution, and Gender on Mexico's Northern Frontier*. Tucson: University of Arizona Press.

Anzaldúa, Gloria
 1987 *Borderlands: La Frontera*. Berkeley: Aunt Lute.
 1990 *Making Face, Making Soul/Haciendo Caras: Creative and Critical Perspectives by Women of Color*. Berkeley: Aunt Lute.

Araujo Peña, Sandra Alejandra, Marisela Ramirez Barbosa, Susana Falcón, Susana Galván, Aurea Ortiz García, and Carlos Ordaz Uribe
 2002 *El culto a la Santa Muerte: un estudio descriptivo*. London: University of London. http://udelondres.com/revistapsicologia/articulos/stamuerte.html.

Aridjis, Homero
 2003 *Santa Muerte: Sexteto del amor, las mujeres, los perros, y la muerte.* Mexico City: Alfaguara.

Bruner, Edward M.
 1986 "Experience and Its Expressions." In *The Anthropology of Experience,* edited by Victor W. Turner and Edward M. Bruner. Urbana: University of Illinois Press.

Calderón, Hector, and José David Saldivar
 1991 *Criticism in the Borderlands: Studies in Chicano Literature, Culture, and Ideology (Post-Contemporary Interventions).* Durham, NC: Duke University Press.

Cantú, L.
 1999 "De Ambiente: Queer Tourism and the Shifting Boundaries of Mexican Male Sexualities." *GLQ: A Journal of Lesbian and Gay Studies* 8 (1–2): 139–166.

Castellanos, Laura
 2004 *La santa de los desperados.* http://www.jornada.unam.mx/2004/05/09/mas-santa.html.

Freese, Kevin
 2005 *The Death Cult of the Drug Lords: Mexico's Patron Saint of Crime, Criminals, and the Dispossessed.* Foreign Military Studies Office, Fort Leavenworth, KS. http://fmso.leavenworth.army.mil/documents/Santa-Muerte/santa-muerte.htm.

Hawley, Chris
 2004 "Catholic Church Upset by Mexico's Saint Death." http://wwrn.org.php?idd=2679&sec=55&con.6.

Manalansan, M. F., IV
 2003 *Global Divas: Filipino Gay Men in the Diaspora.* Durham, NC: Duke University Press.

Naficy, Hamid
 1991 "The Poetics and Practice of Iranian Nostalgia in Exile." *Diaspora* 1 (3): 285–302.

Parker, Richard
 Beneath the Equator: Cultures of Desire, Male Homosexuality, and Emerging Gay Communities in Brazil. New York: Routledge.

Quijano, Édgar Escobedo
 2003 *Santa Muerte: El libro total.* Mexico City: Editorial La Luna Negra.

Vila, Pablo
 2000 *Crossing Borders, Reinforcing Borders: Social Categories, Metaphors, and Narrative Identities on the U.S.-Mexico Frontier.* Austin: University of Texas Press.

all the beauty

God, giver of all good gifts, I thank you profusely for the gift of life
 and **all the beauty** and joy that accompany it.
Help me to live my life with kindness and generosity toward all.
Teach me how **to bring peace** into a troubled world,
 at least into my piece of that world.
And help me always to be grateful.

—MARIE, IMMACULATE HEART COMMUNITY

to bring peace

Shooting Religion from the Bottom Up *The Creative Journey*

BY RICK NAHMIAS

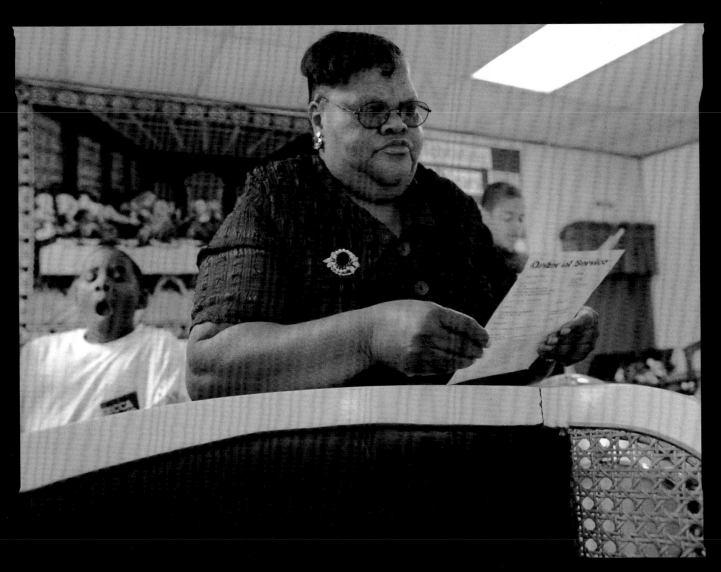

Sunday service, Friendship Baptist Church

I SEE RELIGION AS THE DRIVING FORCE BEHIND humanity's greatest creations as well as our most ruthless acts of destruction. You have the rich millennia-old customs of monastic meditation, on the one hand, and on the other the civilization-altering bloodshed of the Crusades; in our lifetime we can see the noble work of Catholic Charities on one side and the Mormon church's hateful campaign against marriage equality on the other. My deep ambivalence toward religion since childhood is what fueled my desire to explore it on a canvas that could be both inquisitive yet reverential. Beyond where one might stand on the subject of God, what remains undeniable is it's as rich (and simultaneously daunting) a subject matter as any artist could ask for. The depth of meanings, visual metaphors, and historic mythologies in one faith, let alone comparatively across several, offer lifetimes of creative fodder.

For believers, there is not an activity of human existence that incites more passion than that of a person's connection with a higher power. It does not matter the faith or geography—people are viscerally drawn to pray, be they dirt-poor beggars walking hundreds of miles on a pilgrimage to Mecca or billionaires kneeling in mahogany pews in Manhattan. What affects me most about this universal impulse is simply that it is found across all of humanity, cutting through every layer of society, every demographic. It is one of the few great equalizers. You'd be hard pressed to find an element of our existence, besides the physical need for food and shelter and the yearning for love (which some might rightfully equate directly with prayer), that unites, and divides, people more profoundly.

In all honesty, though, rather than any calling to plumb the depths of liturgy, what led me to take my first formal comparative look at faith was a desire to escape from the myopia of the Film Department of New York University, which was rife with very healthy twenty-year-old egos intent on cinematic navel gazing. Peering into NYU's Religious Studies Department, which boasted a small but devoted following, my yet-to-be-discovered fascination with the anthropology of religion was to be unlocked by Professor Jim Carse, a master storyteller and then head of the department. Carse plucked rich anecdotes from the mythologies of ancient religious traditions and made them breathe with contemporary relevance. He brought sacred texts, ceremony, and ritual to life with the reverence of a modern-day mystic.

Soon after returning to California from college, my home state's religious diversity—assessed by many to be the greatest on the planet[1]—called out to me for a closer look. Yet, from the beginning, I kept running up against the question: How does one adequately document such a vast hodgepodge of beliefs and customs? But I was in my midtwenties, and wasn't prone to ask these sorts of useful questions. I just grabbed a camera and film and started shooting.

As a result, over a decade and a half ago, the seeds of *Golden States of Grace* sprouted, first as a project called *The Idea of God in the West*—as academic and overreaching a title (copped from one of Carse's courses) as the project itself was. I began by sporadically attending and photographing events, celebrations, and religious happenings across Southern California—the opening of the Hindu temple in Malibu, the Blessing of the Cars Festival in Glendale, the Easter sunrise service at the Hollywood Bowl. Some good images came out of this, but the lack of cohesiveness was all too apparent even then. Even so, it served as an incubator of sorts, keeping me connected to a subject I cared about, even if I wasn't sure why. But simply caring wasn't enough. In the short time I've been building a career as a photodocumentarian, I've learned one rule-of-thumb: if you don't feel the creative and moral imperative of the work you are documenting, the project will not be finished, or if it is, it is bound to fail on some important level.

Almost a decade later, I was working with the momentum of having just finished my first body of work, *The Migrant Project*, and was soon exploring the possibility of showing it at various venues. It seemed the right time to get started on the next project, and *The Idea of God in the West (IOGW)* looked to be the obvious best choice. Again, in my naiveté (a paradoxical secret weapon to many an artist) I struck out on my own, finding my first ally, Rev. Paul Chaffee, a noted expert in the community of interfaith relations and executive director of the Interfaith Center of the Presidio in San Francisco. His warm, jovial manner and broad encouragement helped me find the spark to begin reaching out to a wide array of academics and clergy (several of whom would eventually become advisors) and bring different perspectives and entire networks of contacts to the project. No one asked why I'd taken on such an unwieldy project—they just unselfishly offered what help they could. Paul's center agreed to be my fiscal sponsor, and I was off and running, applying for a variety of post-9/11 grants focusing on "religious tolerance" and "interfaith understanding," funding which I was not-so-humbly convinced was mine for the asking.

I began researching a handful of the seemingly endless number of faith communities across the state—and soon found the abundance overwhelming. More importantly, within a short time, the work began feeling like, well, work—uninspired and at times incredibly rote. I couldn't help but ask myself: How would I make it through what was clearly a multiyear project with waning interest on my part before a single image had been shot?

A few months later, a couple of glasses of Chianti into a fateful Italian dinner on Fisherman's Wharf with Paul, I sheepishly confessed I had lost my mojo for *IOGW* and that, since none of the early grants had come through, I was seriously considering shelving it entirely and cutting my losses. He paused, studied me a while, then said, "You had no cash on hand when you started your farm worker project, and minimal creative direction too, right?"

I nodded. "Well, what was it that kept you going then?" he asked matter-of-factly.

It was a damn good question, but I had no immediate answer. I thought a moment, then ventured: "The stories of a marginalized group struggling against constant adversity, yet still retaining its dignity. It was inspiring."

He paused again, grinning. "That's your lens—right there."

It was the type of ah-ha moment I had not experienced before. I left dinner with both renewed excitement and an incredibly deepened sense of mission. As the wine wore off, I spent the next several hours at a café on upper Market Street filling a legal pad with page after page of notes, including a list of possible titles for this "born again" project, settling on *Golden States of Grace: Prayers of the Disinherited* just before 2:00 a.m., when the café closed its doors.

As excited as I was, I knew that further refining a specific point of view was going to be essential if I wanted to ensure that the results would not just be a rote cataloguing of people, places, and things. I had turned to white papers and current academic research to help me clarify the most pressing issues facing farm workers for *The Migrant Project*, but that methodology soon proved futile on *Golden States of Grace*. Beyond Howard Thurman, the celebrated theologian and civil rights leader who in the midseventies had written *Jesus and the Disinherited*, which referred mostly to black communities' struggles in the United States, I could find little written material on the subject of the religious practices of the disinherited. Search after search came up empty, which soon forced me to reflect more deeply on the definition of *disinherited*.

My newfound excitement would be met and raised the morning after my dinner with Paul when I met Professor Lois Lorentzen, chair of the University of San Francisco's Department of Theology, for the first time. Nursing a major head cold and sipping hot tea, she spoke in hushed but excited tones of the work she had been doing on her Religion and Immigration Project and a small

kernel of related funding she might be able to help me secure. More importantly, she told me about two groups she knew of and felt would be perfect fits for this newly tweaked concept: Transcendence, a Christian gospel choir composed wholly of individuals self-identifying as transgender, and the community of immigrant Latina sex workers who prayed to a folk deity known as Santísima Muerte (or Holy Death). I remember driving off from our meeting and back across the Bay Bridge toward L.A., completely elated. Within a week, I met with Rabbi Harold Schulweis, the man who had bar mitzvahed me twenty-five years earlier. He connected me with Beit T'Shuvah, the nation's first halfway house for recovering Jewish addicts of all kinds.

The project was suddenly revitalized in a way I couldn't have imagined just two weeks prior. With growing synchronicity, things began showing up on the radar. Even a couple of small grants were tossed my way. I met with Harriet Rosetto and Rabbi Mark Borowitz, the founder and the spiritual director of Beit T'Shuvah. I left with a date for the project's first shoot: I'd been invited to capture their Passover service, which was particularly notable for its unique perspective on the holiday—looking at it as a means of breaking the bonds of the slavery of addiction. This was soon followed by a shoot with Buddhadharma Sangha, a relatively new community of inmates who practiced Zen Buddhism inside of San Quentin Prison.

In selecting the specific groups for inclusion in *Golden States of Grace*, I cast the net wide to show the diversity of communities worshipping outside the secure confines of middle-class America. Whereas it could have been a lot easier to narrow the project's focus, let's say, to just communities of faith dealing with addiction, I felt the multiple levels of diversity from the points of view of faith, socioeconomic background, geography, struggle, and ethnicity would make for a more potent combination. I also hoped that this approach might encourage greater dialogue about who are the disinherited among us and how we *own* the disinherited parts *within* each of us.

Rather than create some sort of academic protocol for inclusion or to simply come to a generic definition of *the disinherited*, I decided the project should cut through multiple layers of how *marginalized* could be defined and, as such, document a panorama of people who—due to world events, societal prejudice, their own hand, or, yes, even an act of God—had been silenced or pushed from mainstream modes of worship. The participating communities would ultimately run the gamut from the elderly to the executable.

When it came to deciding which specific faiths to include, there were even more delicate decisions to be made. Since I am dealing with the marginalized, I was asked, why not examine marginalized sects of each faith? Why not just document the most bizarre "religions" found in California? (Believe me, there is no shortage.) It didn't take long to decide to work with relatively mainstream faiths to help audiences relate more directly to my subjects and their respective modes of worship, which then, I hoped, couldn't simply be dismissed as "fringe."

The communities represented in the project were found through a combination of advisor suggestions, Internet research, mentions in journals and magazines, or word of mouth from people intrigued by the concept. Communities were approached through their leaders, with whom I'd have an in-depth phone conversation or an in-person meeting during which I'd explain the project, describe what final form it might take, and show them a portfolio of work shot to date. Only after I had his or her blessings, as well as the group's consent (which in most cases came in the form of a democratic vote), did I return at a later date with my camera. I followed this procedure with all the groups except for the one without a leader per se: the Latina sex workers, whom I met mostly during the day (alongside my bilingual research assistant, Susanna Zaraysky), then returned to that night or the next night, at an agreed-upon place and time, to document them at prayer just before they headed

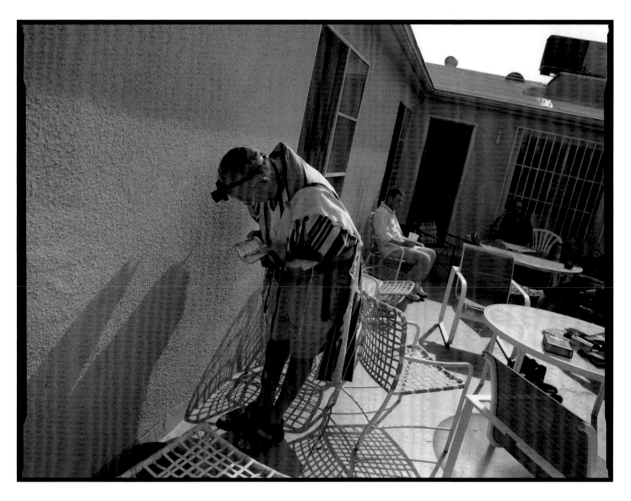

Afternoon prayers, Beit T'Shuvah

out to work the streets. No one came into the project without receiving an understanding of what it was and why I was doing it.

✦

From the very beginning, there was no question in my mind that at its core this project had the potential of challenging some major stereotypes: "the Islamic terrorist," "the nice Jewish boy," "the bitter old nun." Though, at the outset, I had no intent to be political, it would be disingenuous to say I didn't soon become keenly aware that simply by depicting faces that are foreign to most—and thus realigning the

perceived apple cart of neatly defined and accepted cultural and religious images—this work would be innately political. I had previously learned with *The Migrant Project* that my art and politics did not have to be mutually exclusive. That body of work began as a personal search for answers about the human cost of feeding our country, yet evolved on deeper levels into a meditation about how our country, and its leaders, had developed a misguided inclination to look solely outward for an enemy whom I had seen lurking deeply within each of us. It taught me the power of combining art and intrinsically political questions and how these two elements could grow more powerful when merged.

As the heaviest lifting in *Golden States of Grace* was taking place in 2004–5, we had just become saddled with what was increasingly being exposed as a deeply corrupt and overreaching Bush administration that had openly invited conservative Christianity literally and figuratively into virtually all levels of government, blowing away any semblance of a separation of church and state. By virtue of this, megachurches (and, by proxy, our government) were handing down ever-narrowing definitions of who "belonged" in American society—white Christian America. Rabbi Michael Lerner's assessment of the danger lying within this paradigm is powerfully expressed in his 2006 book, *The Left Hand of God*:

> There is a real spiritual crisis in America, and the Religious Right has managed to position itself as the articulator of the pain that crisis causes and as the caring force that will provide a spiritual solution. And then it takes the credibility that it has won in this way and associates itself with a political Right that is actually championing the very institutions and social arrangements that caused the problem in the first place. And with that power that each of these has gained by their alliance, they have become ever more arrogant in trying to impose their worldview on everyone in society. Their alliance threatens to destroy the fragile balance between secular and religious people and to move the United States toward the very kind of theocracy that people originally came to this country to escape.[2]

In the midst of these political and social changes, this body of work began to take shape as something that would, I hoped, look at the questions of who belongs and who prays through a different, if not more challenging, lens.

❖

Though one may find the odd workshop about how long-term personal photodocumentary projects come together, there is little formal training to learn the multiple skills needed for the job. For me, at its best, creating photodocumentary work is an out-of-body experience: something that allows me to climb into my subject, even if it is for only a five-hundredth of a second. It may be only a literal blink of an eye, but in it there is a momentary fusing of subject and photographer in the experience. The challenge is lowering your own guard in order to be fully present for that instant, for that honor. It is your prerogative. And by not going there, you are depriving your subject, your viewer, and yourself from an essential authenticity in the documentary process.

That said, within this process I always encountered instances when my own doubt, judgmentalism, or second-guessing crept into the frame. I keenly remember that the first time I ever felt the hair on the back of my neck stand up was on a shoot for *Golden States of Grace*. I had just started my first prison shoot at the California Institute for Women when I realized the very sweet born-again Christian woman who had been introduced to me by first name minutes earlier, and with whom I was now alone in her cell, was a member of a "family" of notorious serial killers. (I've since come to learn that the best way of working through situations like these is remembering to keep breathing and busy myself with my camera bag of gadgets.)

Another lesson learned was about the urge to self-censor. As was my nature to meet with a community's leader to explain the project and what his or her participation would entail, I was asked to meet with the Board of Directors of the Immaculate Heart Community. I arrived early to the already early Saturday-morning meeting and sat in my car for a few minutes, organizing my thoughts and a portfolio of groups I had documented to that point. When I realized the sex workers figured prominently, I thought, "This is a group of retired nuns. They'll never go for this." In the minutes leading up to the meeting, I ordered and reordered the images, hoping to soften their impact, growing more and

more annoyed with myself for not having thought ahead and prepared a more "nun-friendly" book.

I took a breath. For better or worse, the sex workers were part of this project, and any group that was considering joining it needed to be comfortable with their members' portraits being placed beside those of *any* other participant. As I sat outside the meeting waiting to be called in, it became perfectly clear that playing that fact down or trying to disguise it would cause irreparable harm to the integrity of the project on the whole, as well as create untold nightmares come opening night. So I kept all the photos in the portfolio and gave the pitch. Expecting the worst, I was surprised when Marie Egan called a couple of days later to invite me to document the next Immaculate Heart retreat. But the kicker came at the retreat itself. After two and a half days of shooting and interviewing the IHMs (as the Immaculate Heart members refer to themselves), I was pulled aside by one of the elderly board members and asked if it had been a fruitful visit. I told her it was and thanked her. As I was about to turn away, she said, "Rick, I don't know if you knew this, but the Order of the Immaculate Heart began in Spain in the mid-1800s, and one of the first things they did was outreach to women working the streets. You should know the reason we decided to be part of the project was your pictures of the sex workers. I look forward to seeing the finished product." She smiled and trod off, having no idea what her words meant.

As this project arched across three years, periods of chaotic activity were followed by huge dry spells. I seemed either to have my nose to the ground following several paths at once, or all tracks would go cold for weeks or months at a time, leaving me unsure if the project would yield enough material to mount its first showing at the Fullerton Museum Center in Orange County. (The museum administrators had gone out on a limb by committing early in 2004 to premiere the work in 2006, based on the success they had had with *The Migrant Project* and an early portfolio of images I had shown them of the first four communities I had photographed.)

In the end, even though I found a balance that felt right with eleven communities, there were several others I had thought to include but that didn't materialize for one reason or another—such as children in the juvenile justice system, veterans of the armed forces, and motorcycle gangs.

Most shoots took place over two or three days, some on consecutive days, others a year or more apart. Early on I settled on shooting in medium format (with a Contax 645) black-and-white film and exclusively with available light (except in a handful of instances when there was no option but to use flash). I interviewed my subjects first, to give me more insight into them and vice versa, as well as to build some semblance of trust. The interview often continued into a subject's sitting, granting people who for the most part were not used to being photographed greater ease in front of the camera.

It quickly became clear to me that several precarious elements needed to be balanced in order for the project to succeed, most importantly the issue of diversity on numerous levels. This led me to constantly tweak and retweak the list of communities I'd consider and ultimately approach to participate. I know we live in a society dominated by Christianity (66 percent of California, 79 percent of the nation[3])—but I felt that by including Christians, Pentecostals, Baptists, and Catholics, theirs was a fair representation. My canvas being California, which has a long and infamous history of wiping out indigenous cultures, I felt including at least two of those groups would be appropriate: one Native American, the other Mexican, who, as some of California's other first residents, in fact predated Anglo-European settlers and their imported Protestant faiths.

The final roster of communities was somewhat fluid up until just three months before the work's premiere in late September 2006. It was only after a three-day shoot in June 2006, when I was invited into Kashi Ashram for a weekend darshan with Guru Ma Jaya and her devotees, that I felt I had found a balanced bookend to the project.

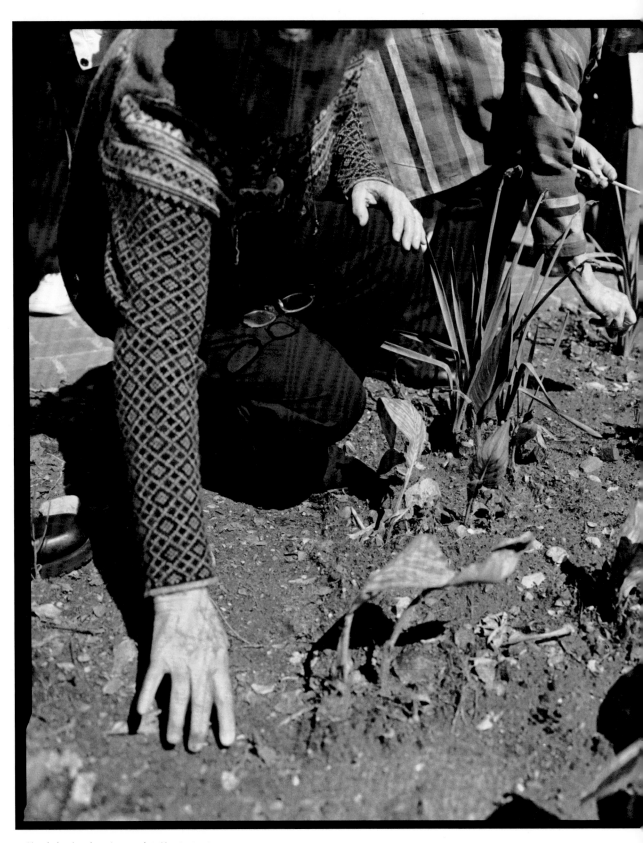

Ritual planting closes Immaculate Heart retreat

Kashi Ashram's long-term, unconditional embrace and devotion to serving, supporting, and caring for people with HIV/AIDS was unique among the Hindu-based communities I had considered working with up till then. Additionally, there was something personal to the fact I began the project with Beit T'Shuvah, which represented the faith I was born into, Judaism, in the city in which I was raised, Los Angeles, and was finishing with Kashi Ashram, which focused on yoga and meditation, the spiritual practices I mostly regularly embrace as an adult, and which was also located, figuratively speaking, in my own backyard—West Hollywood.

As much as documentarians are supposed to keep an emotional distance from their subjects to ensure fair-handed portrayals, ultimately I developed an undeniable protective feeling toward each of the participating communities. Although few, if any, of the groups ever met or interacted with one another, I came to see them almost as kindred spirits, each bringing something unique to an ever-expanding family. Whether it was Women of Wisdom's commitment to building a nurturing place for feminine spirit of every faith to feel safe, connect, and be heard; the Federated Indians of Graton Rancheria's mission of restoring their nearly extinct ancient culture's rituals, language, and dance; or the deaf Mormon branch's dedication to community service, each group carried a theme all its own, often teaching me firsthand deeply moving lessons.

One thing that never ceases to impress me in my line of work is the trust that subjects unselfishly offer up when they sit for a portrait and interview, which could, theoretically, be manipulated to fit any agenda. In dealing with inherently political or loaded subject matter, as I often do, their trust humbles me. The group who invested the most trust in me was in fact, in post-9/11 America, the one with the most, potentially, to lose: the Cham Muslim. Again, in dealing with them, my own expectations and personally held stereotypes about what a small and tight-knit Muslim community might be were shattered.

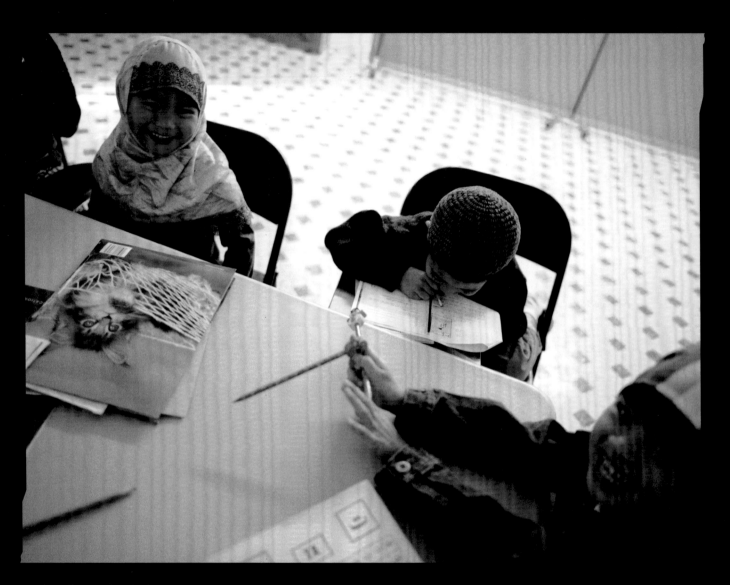

Level one, Cham Sunday school

I was connected to Brother Salim Ghazaly, the imam of this particular community, by Shakeel Syed, executive director of the Islamic Shura Council of Southern California, an umbrella organization of mosques and Muslim groups. He spent no more than five minutes talking with me at the public function where we met before giving me his phone number. With hate crimes toward Muslims at record highs and Islam bashing endemic across the country, I had expected an intense vetting and had girded myself for yet another polite refusal. Instead, a few days later, Shakeel gave me Brother Salim's private phone number, and within ten minutes on the phone with Brother Salim I had been invited down to Orange County, not to talk further, but to photograph the community's upcoming feast of Eid ul-Fitr, their celebration closing out Ramadan. This community of Cham, made up almost exclusively of survivors of the Cambodian genocide and their young children, opened themselves to me with complete trust, without even asking to check a single reference. The process of documenting their potluck celebration and, later on, their ad-hoc Sunday school, built into a few rooms of their small mosque, took me immediately back to my own fond memories of nearly thirty years earlier—gathering with hoards of friends and family to break the Yom Kippur fast at my parents' home and rebelling in every way at the confines of Hebrew school. The paradox was not lost on me: that an experience taking place in a Muslim community— a faith our nation's leaders, and many in the Jewish community, had successfully but unjustly vilified— was what brought such a deep and emotional rush of nostalgia for my own Jewish upbringing. When I returned several months later to record the digital audio portion of the project, it wasn't a sterile room or apartment I was invited into, but the middle of the wedding of a community member. Again, my subjects set no preconditions or boundaries—they simply met me with trust.

In assembling *Golden States of Grace* and considering the multidimensional diversity it encompasses in both an exhibition and this book, I have found significant crossover among subjects: prison inmates could also be recovering addicts; immigrants could also be transsexuals; the rural poor could be both elderly and physically disabled; and so on. It became clear that in order to break down the barriers surrounding many of these people, I would need to present the work, not by dividing it up into segregated communities, but by grouping images by what *joined* them: visual themes, graphic resemblance, or metaphor.

Embarking on the edit of three years of shooting required a second set of eyes, and I turned to creative consultant Bonny Taylor for her keen editorial sense, as well as for the freshness she'd bring to the project. From the over one thousand frames I began with, I brought about two hundred work prints to a gallery Bonny had at her disposal. We grouped and regrouped images for hours, working not just with pairs or triptychs, but creating entire groupings that would make sense thematically within the gallery of the Fullerton Museum Center. With several long, irregular walls making up alcoves and rooms, the space would offer the opportunity for an intriguingly intimate interaction with each set of images.

For an image to make the final cut, it had to have meaning and symbolism and contribute to or comment on the others it would stand beside, while not repeating them. This standard created a very delicate house of cards, and I had to make decisions running counter to the urges to include my favorites or a perfectly balanced number of images from each community. We settled on a set of fifty-six images that we felt, individually and as a whole body, took viewers on a journey and played on common themes communities shared, such as sacred spaces, redemption, and future generations. I then took a blueprint of the museum gallery and created scaled-down miniatures of each of the selects, factoring in several that called out to be life-sized anchors for entire rooms or walls. (For this book, I have reordered the original fifty-six images on the basis of how they play against each other on the page, while taking into account

Thumbnail layout for Fullerton Museum Center installation

Exhibit installed at Fullerton Museum Center

and further defining the groupings in which they had originally been placed.)

After the shoots, along with my exposed film, I would return with several hours of audiotape to transcribe. Being struck by both the passion in the voices and how articulate my subjects were, early on I decided the didactics for *Golden States of Grace* would be composed of the words of each subject wherever possible. With the abundance of material and a desired concept to make the gallery something of a sacred space of its own, I decided to produce an ambient soundtrack of prayer, spoken word, and music. (Additionally, extended interviews would be posted at listening stations.) Toward the project's end, I traded in a microrecorder for professional digital audio gear and then embarked on revisiting my earliest subjects to make sure I had good quality audio of each community. Most groups were able to contribute to either or both of the audio elements, though all the sex workers had all moved on from the cell phone numbers and single room occupancies where we'd originally found them.

The premiere of *Golden States of Grace* at the Fullerton Museum Center in Orange County was a unique and emotionally overwhelming event. Of the eleven participating communities, the five based in and around Southern California had representatives in attendance opening night. Two communities, members from the Teviston and Pixley churches and Beit T'Shuvah's choir, traveled long distances to provide live music, trading off exuberant sets in a tent erected outside the museum for the occasion. There was a great sense of coming together that evening and throughout the first engagement, which ultimately surpassed any expectation I could have had when I first embarked on the project three years earlier. As I visited the exhibit over the following weeks, I saw people from all walks of life, several seemingly meditating for extended periods on the faces and stories of those on the walls around them. The programs facilitated by the museum and interfaith consultant Lucky Lynch in the weeks that followed often brought in overflow crowds and seemed to open conversations between people who had otherwise had no history in talking, let alone hearing one another.

Having my work help engage communications between otherwise disparate groups heightens the sense of satisfaction I receive from what I do to a whole other level. I continue to be enlightened and encouraged by seeing the members of various non-profits and social justice organizations around the country working tirelessly in the name of interfaith cooperation; like my subjects, they are fighting against the odds of complacency and injustice to bring understanding and change to a very divided and entrenched world. If they find this work a tool in doing the difficult and often underappreciated work they do, I can only be deeply humbled to contribute to that noble effort.

Notes

1. http://www.pluralism.org/directory/results.php?state=CA.
2. Lerner, Michael. *The Left Hand of God: Taking Back Our Country from the Religious Right.* San Francisco: Harper San Francisco, 2006, pp. 14–15.
3. http://religions.pewforum.org/maps.

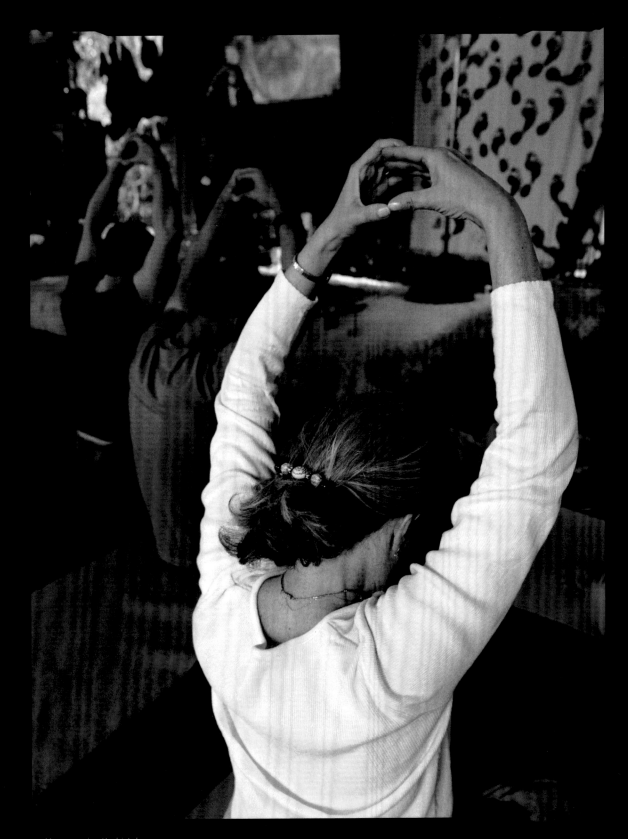

Yoga practice, Kashi Ashram

Acknowledgments

THERE WERE MANY TIMES OVER THE THREE YEARS it took to create this body of work, as well as the additional years spent bringing this book to fruition, when my own vision, skills, and, yes, faith were tested. Ultimately my ability to see this project to the end has in no small part been due to the input, support, and love of numerous people.

My deepest thanks go to each of the eleven participating communities who offered energy, candor, and, most importantly, trust when they opened their lives, ceremonies, and houses of worship to this project. Its content and scope could never have been realized without their ongoing collaboration.

The contributors to this book took time and energy from their busy lives to carefully compose their words and insights and continually offered ongoing belief in the importance of this work's message: Jack, Paul, Harriet, Amir, Miss Major, Vincent, and Lois, thank you for everything.

I'm indebted to those who contributed their own prayers as well as those who helped gather the words of their respective communities: Kathy Marler, Lori Fye, Brother Salim Ghazaly, Asia Smith, Sister Suzanne Jabro, Marie Egan, Susan Reneau, Seido Lee de Barros, Greg Fain, Bobbiejean Baker, and Minister Yvonne Evans. I'm also grateful to Susanna Zaraysky for her ongoing research and support on the exhibit as well as this book.

The Interfaith Center at the Presidio, and especially Rev. Paul Chaffee, have offered fiscal sponsorship and in-kind services, but, more importantly, a wealth of contacts, friendship, and encouragement from the first day *Golden States of Grace* appeared at their door.

I owe a debt of gratitude to the project's advisory board: again, Rev. Paul Chaffee, Amir Hussain, PhD, and Lois Ann Lorentzen, PhD, and additionally: Swamis Atmavidyanada and Sarvadevananda of the Vedanta Center, Hollywood; Rabbi Harold M. Schulweis; and especially Lucky Lynch, whose generosity of spirit, friendship, and buoyancy informed and carried this work forward in so many important ways.

Original project funding came from the Pew Charitable Trust, the University of San Francisco's Religion and Immigration Project, the Kurz Family Foundation, and the Durfee Foundation.

Lisa Pacheco and Luther Wilson unwaveringly bought into the concept for this book from the first time they saw the work presented at the American Academy of Religion. Melissa Tandysh remained open to every creative idea tossed her way, transforming them into this final design—something I only dreamed would actually be realized. Diana Rico's eagle eye kept me editorially honest and open, and Elise McHugh enthusiastically shepherded this project in all its complexity to its final destination.

Additional thanks go to my assistants: Tom Jensen for his ongoing multitasking in and out of the studio, Michael Lowe for his editorial work, Meredith Flores for her research and production assistance going back to the early days of the exhibit, and Bettina M. Chavez for her detailed review of the page proofs. Bonny Taylor brought an independent and critical sensibility to helping edit the core images of the exhibition and reimagining them for this book.

One of my joys in life are the people I have the chance to meet and collaborate with along the way as my work is created and presented. In the case of this project, those new friends include: Leonard Wallock, Wade Clark Roof and the Walter H. Capps Center for Religion and Ethics in Public Life, Jarrod Schwartz and the entire staff of Just Communities Central Coast, Professor S. Brent Rodriguez Plate, and Rev. Dirk Ficca and the staff of the Council for a Parliament for the World's Religions.

Months of work went into assembling the physical exhibit of this book's core images for its premiere at the Fullerton Museum Center (September 30, 2006–January 14, 2007). Among those responsible are The Icon (scans and prints), Steve Kadel (copy editing), Jessica Lasher (graphic design), Keven Kadel (sound mastering and engineering), and the entire staff and board of the Fullerton Museum Center.

Special thanks go out to the following individuals and organizations for their help, whether it came in the form of inspiration, guidance, challenges, or personal and professional assistance: Lt. Larry Aaron, Mark Arax, Aimee Aul, Ark of Refuge Ministries, Joann Bacci, Rosalina Baldonado, Rebecca Bennion, Matt Black, Cheryl Bonacci, Sr. Louise Bond, Fr. Gregory Boyle, Stacy Caldwell, Prof. Jim Carse, PhD, Prof. Chris Chapple, PhD, Elizabeth Chaumette, Lorenzo Ciacci, Lt. Vernell Crittendon, Warden Dawn Davison, Joe Felz, Bishop Yvette Flunder, Ursula Caspary Frankel, Bari Greenberg, Michelle Isaac, Fr. Mike Kennedy, Tim Knight, Swami Krishnapria, John Leland, Rabbi Michael Lerner, Lt. Rudy Luna, Gerardo Marin, Dannielle Mauk, Lt. Eric Messick, Abdussalam Mohamed, Dennis Odums, Prof. Kurt Organista, PhD, Prof. Pamela Balls Organista, PhD, Barbara Osborn, PhD, Amelia Perkins, Lt. Sam Robinson, Stacey Rosenholz, Sr. Katie Simmons, Elena Simon, Rev. Alexei Smith, Richard Smith, Javier Stauring, Shakeel Syed, Lynn Szwaja, Ginger Thompson, Jacques Verduin, S. Lynne Walker, Debra Weiss, David White, PhD, Kimberlee Wirig, Mina Yamashita, Zen Mountain Monastery, and Jeff Zucker.

Finally, thanks to my parents, my entire family, and especially my husband, Steve, for their ongoing support, love, and constant encouragement.

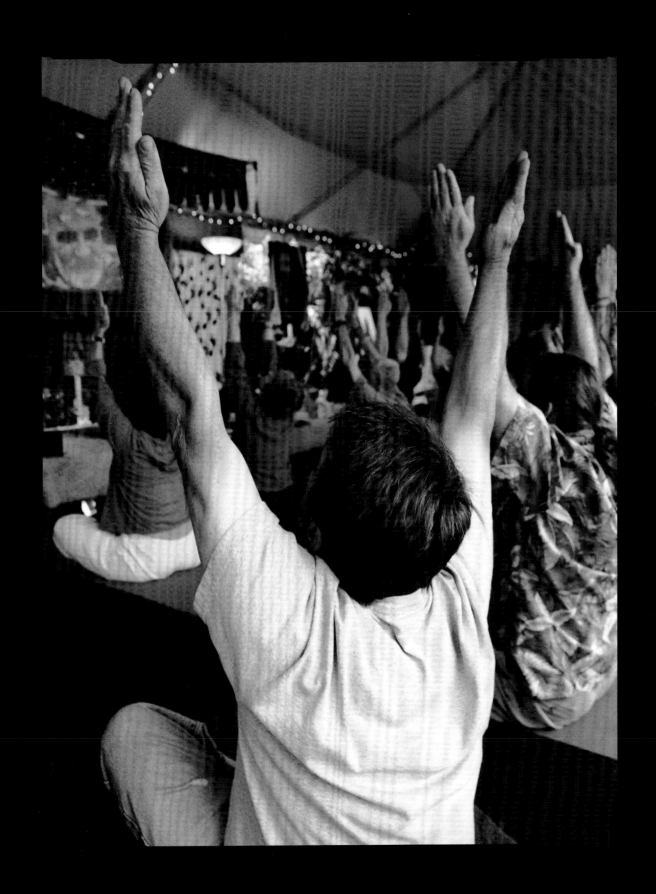

you will be given wings

When you come to the edge of all that you know,
you must believe in one of two things:
there will be earth upon which to stand
or **you will be given wings**.

My wish is that we are all given wings and the faith to use them.

—JANE,
WOMEN OF WISDOM

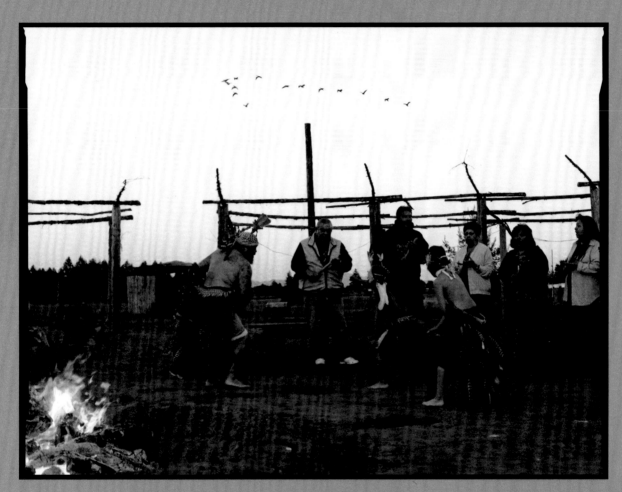

Dancing at the Acorn, Federated Indians of Graton Rancheria

AN AMERICAN PRAYER*

Take refuge, dear children, in the changes in your life.

We will be given wings, the strength to fight and to resist

In a world of seemingly decreasing hope,

Grant us insight and wisdom so that we do good.

If we have been in love then we realize who you are—all-encompassing.

When we see you face to face, we witness all the beauty

And give thanks to life, to the Mother—true compassion.

Remind us to share these gifts: your creation; your practice.

I pray to recognize your presence, to bring peace,

And to ultimately transition to that place of peace.

One day I will become one, I will walk in the light, sharing my blessing,

Finding the gift bestowed in living authentically.

And so let the new leaders of our country and in this community

Hold a reverence for love.

Be always with me,

In dreams beyond today;

And in different tribes and nations may they hear the question.

If God made me, all things are possible.

*With all due respect to James Douglas Morrison.